Art in the Time of Unbearable Crisis

Art in the Time of Unbearable Crisis

WOMEN WRITERS
RESPOND TO THE CALL

EDITED BY STEPHANIE RAFFELOCK
FOREWORD BY BROOKE WARNER

SHE WRITES PRESS

Published 2022
Printed in the United States of America
Print ISBN: 978-1-64742-489-3
E-ISBN: 978-1-64742-490-9
Library of Congress Control Number: 2022910400

For information, address:
She Writes Press
1569 Solano Ave #546
Berkeley, CA 94707

Interior design by Tabitha Lahr

She Writes Press is a division of SparkPoint Studio, LLC.

Dedicated to the indomitable
spirit of the Ukrainian people.

Contents

Foreword

Brooke Warner

When Stephanie Raffelock approached me with the idea to create this anthology as a compilation of She Writes Press authors' work in response to the many crises we currently face, nationally and globally, my first and immediate response was ambivalence. I wondered, as many writers and creators have been wondering in the face of the giant crises we face, whether a collection like this would make a difference, whether it would be additive. And then there was the work it would involve, during a time when the world—as if to make up for the lull of the early months of COVID—seems to be moving at breakneck speed.

I asked for the weekend to think through her proposal. Alone with my thoughts, I began to think more expansively, as we do when not driven by fear and overwhelm. It touched me that we, the authors of She Writes Press, might come together as a community of sister-writers to make something beautiful and lasting during this time when we're all struggling so much—individually and collectively.

Agreeing to move forward turned out to be a balm. All writing is both a mirror and a testament, and I needed both. When living through something big or trying, sometimes it's all we can do to put one foot in front of the other as an act of survival. Our written words, though, show us what we sometimes can't see. How the filter of our minds brings deeper awareness to our lived experiences is what makes writing (and all art) so magical. Making a record, sharing a collective experience, creating intimacies through your words—all of these are reasons to write and to create. To be on the receiving end of making, sharing, and creating is to witness humanity. A collective breath. A moment in time. Captured in all its beauty and heartbreak and despair.

This anthology came to be because we're hurting. As a people, we have been sick and we have lost loved ones. We have been isolated, dealing with the fallout of distance and endings. With the war in Ukraine, cellular losses have crashed to the surface for refugees and their children and their children's children—not to mention the impact on all of us of the immediate tragedies and atrocities we see unfold each and every day. We live in a toxic political wasteland where public discourse has devolved to such a degree that most of us carry hatred in our hearts for people we don't even know. The social justice movement, a bright spot on the stain of this historical moment in time, exists in response to deep-seated hurts that will take generations to heal. Basic rights I once took for granted—to love who we want to love, to express how we want to express, to live free from attacks on our identities—feel threatened.

Throughout the pandemic, I've sat in Zoom circles—of writers in classes I've taught, and of seekers in classes where I've been blessed to support Mark Nepo and Parker Palmer,

both teachers and best-selling authors who bring deep wisdom and comfort to the aching hearts of the souls they gather. These pandemic-era Zoom rooms are our modern gathering spaces, the only spaces most of us have had to connect. Many writers and creators in these rooms have shared their deep ambivalence, not so different from that which I felt upon Stephanie's proposal for *Art in the Time of Unbearable Crisis*. Blocking people's creative spirits is ambivalence, but also grief and aimlessness and guilt. Creators will question why their art matters when there's so much suffering in the world. I've not felt so much grief or guilt myself, but I've been besieged by outrage. I've felt tired, too, like a cliff buttressed up against a rugged sea getting bashed with waves and pelted by sand picked up by high winds—worn by the elements of this existence. Not exactly the best conditions for feeling inspired to write or create.

While I've not been inspired to write or create due to these conditions, I have been devouring books and audiobooks. I read somewhere that the reciprocity of writing and reading is like exhaling and inhaling. A beautiful metaphor for how we need both—the exhale being the creative release, the inhale being the inspiring intake that feeds us.

Art in the Time of Unbearable Crisis is that collective exhale, of She Writes Press authors answering a call and giving voice to this moment. This thoughtful chorus of women is offering the essays, poems, and art in these pages as a means to connect, to bear witness, and to log a record of these times. In these pages are stories of family histories carried through the generations. There is confession—of loneliness, of grief, of fear of what the future holds. There are stories of death and having to survive its lonely aftermath. And there are stories of birth—of babies born during the pandemic—and rebirth,

as some of us have discovered or recovered aspects of our-selves during this time, too. There are stories of longing and of laughing even when nothing is funny, because sometimes that's all we can do.

The response to the call for submissions for this collection was swift. The authors had two weeks—and we received nearly one hundred submissions. The reading of all the pieces was the inhale I needed to take. My ambivalence was smothered from the very first line of the first submission I read, and I was reminded yet again of the power of words to heal, to connect, to inspire. In the groundswell of submissions, I witnessed the profound power of women creators rising up to say yes. Yes, our voices matter. Yes, our words and our art can soothe ang-sting hearts. Yes, connection matters. Yes, I want to be seen. Yes, I see you too.

BROOKE WARNER is the publisher of She Writes Press and SparkPress, president of Warner Coaching Inc., and author of *Write On, Sisters!, Green-Light Your Book, What's Your Book?,* and three books on memoir. Brooke is a TEDx speaker and weekly podcaster (of *Write-minded,* with cohost Grant Faulkner of NaNoWriMo) and the former executive editor of Seal Press. She writes a regular column for *Publishers Weekly.*

Introduction: Making Art While the World Appears to Fall Apart

Stephanie Raffelock

The spirit of creativity is the spirit
of beauty, the broken and the whole.
Art is a mirror unto the soul.

As World War II came to an end, a young soldier stationed in Germany took photos of what was left of the city streets he patrolled in Berlin. Small black-and-white images framed in white borders with scalloped edges show piles of rubble and people wandering. In one picture a man carries a chair, a single stick of furniture with which to begin anew. Another shows a woman digging in the debris for something that used to be but no longer is. An entire country undone—the one-time great destroyer now destroyed—was the subject of the young man's photographs.

The aftermath of that war and all its horrific suffering must have been grief and bewilderment as to how the world would ever again know good.

The soldier documenting the story with his camera was my father, and the year was 1945.

The pictures of life beginning to rise up from the burned-out shell of survival were not the only things that the young soldier brought back from the war. Among his belongings he had wrapped in blankets and carefully tucked away a cocoon of memory, and upon arriving home he slid it under the bed to collect dust until his death. Within that walled-off slice of his life was a series of drawings done in pencil and charcoal—beautiful, serene scenes of deer grazing in the shelter of the forest. I saw the drawings when I was a little girl and I knew that they were my father's treasures. He told me they represented a brief relationship with an artist that led to the purchase of the drawings, which he paid for with packs of cigarettes and chocolate bars.

He loved them so much, he told me, that he carried them back over an ocean and into his life at home. But they were never framed or displayed. He hid them under the bed, along with other things from the war that I would never see or understand.

When my father died in 1980, I pulled the wrapped drawings from their dusty tomb and brought them home with me, framing them and finally giving them the display that they deserved. I know that in spite of hiding them he did look at the drawings from time to time, remembering a friend whose fate was unknown.

Each time I walk by the framed drawings now, I wonder how it is that an artist living in the face of such horror could create such beauty. In these unrelenting days of pandemic and

bloodsport politics, the drawings reach out to me from another terrible time, whispering that I should not forget that there is always something left in the ashes of loss.

That's what art does. It keeps good alive in the worst of times. That's what Amanda Gorman did when she stood on the steps of the Capitol building and recited her poem—she was a light, enlivening inspiration in human hearts broken by so much ugliness, pain, and death. What she gave to us was one long, deep breath that exhaled the healing imagining of new possibility.

The works of an unknown German artist who preserved the beauty of his heart and the well-praised poet who will surely experience fame for her work did the exact same thing. They did what artists are called to do in atrocious times. They affirmed life with their creations. They provided nourishment for the dried-up well of deep goodness for which we are now longing.

Divisiveness and lies, death and destruction, can threaten to strangle our efforts to keep creating. How can creativity be meaningful or significant in these challenging times? How could that German artist even think of drawing when he took in the magnitude of horror around him? How could Amanda Gorman create such a profound moment from steps upon which darkness had been unleashed only days before? These artists created boldly out of grief and the mud of chaos, the cramping labor of what it means to birth love.

The emerging archetype of midlife women is the Creatrix, a word that means *a woman who makes things*. There has never been a greater calling in our lifetime to make things as a life-affirming action, as a way to let in the light. The great poet Jonas Mekas said, "In the very end, civilizations perish because they listen to their politicians and not to their poets." I take his

words as a warning to not be daunted by the power-hungry, to instead find a way to share what is both painful and beautiful in the human condition.

There are piles of rubble everywhere in our collective heart-break. To write, to sing, to dance, to be playful and silly, to make things, to gather things and arrange them, to praise, to pay homage to grief upon an altar in the corner of our garden, to plant the seeds of gratitude—this is the beginning of how we contribute to the cleanup and the rebuilding of a nation's soul. This is our time to make things.

STEPHANIE RAFFELOCK is a podcaster, speaker, voice-over artist, and writer. She is the author of *Creatrix Rising: Unlocking the Power of Midlife Women* (She Writes Press, 2021). She also penned the award-winning book *A Delightful Little Book on Aging* (She Writes Press, 2020).

Believe

Maria Kostaki

"What's up, you Russian!?"

My friend's already-loud voice deafens me like the sirens I hear in Kyiv on CNN; I shrink into myself, as I feel that she's insulting me, though she—unaware of the new meaning the word "Russian" has taken on as Putin strides his army of atrocious madness into Ukraine—thinks she's being funny. I thought its long list of associations had reached completion after the fall of the Berlin Wall, the dissolution of the USSR, and the embarrassment of Yeltsin, and as the memory of the influx of Eastern Bloc sex workers into Europe that so influenced my teenage years finally faded in everyone's mind. I was okay with "Russian" simply meaning "conniving, hot, model-like woman who was married for money."

Really, I was.

"Don't call me that," I manage to say.

All my life, I have been a privileged refugee. A refugee in that I spent my formative years in the USSR, shaped inevitably by oppression and brainwashing, holding on to my grandma's

bony, veined hand while we waited in lines for things like butter and bread for hours in the cold. I have no true home, no sense of belonging, no family waiting for me anywhere. In Greece—where I've lived most of my life—I'm either "the dumb American" or the "hooker Russian"; in the US—where I lived the most inclusive years of my life—I was the "dirty Greek"; and during the few short visits I made to Russia as an adult, I was more of an outsider than I had been anywhere else. But privileged nonetheless, because I've always had a warm home and a room to call my own, because I've never come close to poverty or hunger or immediate persecution, never been in danger from a war or natural disaster. All the things real refugees are faced with. But this self-appointed status has ingrained in me a constant need to help others—a need that's almost infantile, for I act and react as a young child would whenever a disaster hits, and my lack of a place in the world seems to be the key.

As a first grader in Moscow, my dream was to get to high school as soon as possible so I could go on the school trips that take you to help the women gather potatoes on the collective farms. I'd seen a sepia photo somewhere of a woman kneeling in the field of dirt, face streaked in brushes of mud, exhausted eyes looking into the bottom of the camera lens. I thought she was on the verge of tears, and I, my own eyes glistening with tears of love, wanted to go help her out. And all the others that our teacher told us worked hard for the state. Looking back, I'm thankful I never got the opportunity.

Since then, I have yet to accomplish anything grand—I haven't shifted history—but I do strive to help in the little ways I can until the sadness begins to crush me. When Syrian children started washing up on Greece's shores, my own son was three, a detail that made the footage of a dead boy of the same age lying

on a beach hit closer to home than anything I'd seen. Scores of expats began heading to the islands where volunteers were most needed, and my longing to go with them brought me to tantrum-like tears.

But that would be illogical, leaving one's toddler to go help others. Instead, I convinced my son's nursery school to let me host a drive for shoes and socks, which was what the refugee children needed most, the news told us. (No war and their parents were what they actually needed most.) I hauled garbage bags and boxes, asked a friend to clear her schedule so she could help me transport whatever I collected to the friend of a friend who was taking a ferry to the refugee camp. I expected to get at least a pair or two from each family at the school; *Kids grow so fast at this age*, I thought; *surely they'll have worn shoes, surely they'll go buy socks.* Two moms contributed. One pair of shoes. Three pairs of old socks. I gave away stuff my kid was still wearing.

The friend that had referred me to the woman gathering supplies was a professor from my undergrad years. She began volunteering at a camp here in Athens, playing with the kids, helping them draw. It shocked me because she was hardly the motherly type, but I suppose being motherly is not a prerequisite for kindness.

I self-published a children's book. Started a Kickstarter campaign, vowed to donate all proceeds to a new NGO working to house lone refugee minors. The campaign barely raised half the funds for publication, the publisher refused to cut my agreed print run to the number of copies I could afford, and the book never sold enough copies to cover the difference, let alone make anything to donate. But today, that NGO has fourteen homes that have sheltered over seven hundred children. And as life

works in serendipitous ways, I freelance for them from afar—
not saving the children, but hopefully helping them to do so.

The refugees gave way to the International Women's March.
Trump won and the adopted American in me came raging out.
Athens is not the biggest hub of women's rights (not even close
before #MeToo, when dozens upon dozens of women finally
began speaking out), it's not pro-American, and the women I
knew would come march with me I could count on one hand.
But suddenly, I found my face in *The Guardian*, and a few days
later I stood on the curb outside the US embassy, one of my
best friends by my side holding the blowhorn that was attached
to some form of other apparatus that I had to speak into, with
only five minutes to get rid of my fear of public speaking.
We had a permit for a quiet gathering—"30–50 mothers and
children," I'd sincerely written on the police application for
peaceful protest—but there was a field of heads covered in
pink hats with signs waving in the air at the foot of my make-
shift soapbox. After I spoke, we marched, and another group,
there to champion refugee rights and marching in the other
direction, turned around and joined us. Or did we join them? It
doesn't matter.

I have never felt so high.

I have never been so proud.

I have never felt so strong.

I have never been so one with the world.

Not even the next year, when we upped our game and
moved to Constitution Square—real mic, speakers, soundtrack,
and all. There, where a twenty-something girl working at a
café asked me what we were doing taking up public space,
asked me why we think women don't have equal rights when
in Greece, at least, they absolutely do. For years, I looked for

her every time I walked by that café. I'm assuming that by now, she knows. Maybe she's looking for me too, to tell me we were onto something back in 2018, to say "me too."

And now, Ukraine. A fourth of my blood runs blue and yellow, something I was unaware of until the day Vladimir Putin decided to "recognize" the Donbas region, where my grandmother was born. I never knew this part of my already-fragmented history—not because it was a secret but because nobody thought to tell me, for it was part of the USSR when all of us were born and for much of my grandmother's life. That's my theory, at least. And by the time that fell apart, I had a Greek passport, though I barely spoke the language, living in the bubble of an international school, and though I cared about becoming American more than anything. Shortly after the nation of my birth ceased to exist, the US bases in Athens began to shut down. The threat was gone. The Cold War was over. But for me, what mattered was that it was the end of American onsite festivals ("Zucchini Dayz," an autumn one was called) that my friend's military dad would have to get special permission to sign me in for. Gone were the hot dogs, the Doritos, grape Hubba Bubba, bouncy castles; gone were the days of being questioned at the gate by soldiers probably less than a decade older than me about my Soviet passport. I had so wanted to display my Greek one, but I never got the chance.

In my late teens, as communism began to see one fall after the other, the Eastern Bloc sex workers trickled into Southern Europe. Taking a taxi late at night was tricky. I never knew what to pretend to be, so I often innocently told the truth. And then it all faded. I moved to New York, the Towers fell, Bush told us to go shop to help the city as he stood on top of the massive heap of rubble. I did as I was told. I felt like a New

Yorker, I felt like I belonged, I still thought that mattered then. But now, again, I'm a Russian.

But this time I see kindness everywhere. This time I know I'll never change the course of history—that none of us every-day people can. As Putin began to roll his steel caterpillars into a land that was never his, the internet exploded with humanity. Almost overnight, hundreds of thousands of people formed groups, blindly and wholeheartedly threw open the doors of their homes, organized food and supply drives, texted with those running for their lives, and more. I saw it all happen on my screen; I was mesmerized for days. Two million refugees and counting. Nothing we can do is enough. But many bits of things are something. It's better than a pair of shoes and old socks.

I dreamed of going to a bunker to read bedtime stories to children hiding underground. My mother's husband—a lawyer, policeman, and political refugee who survived not only Putin's persecution but also the siege of St. Petersburg as an infant—wanted to pick up his rifle and head to Ukraine to help them fight; he was hindered only by his age. A Polish woman in Athens asked for help for a Ukrainian friend of a friend of a friend who was preparing to drive from Athens to the border of Poland and Ukraine to pick up her cousins. She was gathering all the medical supplies, baby food, and blankets that she could fit into the car to leave there. I bought baby formula and nuts. My friend helped her find places to stay on her journey.

Some others have given me money to do more. I don't know what more to do. Bombs keep falling. People keep dying. Madmen keep on living. My grandma in Moscow speaks of military operations against the Nazis. Protesters and the very few independent presses still in operation are using code words

so as to not be caught and arrested. All I can do is hope that it's over by the time your eyes skim these words.

The Native Americans say that we inherit the trauma of our ancestors. I hope that's not so, though I'm possibly living proof of that beautiful, sad theory. But if we inherit trauma, maybe we also inherit the joy, the kindness, the love.

I feel others' pain more than I feel my own. I am at an age where I'm comfortable with not belonging, at ease with constantly being swayed by the suffering of others, even at peace with the failure to rally up big troops for my cause. Because on this journey I've been touched by the kindness of others; I've been injected with the adrenaline of the crowd below my blowhorn; maybe I even edited a paragraph that got that NGO the coveted grant it so desperately needed. Tiny pieces of a difference are all that I've gathered in my basket.

My child will inherit this. Not the evil in my history. I know he's been watching. I think he sees that I'm everywhere and nowhere at the same time, that I'm no one and I'm everyone. That's my superpower.

MARIA KOSTAKI is the author of *Pieces* and *When Clouds Embrace*. A freelance writer and journalist based in Athens, Greece, she's currently working on a collection of short stories. She's the mom of a nine-year-old kid, and, most importantly, she believes.

Ode to Morphine

Deborah Tobola

Who knew it would be blue? I fill the dropper—
my mother opens her mouth like a baby
bird. *Baby Bird, that's your new nickname*, I say.
I think it's sky blue,

the morphine, but I need to know the exact
color of the elixir that transports her.
So I google "color of morphine" and find
an analogy

by poet Sarah Hannah, who tended to her
dying mother. *Pale blue Canterbury Bells
are the color of liquid morphine*, she wrote.
Of course a poet

is the one who gives the answer. Her mother
was an artist who loved flowers. My mother
is not an artist. But my father called her
his little flower.

In January 2020, **DEBORAH TOBOLA** began caring for her then eighty-six-year-old mother. Somehow (hypervigilance), they made it through the pandemic. Her mother recently entered hospice care in Deborah's home. Reading and writing poetry helps Deborah stay connected to the world, in all of its beauty and anguish. She's recently fallen in love with the Sapphic ode.

Packing Essentials

Irena Smith

SEPTEMBER 1977: My parents and I leave the Soviet Union to seek political asylum in the US. We have four suitcases—brown, cheaply made. They hold everything you might need when you're fleeing a country that never recognized you as a full citizen even if you lived there for generations: a hot plate, a few pots and pans, shoes, toothbrushes, an umbrella, clothes, an electric converter, an assortment of my father's tools, and a fat book with an orange-brown cover scored by three vertical lines: *The Collected Works of Mikhail Bulgakov.*

We travel via Austria and Italy because there are no direct routes for Russian-Jewish refugees to the US in 1977. We depart for Vienna from Sheremetyevo Airport in Moscow wearing multiple layers—two pairs of underwear, two pairs of pants, short-sleeve shirts under long-sleeve shirts under sweaters under coats—because not everything fits into the suitcases. Partly because of that book. That heavy, unwieldy book that my parents didn't have to bring, but did. The book that edged out my stuffed rabbit who beat on a drum when you wound him up.

OCTOBER 1975: My uncle Boris, who lives in Odessa, befriends two East German women he worked with on a rail project in East Germany. He gives them my parents' contact information, and when they visit Moscow, they look up my parents and stay with us for a few nights. They bring gifts: a semaphore orange sweater for me, *The Collected Works of Mikhail Bulgakov* for my parents.

Bulgakov is legendary in the Soviet Union, but his work is almost impossible to find. Excerpts from his novels appear in magazines, but they're heavily censored; his novels, which have been issued in laughably small print runs, are censored as well. *The Collected Works of Mikhail Bulgakov* contains three novels: *White Guard, A Theatrical Novel,* and *The Master and Margarita.* Because they were published abroad, they are uncensored.

NOVEMBER 1977: After two weeks in a residential hotel in Vienna, my parents and I rent a room in a four-bedroom apartment in Rome, where we wait to be granted refugee status by the United States. Two other Russian-Jewish families, also émigrés, rent the other two rooms. There is one kitchen and one bathroom. The apartment is near the Vatican and has tall windows and stone floors and an old, extraordinarily small, and extraordinarily mean landlady named Maria who lives in the fourth bedroom and polices our use of the gas stove.

While we're waiting, I begin reading *The Master and Margarita.* I'm nine years old. Why my parents decide to let me read Bulgakov, I'm not sure, other than that they may be distracted by the slow-moving chaos of waiting in long lines for documents and then waiting in other long lines with those documents to get new ones. I've already read *Anna Karenina,* which came from a Russian-language library run by the Hebrew Immigrant Aid

Society. I'm enchanted by Anna's devastatingly simple black velvet dress and the way she mesmerizes everyone at the ball and her small skillful hands and the descriptions of food I've never tasted or seen and Levin's long, patient courtship of Kitty. Reading the last novel in the orange-brown book in our suitcase seems like a logical next step.

Anna Karenina enchanted me, but reading *The Master and Margarita* feels like an invisible power has picked me up and plunged me into a stereoscopic world, more real than reality itself. The yellow flowers against Margarita's black coat; the sudden violence of the train severing Berlioz's head; the consuming, octopus-like fear spreading its tentacles into the Master's cozy basement apartment; the severe, majestic cadences of the Jerusalem chapters, where the itinerant philosopher Yeshua Ha-Notsri faces Pontius Pilate; Hella's greenish hand slowly reaching through the transom in the dead of night. Behemoth, the enormous talking black cat who drinks vodka. Matthew the Levite's agony as Yeshua slowly perishes on Golgotha. The twin thunderstorms that swallow ancient Jerusalem and 1930s Moscow. And the heavy, thudding finality of this sentence, uttered by Satan himself in a dim, candlelit bedroom: "Manuscripts don't burn."

There's a lot I don't know as a nine-year-old; it's not until I'm in college that I understand the significance of Bezdomny's plunge into the Moscow River or Pilate's incessant rubbing of his hands. At nine, I don't understand why the Master burns his manuscript in his stove or why he disappears following a midnight knock on his door or what it means that he reappears in his courtyard three months later, wearing the same coat but with the buttons torn off, or why someone else now lives in his apartment. My mother explains to me that the Master

was arrested and likely tortured and that, too, is something I struggle to understand.

I'm puzzled by so many other things as well: why we had to leave behind my wind-up rabbit, why I will never become a Young Pioneer and receive a flaming red kerchief to wear proudly around my neck, how it could be that everything I was taught at school was a lie. Later, I will read Bulgakov's *White Guard* and learn that the people I learned to call enemies of the people—private property owners, aristocrats, intellectuals—were not actually enemies. *White Guard* is set in Kiev during the First World War and the Russian revolution, and its central characters, two brothers and a sister, struggle to hold on to the vestiges of a life that is brutally, methodically, being destroyed. The sister, Elena, keeps picking up Ivan Bunin's short story "The Gentleman from San Francisco." We have art, Albert Camus wrote, so we don't perish from the truth.

APRIL 1985: Abram, my father's cousin, who left Odessa for Israel decades ago, comes to visit. We've assimilated: my parents work as engineers, we live in a three-bedroom house in Silicon Valley, I speak fluent English. I'm cocky in a way that only sixteen-year-olds who believe they know everything can be. We start to talk about literature, and I mock the two English-language translations of *The Master and Margarita* I've read (one based on a censored original, one based on a complete copy but semantically and stylistically clunky). Abram fixes me with a stern look from beneath his graying eyebrows and says, "Why don't you translate it yourself then?"

His words are a revelation. Why don't I, indeed? I sit in my room with a typewriter and a Russian-English dictionary and the orange-brown book and quickly discover that translating—or at

least translating well—is hard. I limp through the first chapter, where the poet Bezdomny and the editor Berlioz meet Satan on the outskirts of Moscow, and find myself utterly stymied by the first line of the second chapter: "Early morning on the fourteenth day of Nissan, clad in a white cloak with blood-red lining, Pontius Pilate, the Procurator of Judea, entered the covered colonnade between the two wings of the palace of Herod the Great with the shuffling gait of a cavalry officer."

Russian speakers will know that this is not a faithful translation. Russian permits a heavier accumulation of prepositional phrases than English; translated verbatim, that first sentence is, "In a white coat with blood-red lining, with the shuffling gait of a cavalry officer, in the early morning of the fourteenth day of Nissan, into the covered colonnade between two wings of the palace of Herod the Great walked the Procurator of Judea, Pontius Pilate." The sentence catches me in a trap: Do I stay faithful to the text or do I rearrange the sentence? I rearrange the sentence, but the discomfort of failing to capture the majestic, unhurried rhythm of the Russian is too much. I want the sentence to end, as does the Russian original, with Pontius Pilate's name, but I can't figure out a way to make it work. I stop translating.

OCTOBER 1986: I'm a freshman at UCLA. For reasons I can't entirely articulate, I bring the five typewritten pages with me and show them to Irina Paperno, my professor in Advanced Russian Language and Literature. She stops me after class two days later and tells me she showed the translation to Michael Heim, another professor in the Slavic department. He would like to meet me.

When I go in, I don't know that Michael Heim is Milan Kundera's American translator, that he speaks eight languages

fluently, that he is the preeminent translator of his generation. All I know is that he has collar-length hair and a sharp, stubborn jaw and dark, dancing eyes and an office filled floor to ceiling with books. We spend over an hour parsing my translation, discussing the treacherous stylistic shifts between the Moscow and Jerusalem chapters, the pitfalls of semantically faithful but stylistically awkward translations, ways of capturing the essence of an author's voice.

I never finish the translation (instead, I write a dissertation about semantic instability and what it means to be American in the novels of Vladimir Nabokov and Henry James), but *The Master and Margarita* remains a lodestar. I tell others about it, and they report back, sometimes years later, to tell me how it changed their life. There is something uncanny about that book, I'm convinced of it. Before I was born, my parents went to Sadovaya 302-b, the Moscow house where Berlioz lived and where Satan and his retinue took up residence after his death. The entire house was dark and only one window, right where apartment 50 would have been, was illuminated by a candle.

I think, often, about the ponderous weight of that line, "Manuscripts don't burn." Except that they do. They are burning now, all over Ukraine, just as they burned across Europe during World War II, and at other times in Japan and Korea and Africa and Iran and Chechnya and Georgia and Afghanistan and Syria and Iraq. No supernatural force can rescue them from the conflagration, nothing can comfort the untold millions fleeing without the luxury my parents had to curate their few belongings, to pack, to grab a beloved book. Bulgakov himself burned his own manuscripts, trembled in fear of the midnight knock on the door, witnessed the death and desecration of war.

And yet. A censored version of *The Master and Margarita* appeared in a Soviet literary magazine in 1967, the year before I was born. That same year, a manuscript was smuggled out of the USSR and published in Paris. A version containing the omitted and censored parts was typed and duplicated by hand and circulated clandestinely in the Soviet Union; that version was published in Frankfurt in 1969, and in 1975 two young East German women gave it to my parents, who packed it in a cheap brown suitcase and, in September 1977, left a homeland that was not really a homeland.

The first law of thermodynamics holds that energy cannot be destroyed; it can only take a different form. And so, as the world convulses once again, I try to hold Bulgakov's words to myself—to remember that manuscripts may burn, but art does not.

IRENA SMITH emigrated from the former Soviet Union in 1977, and in spite of tearfully insisting that she would never, not ever, learn to speak English during her first year in the US, she went on to receive a PhD in comparative literature. She currently works as an independent college admissions counselor and lives in Palo Alto, California, with her infinitely patient husband. Her memoir, *The Golden Ticket: A Life in College Admissions Essays*, will be published by She Writes Press in April 2023.

Blue

(For Irina)

Cheryl Krauter

Irina's eyes were blue
stunning
bright
like cornflowers
warmed by the yellow sun
they shone with the innocent dreams of a young life
that was just beginning.

When we sailed from Moscow on the *Lev Tolstoy*, a river cruiser
once used for the pleasure of high-ranking Kremlin officials,
in 2008, we knew you as a twenty-three-year-old Ukrainian
woman studying for your university exams. Given one chance to
succeed at the only prospect that might grant you a future, you
were frightened, anxious, hopeful that your destiny might open
wide into the blue of a vast prairie sky. Dreams were fragile
because of the pressure, the one shot you had for transcending a

life as a server on a tourist boat for rich Westerners who would never know or care where you went when another frozen winter descended on the Volga River at summer's end and you returned home to Ukraine.

Irina would gather pastries
stacking them in mounds
on a delicate blue-patterned china plate
stuffing the sweet delicacies into her mouth as if it was
her last meal.
Did she know what was coming
did they all know?

In the evenings we gathered to listen to the articulate university professor from Moscow, her lectures so entertaining, so intelligent. She taught us the history of Russia. During each talk she would manage to work in a few moments of praise for Vladimir Putin—revering his leadership, holding him in high esteem—and then she'd continue on with her monologue. At first we were confused, shocked, until we understood that she feared being monitored, watched, listened to by someone on the boat. Were we all being watched?

The professor had passed her tests
had made it through flaming, fiery hoops
to success
did anyone know or care where she went
when she returned home in Russia
were her eyes blue
we never knew
we never got close enough.

Irina
the others were not so innocent
they had long been denied their emancipation
when they spoke of their dreams of freedom
the sound was like the grinding of gravel in their mouths.

I am alone on the weathered, aged deck of the *Tolstoy* as it floats along the Volga. Gazing out across vast, fathomless pine forests that stretch into an infinite horizon, looking up into a cerulean blue sky, I become aware that there are no wires, no planes—the world is, for once, soundless. This moment of stillness remains the purest of my life. I stare into the abyss of the ancient trees, wondering if there are humans living there among the wild beasts who, unlike them, wander freely.

Irina
you would be in your thirties now
where are you?

In Ukraine, alive and running for your life? Did you ever pass your tests and make it to university, or did the innocent hopes of a young woman fade into a tattered blue memory? Are you in a massive crowd at the train station, running for safety, hiding beneath a bridge, carrying a child, holding them to your breast, terrified in the chaos? When you look up do you see a patch of blue sky or chunks of broken buildings hailing down on you? The pastries on the boat are a distant memory. Are you hungry, hungrier than you were those long years ago on a peaceful river in Russia—starving, freezing, frightened?

University professor
where are you today
alive
silenced
dead
forever quiet?

Women of Ukraine
I see you
Women of Russia
I hear you
you are not forgotten behind the cold blue tombstone eyes of
a megalomaniac
his face a stone
his heart a jagged, bloodless rock.
I look into your grieving blue eyes
and imagine your dreams
of drinking from a cup of longed-for freedom
and
finally
finally
tasting the nourishment
that will end the starvation of your bodies, your minds, your
souls.
I see you
I hear you
I stand for you
I surround you
in fields of sunflowers
beneath
an azure blue
sky of peace.

CHERYL KRAUTER, MFT, is an existential-humanistic psychotherapist with more than forty years of experience in the field of depth psychology and human consciousness. She has published three books: *Surviving the Storm: A Workbook for Telling Your Cancer Story* (Oxford University Press, 2017), *Psychosocial Care of Cancer Survivors: A Clinician's Guide and Workbook for Providing Wholehearted Care* (Oxford University Press, 2018), and *Odyssey of Ashes: A Memoir of Love, Loss, and Letting Go* (She Writes Press, 2021).

Frankenstein's Monster

Jill McCroskey Coupe

Two reviewers described my first novel, published the year Donald Trump was elected, as being about tyranny. My second novel, published the day after George Floyd was murdered, is about race. Both books were completed long before publication, making any mirroring of current events entirely coincidental.

I'm no seer. I simply write fiction. I try to tell a good story.

In the first chapter of the novel I began writing in 2019, a woman named Gemma enters a nursing home. She spends the long days sitting in her wheelchair, gazing out at the distant mountains, looking back on her life.

Gemma has no idea—nor did I, when I began telling her story—that a global pandemic is about to hit.

Three years later, I'm having trouble concentrating on Gemma, with daily headlines mirroring the stuff of horror fiction. The killing of Ukrainian civilians trying to escape an unprovoked war. The bombing of a maternity hospital. The

attack on Europe's largest nuclear facility. Nightmare scenarios, these, beyond the boundaries of human sanity.

In most horror stories, though, there's at least a certain logic to the events and characters portrayed. In 1820, when she was still a teenager, Mary Wollstonecraft Shelley published *Frankenstein; or, The Modern Prometheus.* The monster created by Victor Frankenstein exhibited human characteristics and feelings. I've read the book. I sympathized with the poor creature in the end.

It's hard to sympathize with a man like Vladimir Putin. Instead, we look for ways to give aid and protection to his victims.

But what can we do as writers? Cruelty, greed, prejudice, and hatred have all been part of our long human history. Can words on a page (or screen) have any sort of impact?

The young Mary Shelley wrote her novel on a dare. In 1814, while visiting Switzerland with Percy Bysshe Shelley (her future husband) and Lord Byron, she and her travel companions agreed to see who could come up with the best horror story. And here I am, more than two centuries later, remembering her monster.

Art does that.

Fiction, as my mentor John Dufresne claims, is "The Lie That Tells a Truth." Stories can help us understand each other, see into another person's soul.

The most beautiful building I've ever been in is the Great Mosque in Córdoba, Spain. After 9/11, my memories of its spectacular interior—an enchanted forest of pillars and arches—made me deaf to all the anti-Muslim rhetoric I was hearing.

Art can do that.

I've read that some Russians still perceive Ukrainians as serfs, just as some Americans still look upon the descendants of slaves as inferior human beings.

The quilters of Gee's Bend, Alabama, practice an art that has been handed down for generations, going back to the days of slavery and perhaps even to Africa, with Native American influences mixed in as well. The brilliant geometric designs they stitch together are evidence of a rare artistic intelligence at work as the quilters provide for a simple human need: warmth.

Mary Shelley created Victor Frankenstein, who in turn created a monster, a creature so memorably human that, more than two hundred years later, he's part of our culture. Shelley found the right words, then found a way of making them available to readers.

That's what writers do. We find the words and weave them together. For us, it's the most thrilling treasure hunt imaginable.

I'll stop now. Gemma is calling to me from her wheelchair.

Award-winning author **JILL MCCROSKEY COUPE**'s novels, *Beginning with Cannonballs* (2020) and *True Stories at the Smoky View* (2016), depict unlikely friendships. Her master's degrees—an MFA in fiction and an MLS (Library Science)—are dead giveaways: she has always loved books. Please visit her online at www.jillmcoupe.com.

Do-Nothing Day

Robin Clifford Wood

Have you ever savored a do-nothing day
instead of regretting, upsetting your way
through the hours with glowers of scolding and shame,
accusing and bruising your mind and your name?

Well here's a suggestion—I give you permission
to fill one sun's tracking with acts of omission.
Resist the insistence that says, "Go produce."
Lie around with your hound, live a life on the loose.

Take a break from the ache of the global disaster.
You might find your fight reignites all the faster.
Be kind to your mind; let your angst go on leave.
The chaos will slay us without a reprieve.

I wish you would try it—the quiet, I mean.
Such wonders abound all around you, unseen.
Embrace the staycation that's stimulus free,
and let your mind wander and ponder "to be."

Sit at the window and watch for a while
'til you find you're unwinding and ready to smile.
Ah—there it is, fizzing like sparks in the room;
your smile's there aching to break through the gloom.

Decry all the "shoulds," wooden raps to the head.
Today is for playing or staying in bed,
for cuddling, muddling, naps, and oblivion,
shedding the treadmill of dread you've been living on.

Say it's okay, it's okay—feel relief;
it's okay to feel gay in the midst of the grief.
You need to refuel, you're a fool not to do it;
the fuel to fight cruel is elation—accrue it!

Tomorrow you'll wake up all rejuvenated.
You'll shake off the night with your psyche inflated.
You'll stretch and you'll yawn with the dawn, bright or gray,
all steadied and readied to pave a new way,
improved by the groove of your do-nothing day.

ROBIN CLIFFORD WOOD is an author, poet, essayist, and teacher. Her poetic work has received national recognition and has been adapted for theatrical audio production. Her first book, *The Field House: A Writer's Life Lost and Found on an Island in Maine*, is a biography-memoir hybrid about the life of Rachel Field, a poet and award-winning author from the early twentieth century. Wood lives in central Maine with her husband and a dear old dog named Clara.

Now Is the Time
to Write a Sentence

Julie Maloney

When the oncological social worker from the hospital asked me to facilitate online classes, it was with some trepidation that I said yes. I had been teaching Writing to Heal workshops for almost fifteen years in a large room with a closet at the Carol G. Simon Cancer Center at a major metropolitan hospital in New Jersey, thirty-five miles outside of New York City. Patients diagnosed with different cancers pushed through the door and chose a chair in the circle. Some stayed for years.

As the pandemic dictated the pivot, I wondered whether anyone would want to come online and write from their deepest selves about their biggest fear: dying too soon.

We began our first Zoom session in April 2020, with nine writers. From the beginning, I called them *writers*, because it didn't matter if they had ever taken pen to paper before—things were different now.

A writer is someone who writes.

Together, we built a community of faces on the screen. I'd be lying if I said that they didn't look sad. In the past two-plus years, we have continued with a strong group of six writers—some of our original nine had to pull out due to work constraints and family obligations—and the core group has grown into something nothing short of miraculous. On Wednesday evenings, one man and five women show up from a space in their homes to write together, read aloud, and respond to one another's work. Some evenings, there are tears. Others, big laughs. If you wonder how cancer creates laughter, I guarantee you that some experiences are so unfathomable, the only thing left to do is to laugh through the tears. I've had breast cancer myself, twenty years ago.

What do tears look like on the screen? They are more visible. There is no hiding. Faces crumble, beginning around the mouth and then traveling up the cheek muscles until the eyes close. "We are gifting each other every time we read aloud," I say. To bear witness to the pain of others makes us better humans. I am not a psychologist or a therapist or a counselor. I am a writer. And this group of incredible human beings that I meet on the screen are writers, too. They write from a new vocabulary they know to be true because it's happening in their own bodies.

They read aloud on the screen via their computer microphones. I watch their faces react to words like "awful" and "radiation" and "spirituality" and "remission." I study their backgrounds—their home spaces. One woman I thought was coming in to us from her bathroom, but eventually I realized it was just a small room—maybe her laundry room? Some sit on the corner of a couch. Others sit at a table or desk with knickknacks crowded onto shelves behind them. What I see behind the digital squares is not important. It is what I hear.

Their voices get stronger every week. Their words soar from the heart muscle after a writing workout we do together. We keep falling in love with each other over and again because of the stories.

I see the young woman who's begun chemotherapy for the third time since we've been on the screen. This same woman wore a beanie with a pom-pom at each workshop until one evening she showed up, radiant, with her hair grown to her chin—only to have it fall out again months later when her cancer returned. When that happened, the hat reappeared.

The man in our group is stressed about how to reenter the working world when the guys he knew on the power and grip equipment on Broadway in New York have now been replaced by younger men. He thinks about what's out there for him as he takes walks around his neighborhood by the woods, noticing it for the first time in a long time. He puts into words what takes up space in his head. I tell him he is a poet. He has no idea that in another life he could have been a poet laureate. Dined with Ted Kooser and Joy Harjo. He is that good.

The woman on the top row of the screen rarely smiles. She writes about moving from her home to a place she doesn't know. The unfamiliar coupled with the pandemic going on and on weighs on her more each week. She wonders how she can whittle down her stuff. What to take with her?

That evening we write about what we carry . . .

When year one moved into year two of the Virus, I asked the oncological social worker if the workshop could stay on the screen "forever." By now, everyone knew how things worked. It seemed easier for those not feeling well to show up when sliding into their cars was not required.

One woman came to us one week from her bed, oxygen tank near, to say goodbye. She was too weak to sit up, but she wrote to the prompt and read aloud. In better days, she had turned point of view on its head, writing how it *was* possible to go home again as she strengthened a tense relationship with her grown daughter. Her last time on the screen, she gave us kisses from her written page. She passed just a few days later.

The computer screen has been a lifesaver for me and for the writers who show up with me on Wednesday nights. To say I am honored to do this work is an understatement. Deep listening is balm for the soul, and this small community on the screen has redefined it. It's not just cancer that these writers write about—it's everything from childhood wounds to loving more. They write about what to walk away from and what to embrace. They write about life and death and the meals they cook in between. They write about the ocean and chocolate and a garden. One writer names her small backyard with a few trees "paradise." Where does one go after visiting *paradise* described by a woman sorely ill?

I hold on to the beauty and wisdom and strength demonstrated by this writing group on the screen. Their faces offer the comfort of family in the best of ways. Their words feed me. "What stays with you?" I ask after someone reads aloud. Their mouths, no longer tight, open freely as we tell each other what we loved about the story. This is the work I know how to do best. During these difficult times, I've learned that *paradise* is a good place to find hope.

JULIE MALONEY is a writer and poet and the founder/director of Women Reading Aloud, an international writing organization dedicated to the support of women writers. Her debut novel, *A Matter of Chance*, published by She Writes Press, won the Eric Hoffer Book Award for Fiction in 2019. She has a new novel in the works.

On an Orientation Toward Giving

Anne Liu Kellor

On my way to class, I drive south down I-5 and take the James Street exit, pull up in the left lane on the one-way street, and idle near the stoplight at Cherry where the homeless have lined their tents in increasing numbers. Often, I'll see a man sweeping. He is thin, middle-aged, and focused on the debris. He works, sweeping dirt into little piles, whether on the sidewalk or at the side of the road, concentrated in his efforts.

Most days now, I have learned to arrive at this intersection with a dollar pulled out of my wallet, ready for a quick exchange. I know it's not a lot, but it still feels generous to me after so many years of mostly not giving.

I used to want to avoid this exchange, because I didn't like the process of discernment that accompanied the act: *Is this person going to spend it on drugs? Is this person truly needy, compared to that person?* I used to think I had to make a split-second judgment about who was worthy, who was going to

spend it on food versus booze, who would thank me versus grunt or say nothing, who would make me feel good about my choice.

It was liberating to realize, some years ago, that I didn't have to make that decision. That ultimately it was okay if that person wanted to buy alcohol. Who was I to say it was not what they needed most in that moment? Who was I to say that it was not the one thing that might help them through the night? My small change was not going to change anyone's life, but my choice to give *could* determine whether I paused to see that person. Man or woman. Old or young. Drunk or sober. Somewhere in between. And that I cared about that person as I would care about anyone, because they are a precious human life. They are asking for help. And I am able to give it, one dollar, a protein bar, whatever I can reach for from inside my safe, comfortable car.

"What unites us all as human beings is an urge for happiness, which at heart is a yearning for union, for overcoming our feelings of separateness."
—SHARON SALZBERG

How do we orient ourselves toward giving, toward loving, toward caring about others and the world beyond our small, daily lives? There are days I am caught off guard when I approach that stoplight; days I have forgotten that I will soon be paused alongside a homeless person; days I have forgotten to see if I have a dollar—or have remembered but have simply chosen not to be bothered, chosen to stay within a more confined space, preoccupied with my thoughts or feelings.

What is this space in us that thinks of giving, then pulls back and looks away? It's happened to me before with online

campaigns, GoFundMes, opportunities to donate to my son's school . . . I have the impulse to give, I might even write a check or start to enter my credit card information. But then I forget to bring the check, or some glitch happens and the payment doesn't go through, and once my initial impulse has passed, it's so easy to let it fade.

It's as if, if I don't seize upon the moment when my desire to give first presents itself, my default mode of passive not-giving takes over.

It's as if I have to train myself, daily, weekly, into an orientation that skews toward giving. Because I've been taught to be frugal, to be smart with my money, to save it away like a good girl—only give to the truly needy, don't waste, don't risk.

It's as if my privileged upbringing has taught me that I have the power to decide who is worthy.

It's as if I've been taught my whole life to err on the side of caution and distrust.

It's as if I am trying to shift my entire orientation toward how I live.

> *"Generosity allies itself with an inner feeling of abundance—the feeling that we have enough to share."*
> —SHARON SALZBERG

In *The Miracle of Mindfulness,* Vietnamese Buddhist monk Thich Nhat Hanh suggests hanging an object like a branch above your bed—something that will remind you first thing upon waking to orient your day toward awareness. Instead of immediately checking your phone or thinking about your to-do list, what if you learned to smile, take a deep breath, and wish

yourself and the world happiness? *Imagine.* I *want* to learn how to do this. It may be a small gesture within a day that is still mostly full of checking my phone and to-do lists—but I have witnessed what happens when I *am* able to trigger this shift in my consciousness, this small but huge shift away from preoccupations with my own self to a state of mind and being that wishes comfort and loveliness upon all.

It starts with myself: *May I be happy*, I practice saying as I breathe in, and to me, "being happy" means being without worry, anxiety, self-judgment, doubt. And then, I exhale: *May all beings be happy*, I say—and by "happy," I also mean *safe*, or *fed*, or *aware of their own intrinsic beauty and worth*. Within these thoughts, I feel a small shift in my heart, opening. Within these mantras, I still include my own first-world problems that have the power to cast dark clouds upon my day, *and* I include an awareness of a vaster world, of people who are suffering in more urgent ways. I don't minimize my own pain—how can I care about the world if I don't show care for myself?—but I strive not to forget about other people's pain. Because not only does this help to put everything in perspective, but I also *like* myself more when my heart is open. I know that this shifting of the orientation of my mind and heart is where I must begin—again and again—because this is the place from which true acts of compassion can spring.

In 1978, Thich Nhat Hanh also advocated that everyone should enjoy one day of mindfulness a week. A day where you do everything slowly—slowly eat and bathe and dress, slowly sweep and do the dishes, slowly sit and drink a pot of tea. Meditate or read scripture or write a letter. Or make art. Enjoy an entire day like this—*every week!* Not once a month, not once a year on retreat. Every week. *Ha!* we laugh, we in

our modern-day existence. And yet this came from a monk who was no stranger to war and devastation; *we need this*, he reminds us. Our bodies need it. Our minds need it. We need this kind of deep rest. We need to recharge in order to be more effective in our work. And I appreciate this permission to want this for myself as essential, not as some privileged indulgence; to know that my deep longing for retreat is not a weakness but instead my body's accumulated wisdom speaking to what I need to refill my well.

Everyone's well is different.

> *"Great fullness of being, which we experience as happiness, can also be described as love."*
>
> —SHARON SALZBERG

Every month or so, no matter the season, I see the same man sweeping. I recognize him because of his deliberateness—his undeniable, singular task. Maybe he is making order out of chaos. Maybe he is tidying his space. Maybe he is emptying his mind. Maybe he is filling time with movement. Maybe he is crazy. Maybe he is sane. Maybe he is unknowable to me, a stranger. Maybe he is recognizable to me, a friend.

May I be happy. May you be happy.
May we all be seen and cared for and at ease.

ANNE LIU KELLOR is a mixed-race Chinese American writer, editor, and teacher based in Seattle. Her critically acclaimed memoir, *Heart Radical: A Search for Language, Love, and*

Belonging, was praised by Cheryl Strayed as "insightful, riveting, and beautifully written." Anne is the recipient of fellowships from Hedgebrook, The Seventh Wave, Jack Straw Writers Program, 4Culture, and Hypatia-in-the-Woods. She teaches writing workshops and facilitates a yearlong creative nonfiction manuscript program for women and nonbinary writers seeking mentorship and community.

A Life in Six Wars

Kate Raphael

JANUARY 1981. Ronald Reagan is sworn in as the fortieth US president. A former actor with comic book swagger, he cut his political teeth as governor of California by declaring war on the state's public colleges, determined to crush the Free Speech Movement and the Third World Liberation Front. He sent the National Guard into Berkeley to put down the People's Park protests, killing one student and wounding many. After four students were killed by the National Guard at Kent State in Ohio in 1970, he made headlines for saying, "If we're going to have a bloodbath, let's get on with it."

Now he is going to be my president. I am twenty-one years old. The election that brought Reagan to the White House was the first I was eligible to vote in. Needless to say, I didn't vote for him.

George H. W. Bush, smirking former director of the Central Intelligence Agency, is the new vice president. Under Bush, the CIA

helped to craft and fund Operation Condor, a campaign of terror to repress dissent and maintain authoritarian governments in Latin America. This is not a secret. We—my friends and family—thought the presence of Bush on the ticket would mean we would get four more years of the inept but well-meaning Jimmy Carter. Reagan has a winning smile, but Bush is a coldhearted assassin with eyes to match. Surely people have not forgotten the photos of children running from American napalm in Vietnam, the gun pointed at the head of a kneeling and blindfolded prisoner, the stories of torture in the National Stadium in Santiago, Chile. But apparently, they have. Or they never cared at all.

Reagan names Soviet Russia the Evil Empire. He falsely claims the Nuclear Freeze movement is "instigated" by "foreign" (read: Russian) agents. He invades Grenada, a tiny Caribbean island I've never heard of before, overthrowing the Marxist government. He covertly funds the contras trying to overthrow the government of Nicaragua after Congress refuses to allocate the money.

I protest. I march for the Nuclear Freeze, joining millions around the country in the largest single day of demonstrations to date. I am arrested, for the first time, at a naval weapons station from which munitions are shipped to Central American dictatorships and where nuclear weapons are stored in underground bunkers made visible by coils and coils of razor wire surrounded by blinding lights. *Whom are they trying to keep out?* I wonder. *Who would be crazy enough to let loose a nuclear warhead, which could destroy the world in a second?*

We march to the doors of the banks that fund and profit from war. We die in their doorways, conduct funerals in their lobbies, our faces and hands smeared with red food coloring mixed with Karo syrup. We threaten No Business As Usual if

they don't stop the wars. Sometimes we are arrested. The wars continue without pause.

I am young, and bold, and grew up on stories of resistance—stories from Nazi-occupied Europe and from the movement that helped end the Vietnam War. I was born in the Jim Crow South but mostly grew up in the New South, because people believed they could make change and they did. I believe we can do it too. I throw myself into it, leave graduate school and give myself to the movement. I would die for it if that were asked of me, but what's actually asked is that I suffer through endless boring meetings on hard chairs in cold rooms without enough bathroom breaks. I don't really mind. I make friends, and fall in love. And believe we will win.

JANUARY 1991. George H. W. Bush has ascended to the White House as heir to the Great Communicator, who demolished the economy with genial precision. On the pretext of rescuing Kuwaiti infants ripped from incubators by Iraqi troops (they weren't; the account of such an event given to Congress was manufactured by the US public relations firm Hill & Knowlton), Bush sends US fighter jets to assault Iraq with 88,500 tons of bombs. US tanks roll through the Saudi desert across the Iraqi border. Bush tells us Saddam Hussein is Hitler reincarnated.

The 1991 US operation in Iraq is called Desert Storm. The 1979 Soviet invasion of Afghanistan was called Storm-333. Soviets troops only withdrew from Afghanistan two years ago, in 1989, as the Berlin Wall was coming down. Many commentators say Afghanistan destroyed the Soviet Union.

I am working the graveyard shift in a law office. During Desert Storm I work all night, protest all day, and organize all evening. Or sometimes I protest all evening and organize all

day. We march so much we call it Jane Fonda's Workout. We surround the Federal Building in San Francisco, go to jail by the hundreds. On the eve of victory in Kuwait, US-led coalition forces bomb a convoy of retreating Iraqi soldiers, killing thousands, on what becomes known as the Highway of Death. Iraq sets fire to Kuwaiti oil fields, sending toxic plumes across the region and into the lungs of US soldiers, who come home with Gulf War Syndrome, which the Defense Department says does not exist.

OCTOBER 7, 2001. President George W. Bush sends US troops into Afghanistan, the first open military action in the Global War on Terror (GWOT). Hazmat-clad work crews are still digging in the rubble where the World Trade Center stood, still finding bodies, still picking up cancers, lung disease, and gastrointestinal disorders.

I am forty-two. I do not go out to protest. It's not because I think it's right to invade Afghanistan over an attack that might have been planned on its soil. It's not because I knew, even before 9/11, about the Taliban's brutality toward women (I might be one of the handful of people in the United States who has previously heard of the Revolutionary Association of Women of Afghanistan and its founder, Meena Keshwar Kamal, who was assassinated in 1987, likely by mujahideen funded by the US government as part of its Cold War against the Soviet Union).

I don't protest the US invasion of Afghanistan because I don't believe we can stop it.

Instead, I go to a concert in Golden Gate Park called "Our Grief Is Not a Cry for War."

Three months into our Afghan War, I watch with horror as prisoners in orange jumpsuits and black gas masks that

make them look like strange robots kneel on the tarmac at Guantanamo Bay. I don't know that they will be held without trial for years on end, that some will die on hunger strike, others by suicide, that they will be cut off from their families for two decades. I do know that I have never seen a public spectacle like this one in my country, and that my countryfolk are not responding the way I always thought we would. With fifty friends, I organize a street theater where we wear orange jump suits and quickly sewn black hoods and sit outside a crowded transit station in makeshift cages. People step around us, trying not to look, as they hurry home to get dinner on the table.

OCTOBER 2002. President Bush is making a case for another war against Iraq. One of his accusations against Saddam Hussein is that he tortures political prisoners and holds them indefinitely. He claims Saddam has weapons of mass destruction. The US government provided Iraq with those weapons in the 1980s to fight against Iran, but after the US-led invasion of Iraq in 1991, the United Nations and the Iraqi government destroyed its stockpiles of chemical and biological weapons.

Worldwide, people pour into the streets to say no to more war. I march through San Francisco with 150,000 people, initially reported as 8,000 by the *San Francisco Chronicle*. Even the police tell them their numbers are too low. Bush says he doesn't listen to focus groups.

We call for peace and prepare for war. The Department of Homeland Security tells everyone to buy duct tape and plastic sheeting to withstand a terrorist attack. The Home Depot quickly sells out of those items. The US corporations already making a killing in Afghanistan—Halliburton, Bechtel, Booz Allen, CH2M Hill, and Carlyle Group—get ready to expand their operations

into Iraq. Many of them have headquarters in San Francisco's financial district. We find their addresses, make a map. We tell the media if they insist on going to war, we will shut down their ability to make money in our city. Communities organize. High school peace clubs make posters for walkouts. Yoga teachers tell their students, "The day the war starts, bring your mats and meet me at the Transamerica Pyramid."

MARCH 20, 2003. Yesterday, US planes launched their assault of "shock and awe" in Iraq. Twenty thousand of us come out in the dawn hours, set up roadblocks, lock arms into concrete-filled pipes, hold banners, paint murals, paint faces. There are clowns, jugglers, marchers on stilts. Alongside the members of my affinity group, mostly queers who have known each other since the Reagan era, I wrap myself in plastic sheeting and make a spiderweb of duct tape in front of the largest television and radio studios in town. A car tries to drive through our web, narrowly missing some of us, before driving off with duct tape trailing from its rear.

The police arrive, announce that we're about to be arrested for blocking the street. We decide it's too early for that and move onto the sidewalk. They take off, called to an intersection of greater strategic value. We ooze back into the street, where we remain for the next three hours.

The police can't keep up with the crowds. They split us into mini-marches, but we flow back together. All day more people keep showing up, hearing on the news what's happening and wanting to be part of it. Workers who can't get into their buildings decide to join in. The next day the media accuses us of causing mayhem. We say, it's not we who cause mayhem. Talk to Bush. We are just making the mayhem visible to people far away from the fighting.

MARCH 20, 2022. Half a million Afghan refugees flee the Taliban as it sweeps through cities and villages abandoned by the Afghan military. They join the estimated four million already in camps in Pakistan, Iran, Turkmenistan, Uzbekistan, Tajikistan; a lucky few make it to Europe, Canada, Australia, or the United States. Twenty years after the first US troops landed in Kabul, President Biden says he didn't expect the government to collapse so quickly. How quick was it?

Of the 780 prisoners at one time detained in Guantanamo, 38 remain. I don't know whether they still wear orange jumpsuits. Two of them have been convicted of war crimes.

Nine million Ukrainians have lost their homes in three weeks of Russian invasion. They receive a warmer welcome in Europe than their Afghan (and Syrian, Libyan, Somali, Ethiopian, Palestinian) fellow travelers, unless they are gay, or Black. For Jews (like my grandfather, who fled Kiev in 1906), I expect Poland is a very strange place to arrive as a refugee. Suddenly, people remember that both Russia and the US still have lots of nuclear weapons.

I haven't gone out to protest. Whom would I protest, and what would I demand they do? I sit at my computer, where over the last two years I have spent an inordinate amount of my life. I am sixty-two. I am no less bold than I was in 1981. I would still die for the movement, if I believed it would hasten change. But I'm less willing to spend my evenings in boring meetings on hard chairs.

KATE RAPHAEL is the Lambda-nominated author of *The Midwife's In Town* and the Palestine mystery novels *Murder Under the Bridge* and *Murder Under the Fig Tree*, which won Foreword INDIES and Independent Publisher (IPPY) awards. She won a 2011 Hedgebrook residency and coproduces *Women's Magazine* on KPFA Radio. She lives in Seattle.

It Is the Breaking Open

Gail Warner

It is not our fear
It is not the apprehension about what we will lose
It is not even the dreadful blow of death
It is not the unknown depth of feeling
It is not our helplessness
For all of these are thresholds.

It is the breaking open that changes everything.

It is how so many things can be instruments
Opening doors we have closed
Stopping the striving that exhausts us
Lifting weight that burdens us
Exposing our arrogance

Uncovering our self-diminishment
Tearing down fixed opinions that imprison us
Inviting music that we haven't been able to hear.

It is the breaking open that changes everything.

It is not the awful anxiety
It is not our frantic efforting
It is not the emptiness that transforms us
Nor our stumbling in the dark
All of these are doorways into surrender
Into humility and kindness
Knowing we all are in the same vulnerable human boat

It is the breaking open that changes everything.

GAIL WARNER is a poet, decades-long group facilitator, and body-centered psychotherapist who runs a retreat center called Pine Manor, a gathering place and creative canvas for therapists, body workers, artists, energy healers, musicians, spiritual teachers, poets, and writers. Mother, grandmother, earth mother, and psychotherapist of over forty years, Warner guides others into deeper connections with their soul and the soul of the natural world while endlessly and humbly walking the same journey herself.

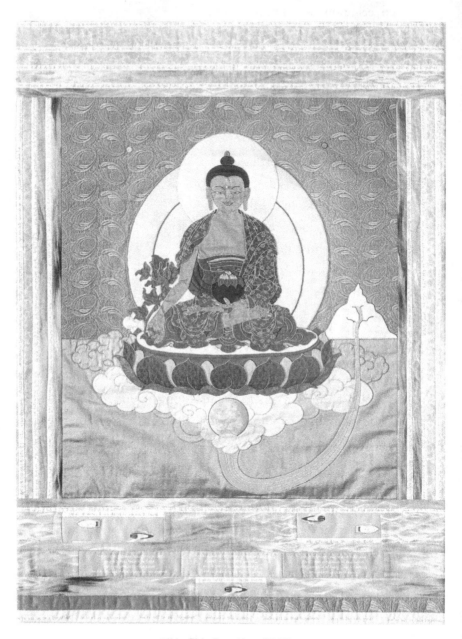

All in This Together, 2020,
Tibetan appliqué quilted thangka, 108 x 77 cm

All in This Together

Leslie Rinchen-Wongmo

I started making this silk Medicine Buddha in 2011, when my mother was undergoing treatment for metastatic cancer of unknown primary site. So many of our ailments are like that, aren't they? Of "unknown primary site." Secondary effects draw our attention while root causes remain obscure.

Happily, my mom recovered well. Others have not been so fortunate. For the next several years, I let the thangka remain unfinished, only to return to it during a worldwide health crisis.

In the early days of the COVID-19 pandemic, a sense of global interconnection permeated the atmosphere. The phrase "we're all in this together" kept coming to my mind. At the same time, different people clearly experienced different impacts from our shared crisis—depending on their work, health, resources, and race, as well as whether they lived alone or with others. The virus interacted with imbalances at our roots.

Tibetan medical practices are based on the premise that disease arises from imbalances caused by the mental poisons of ignorance, attachment, and aversion. True healing must,

therefore, be grounded in spiritual transformation. Buddhas are referred to as great physicians because they possess the compassion, wisdom, and skillful means to diagnose and treat the delusions that lie at the root of all suffering.

Spurred by the global pandemic to return to this artwork, I found the clouds and mountains wanting to offer the whole Earth to this healing buddha. I turned to my friends and readers to surround the buddha with voices from around the world expressing the unifying truth "We're all in this together."

My call had ripple effects, and the languages poured in. Friends and friends of friends all around the world responded with an outpouring of linguistic generosity—twenty-eight languages in all! I printed, stitched, and quilted the words into a watery border representing the ocean of samsara—the field of interdependence and misunderstanding from which our diverse experiences arise.

As I worked, a prayer from the great Buddhist commentator Shantideva arose to join the translations:

May the frightened cease to be afraid
and all those bound be freed.
May the powerless find power
and all beings strive to benefit one other.

May I be a guard for those without protection,
a guide for those who journey,
and a boat, a bridge or passage
for those desiring the further shore.

May I be the doctor, nurse and medicine
for all who are ailing in this world.
May the pain of every living creature
be completely cleared away.

I offer this prayer to you, along with my artwork. May it radiate joy, light, and comfort to all.

LESLIE RINCHEN-WONGMO is a textile artist and the author of *Threads of Awakening: An American Woman's Journey into Tibet's Sacred Textile Art.* A master of the Buddhist art of appliqué thangka, she stitches bits of silk into elaborate figurative mosaics that bring the transformative images of Buddhist meditation to life. Visit her at www.threadsofawakening.com.

His Name Was Vinny

Denise Larson

Have you ever mourned a loved one? Someone irreplaceable? The grief is overwhelming. It ebbs and flows with a combination of anger, sadness, hopelessness, and despair. It becomes hard to feel anything else, and when sorrow is etched on your face, you can't even fake it.

My husband, Vinny, died of COVID-19 in 2021. He passed away just weeks before it would have been "his turn" to get vaccinated. He was not a victim of a sudden heart attack, debilitating stroke, prolonged cancer, car crash, street violence, or war. The thing that invaded his body was just a tiny microscopic organism. A virus that cared not one whit for any political ideology or social upheaval.

My brain is still trying to make sense of this unimaginable event. Every day I note the bleak uptick of COVID-19 deaths. Statistics. But the grim, raw numbers rarely link to the actual human beings who are gone. Maybe we see a glimpse of a patient

on a ventilator fighting for their life, or perhaps a brief video of heartbroken family members saying goodbye via FaceTime. After they're gone, they just blend into the daily count of thousands of others. To add insult to injury, some use the pandemic as a political ploy to gain power by scoffing at scientific efforts to contain it.

What if there was a memorial to the nearly million people in the United States who have perished from this plague? What if all their names were engraved on a wall, like the Vietnam Memorial? How many miles would it stretch? What if the names were carved into plaques beside a reflecting pool? How big would it have to be? What if all the family members stood up and said each and every name out loud? How long would it take to recite a million names?

My husband's name was Vinny. He was more than a statistic: he was my soul mate, my best friend. He was one of a kind. With him, what you saw was what you got. He didn't lie, and he hated artifice. When I lost him, I lost my DJ. Music was his passion, his hobby, his reason for getting up in the morning. His daily curated playlist filled our house with the music he loved: Bruce Springsteen, Bob Dylan, The Band, Neil Young, and on and on. Now the house is quiet; it's too painful for me to put on one of his records or CDs.

Vinny's other passion was baseball; he was a big fan of the San Francisco Giants. He relished sitting on the couch for an afternoon game with some snacks and a martini, yelling at umpires and rooting for his team. Now I avoid even following the latest Major League Baseball news.

Vinny was a devoted husband and a loving father. His daughter, whom he loved with every fiber of his being, misses her father.

Let me tell you how Vinny contracted the virus. It's important to share this story to understand the man. In December 2020, like most of us, Vinny was feeling pent-up stuck at home watching the pain so many people were going through on TV. He wanted to do something to help. A vaccine was said to be just over the horizon, but the rollout was slow and he couldn't wait. Patience wasn't one of his virtues. So he signed up to volunteer at the local food bank.

Twice in January 2021, Vinny went to the food bank and helped sort donated canned goods. The sorting bins were outside, and everyone wore masks and kept a six-foot distance from each other. But the third time he volunteered, rain was forecast, and they brought the bins inside. The bins were closer together, but, still, everyone wore masks and tried to maintain as much distance as possible. Vinny told me later he felt a bit uneasy, but he decided to complete the two-hour shift he'd signed up for anyway.

Three days later, we got an email stating that one of his fellow crew members had tested positive for COVID. The next day, February 1, 2021, Vinny started showing symptoms and also tested positive.

Could it be that his mask slipped down below his nose for a few seconds when that other crew member was nearby? Or did this persistent virus make its way into his body in some other insidious way? Whatever the path, he was sick. Mild symptoms turned to moderate, and then it got worse.

Two weeks after testing positive, Vinny was hospitalized. Visitations weren't allowed. We hoped, and we prayed, and we sent positive vibes that he would improve and return home. But on February 23, he died. The only blessing was that the hospital allowed me and our daughter to be with him, to hold

his hand as he passed. I know not everyone in our situation received that privilege.

After witnessing someone get so sick, so fast, I shudder to contemplate the horror we would be living through today if scientists hadn't so quickly developed effective vaccines.

After the pandemic subsides, there will never be a back to "normal" for me. The expectation to "just move on" rings as hollow as a bell without a clapper. In light of so much loss, so much silence, so much loneliness, I'm expected to be strong and resilient, but sometimes I fail. Mired in this big, dark hole, the only thing that helps is making connections. Family, friends, acquaintances, and even strangers help, because connection is what I'm missing. But although these relationships promise to fill the void, I know the emptiness will never completely go away.

In order to retain my emotional equilibrium, I have to learn to live with what has happened. But I want you to know that Vinny and the other nearly million souls in this country that have succumbed to this virus are more than just numbers: they have families, and friends, and they have names.

So right here and right now, I'm proclaiming my own memorial. For the record: My husband's name was Vincent Bernard Mierjeski, affectionately known as Vinny. He has family and friends who will love him forever. And Vinny, I will always miss you.

DENISE LARSON is the author of *Anarchy in High Heels*, a memoir about her adventures in Les Nickelettes, a trailblazing feminist comedy troupe formed in the '70s. For thirteen years,

she helmed Les Nickelettes, taking on the responsibilities of actress, playwright, producer, stage director, and administrative/ artistic director. After a twenty-year detour into early childhood education, she retired and has now returned to her first love, theater, this time in collaboration with the Cosmic Elder Theater Ensemble.

To Become Such a People: Stories of a Shared Planet

Barbara Wolf Terao

So much in this world depends on territories and who lays claim to them. Moles dig tunnels underground and live generally solitary lives. If the tunnel of one mole breaks into the tunnel of another, a fight to the death ensues. As Marc Hamer wrote in his surprising memoir *How to Catch a Mole*, "Fighting is in the nature of things with territories."

Hamer's statement has me thinking about environmental destruction and its role in spreading coronaviruses around the world. What is an animal's habitat if not a territory? Individuals of every species need a place to call home.

The history of aggression between groups and their territories is long and deep. I read an entry on war in our *World Book Encyclopedia* that said most wars are caused by fighting

over land and resources. Could this be true of wildlife as well as human beings? After all, humans aren't the only inhabitants of this planet, though we sometimes act like it. When we violate the homes of our fellow creatures, they may not consciously go into battle with us, but the environmental and health consequences can be as dire as any war. According to epidemiologists, many of the most deadly viruses affecting humans are transmitted from bats, birds, and other animals. We encroach on their habitats or capture them for market and thereby expose ourselves to new combinations of germs to which we have no immunity.

I'm recalling a story of habitat encroachment that's stayed with me for decades now. In the face of invasions and a pandemic, it comes to mind once again.

Oral historian Paula Underwood preserved many ancient tales taught to her by her father, and the first one she published was *Who Speaks for Wolf* (A Tribe of Two Press, 1983). I'm not Indigenous, but Paula gave me permission to share the story and encouraged me to do so. Before Paula's death in 2000, I was one of many people who studied with her in the high country of New Mexico and among the redwoods of California. Paula reminded us, through her stories and aphorisms, to honor all species, not just our own. She invited us to listen to trees, wind, and our own hearts and minds.

Who Speaks for Wolf begins in a time long ago as a community of people outgrew their living space and sought a bigger one. Runners were dispatched to evaluate alternative sites for their village until a place was found that had room for the longhouses and for the Three Sisters of corn, beans, and squash. After much discussion, it was decided to move the community to the new site.

At that time, a man called Wolf's Brother returned from a journey. As his name suggests, he was the resident expert

on wolves, having spent much time with them. When Wolf's Brother heard that ground had been broken to begin building their new homes, he asked the people to choose another spot. He knew that wolves favored that location as a gathering place and would be a constant presence, threatening their food supply and even their children.

This person was well known for understanding the ways of wolves, but his advice was overruled because the establishment of the new village had already begun. When all was prepared and the people moved in, the community, as Wolf's Brother predicted, had to constantly contend with wolves. They could neither safely share space with them nor scare them away. After trying this and that, they came to the question of the final solution, which was to kill the wolves.

This is an ongoing question. Rather than take over every inch of Mother Earth, can we leave room for other beings? Unique species become extinct or endangered every day. As environmental activist Greta Thunberg said to the United Nations at their Climate Action Summit in 2019, "We are in the beginning of a mass extinction, and all you can talk about is money and fairy tales of eternal economic growth." Is this the kind of people we want to be?

Pioneering conservationist Aldo Leopold hunted wolves early in his career in the US Forest Service. The goal was to exterminate predators and increase the number of deer. But watching a wolf mother die right in front of him changed Leopold forever. As he wrote in *A Sand County Almanac*, "We reached the old wolf in time to watch a fierce green fire dying in her eyes. I realized then, and have known ever since, that there was something new to me in those eyes, something known only to her and to the mountain."

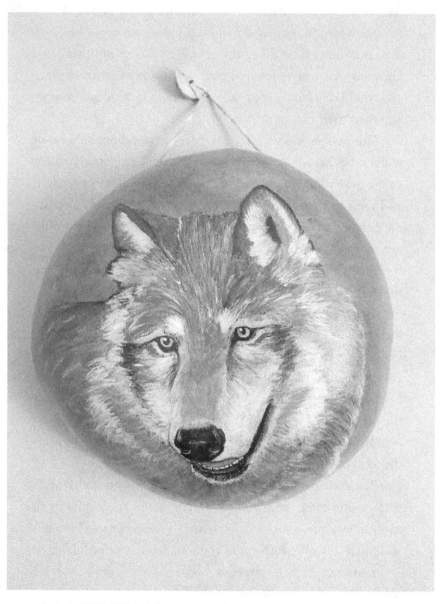

Photo of "Wolf Spirit Ocean Drum," made by artist Dynva Todd of Whidbey Island. The gourd drum was a healing gift from my friend Dynva as I went through cancer treatments. Dynva gave me permission to share her art here.

Familiar with the light within the wolves, the people of Wolf Brother's village had no desire to slaughter them. As Paula wrote, they knew "such a task would change the People: they would become Wolf Killers, a People who took life only to sustain their own, would become a People who took life rather than move a little. It did not seem to them that they wanted to become such a people." They went in search of a different place to call home.

In hindsight, the people of the village wished that Wolf's Brother had been included in the decision-making from the beginning. They came to recognize the value of his words. From that time on, as the story goes, they included a question before major decisions were finalized: "Who speaks for Wolf?"

Wisdom comes from such challenges as these when we take an honest look at the chain of cause and effect in which we have participated and make new decisions. Health is not promoted in markets where animals are stacked in cages, raccoon dogs on top of chickens, but in appropriate spaces where we can live, move, and breathe, and allow our fellow creatures to do the same. To that end, we can listen to reliable data, put our heads together for better solutions, and ask who is willing to speak for wolf, water, and worm. Who speaks for Mother Earth?

BARBARA WOLF TERAO is author of the upcoming She Writes Press book *Reconfigured: A Memoir*. A psychologist, land ethic leader, and cancer survivor, she writes for newspapers, journals, and magazines, as well as for her own Of the Earth website, ofthebluepla.net. Barbara and her husband live on Whidbey Island in Washington near their children and grandson.

Let's Go Eat Waffles

Lindsey Salatka

In times of unrelenting, unbearable crisis, I can see how you would be tempted to say, "Let's go eat waffles."

Dark lords pervade and rise, killing innocents in the East, erasing reason in the West. We run from disease to gun spray to Don't Say Gay spray as the earth ignites, yet coal-producing states still vote no. There's no room at the inn if you're a mother in trouble. Is anywhere safe to breathe?

I can see how a waffle would call to you—warm, with hints of lemon zest sparkling on the tongue, easing the permanent eleven carved between your brows. Slivers of strawberries slide by on maple sap, a touch of crunch to balance the sweet and tart, a measure of mouth-melting perfection to offset the evil. The insane. You'd want to hide somewhere and gnaw on a warm square, run your tongue over the repeated pattern pressed into it, the lines predictable and straight like graph paper. You need to bring some order to the chaos surrounding us and within us, brought by the trauma we've witnessed, offset by the bravery of a leader born from comedy, now pacing and begging in the rubble.

You'd want to offset this trauma even more by snarfing something moist on the inside, a thin layer of crisp holding its shape as you hunch in the corner of a dark, cool room sans screen.

Does this make you a monster?

On the contrary, it makes you human. The most rewarding part of humanity is when we nurture others, and the best way to care for others sustainably is to first nurture ourselves. You can't drive if your tank is empty. From a place of frozen heartbreak, you are powerless to send love into the wreckage. Does a sad person make you happy? Doubtful. Does a terrified person make you want to live and thrive? No. Be like the person who sings for the huddled masses, who brings flowers, who teaches children in the train station. Do what you do well and do it to honor them. Live and give so they may as well. Create joy, spread love, and care for yourself in these times of heartbreak. Do your art, write your story, eat your waffle.

LINDSEY SALATKA is an author, editor, and ghostwriter. She serves as the director of the KidsWrite! Children's Writing Contest and is on the advisory board of the San Diego Writers Festival. Her debut novel, *Fish Heads and Duck Skin*, was published in July 2021 by She Writes Press.

The Tide Pool
of Our Lives

Rosie McMahan

Living through the tide pool of our lives
High stakes and treachery
Shelter and novelty
This place where ocean meets the land
steep rocky ledges
sloping sandy beaches
We now worry that the water has receded
and will not return anytime soon
Stranded or safe? How shall we feel?
All of us cope the best we know how
with this ever-changing world
Normally, connection makes all the difference
but of late, hard shells, clinging, and camouflage
are the preferred means of surviving
Animals in a tide pool adapt and so must we
But at what cost? What gain?
Who will we be to one another?
How will we be to one another?

First a daughter, sister, wife, and mother, **ROSIE MCMAHAN** is also a survivor, feminist, writer, educator, counselor, attending Quaker, community activist, and avid botanical enthusiast. Quite a few of her poems been published in several journals and she can often be heard reading at local venues in western Massachusetts, where she has lived for twenty years. Her book, *Fortunate Daughter: A Memoir of Reconciliation*, was recently announced on the long list of the 2021 Chanticleer International Book Awards. Most of the time, Rosie is waiting for something good to happen.

Creative Regenerating

Cynthia James

Well, here we are—living in a world that is navigating a pandemic, unforeseen war, and economic challenges. The entire world has been in a "Giant Pause" for more than two years now, and we have never been here before. We cannot do things that we have taken for granted. Movies, dinner dates, shopping in malls, plane rides, bus rides, trips to the beach—all are questionable. Dropping by a friend's house takes much consideration. Going to clubs and even church can feel dangerous. So what can we do?

I believe we can use this time to regenerate our enthusiasm and love of life.

I have spent a lot of time working with clients and in personal contemplation about what this means. Some people are telling me they feel trapped. Others identify as going stir-crazy, while still others yet are experiencing mild depression focusing on addictive behavior.

It is clear that we will never go back to the "normal" we all knew. It is also clear, to me, that this could be an extraordinary

opportunity to experience "creative regeneration." What do I mean by that?

In biology, regeneration is the process of renewal, restoration, and growth that makes genomes, cells, organisms, and ecosystems resilient to natural fluctuations or events that cause disturbance or damage. Every species, from bacteria to humans, is capable of regeneration.

Being creative, in this instance, means taking risks, ignoring doubts, and facing fears. It means breaking with routine and doing something completely different. Being creative means searching for inspiration in even the most mundane places as we open to healthy states: mentally, emotionally, spiritually, and physically.

We are seeing it on social media: At-home concerts, virtual dance parties. Livestreaming church. We are also witnessing people singing from their balconies and holding dance parties in people's yards (social distancing with joy)! We even saw a neighborhood line the streets in their cars to welcome a girl that had gotten through chemotherapy home. All of this represents "creative regeneration."

I have spent the last three weeks experimenting with "creative regeneration," and I want to share my process with you. Hopefully it will ignite inspiration as you traverse this unprecedented time.

The Creative Regeneration Technique: Regeneration During the Pandemic and Beyond

CLARITY—FACTS OR FICTION?

I have to admit, when I first heard about the virus, I didn't take it seriously. It seemed far away. Plus, I have a strong positive

attitude and wanted to keep my attention on health and well-being. When someone close to me decided to self-quarantine, I was judgmental. (Denial was in full play here.)

That time of annoyance and ignorance quickly passed as countries began to shut borders and order lockdowns. So I took the first step. I went to reliable medical and scientific sources to gain clarity. I listened to some news (from a variety of sources, not just one), but most of my information came from doctors and scientists. Today, I check the news once a day to keep informed.

Thoughts for you

- Keep in touch with reputable sources to get up-to-date information. Once or twice a day is enough. You do not want to become addicted to news. It can really impact your emotional and mental state of health.
- Have conversations with people that will uplift you; avoid interactions with people who will bring you down with unsubstantiated theories. That includes social media.

ACCEPTANCE

Once I got the facts, my husband and I moved into action.

1. We went shopping and got items that would last for a long period of time.
2. We self-quarantined.
3. I contacted my clients and asked them all to move to Zoom so that I could continue support.
4. We cleaned all new things coming into the house (food bags, packages, mail).

5. We contacted vendors and companies we do business with to find out how they were supporting clients. Many already had plans in place.
6. We did things we knew would support our immune systems.
7. We created time to amplify our spiritual practices to keep strong mental attitudes.
8. We made sure we got plenty of rest.
9. We exercised daily (we always worked out before, but we got very intentional about the practice).

Thoughts for you
- Create a plan to keep in touch with loved ones.
- Make sure you have enough food and supplies in case someone becomes ill (two of my friends had to navigate someone in their home having the virus).
- Look for things to create positive energy in your daily life.
- Get plenty of rest.
- Make sure anytime you leave the house you consider if a mask, gloves, and/or sanitizers are important.

GRATITUDE ADJUSTMENT

Once we were secure in our home, I had this overwhelming sense of gratitude. I had just been in India, on numerous planes, speaking in various communities and conferences. I became clear how extremely blessed I am to still be strong and healthy. I do gratitude work daily, but that became the moment that I decided to pause daily and give thanks multiple times.

Thoughts for you

- Stop several times a day and give thanks for anything and everything.
- Send texts honoring people you love.
- Give thanks to any people in service to you (grocery stores, post office, etc.).
- Write down your "gratitudes" at night before going to bed.

Creativity During Crisis

Here is where it gets to be fun. I will share with you how I have been using creativity to regenerate and reenergize myself and my life. First, here are the steps:

1. **PAUSE AND RESET**—Take conscious steps to rest, sit down, look at the sunset, listen to calming music, read a book.

2. **RELECTION AND REFOCUS**—Think or journal about what is really important to you. What and who makes your heart smile? What lights you up? What do you love that you you've put aside until you "have time to get to it?"

3. **MOVEMENT IS MEDICINE**—Do something daily to get the energy of your body moving. Go online and find yoga classes, dance classes, and stretching sessions. Lots have emerged during this pandemic.

4. **CLEAR AND MAKE SPACE**—Now that you have time, what can you organize, clear, or clean out? What spaces need to be

cleared up to make room for something that could support you moving forward? (This can include closets, drawers, files, and more.)

5. **READY TO RECEIVE**—This is where your powerful imagination comes in. Start visioning and visualizing new ways of being and expressing. You don't have to know how to get there. Let the dreamer inside of you go wild. Write it down.

6. **EXPLORE**—Start playing with ideas. How can you rejuvenate an idea that has been on hold? What classes are available online to support your ideas? Who can you collaborate with to create new ventures? How can the artist in you come alive?

7. **GET OUT OF THE BOX**—Try new stuff. There is nothing to stop you from experimenting. You've got time and space. Let your inner child/inner artist come out and play.

Here is what I have done using this process.

1. Gotten eight hours of sleep.
2. Made time for one hour of spiritual practice in the morning.
3. Hosted a weekly community prayer circle for people around the world (still going).
4. Cleaned out my closets and old papers.
5. Redesigned my home office and made it feel like a sacred space.
6. Ordered new equipment to make my online recording area feel more peaceful.
7. Created some new recipes to support our not being "food bored."

8. Started collaborating with a few people and created new products.
9. Walked and moved daily (I have a few dance videos and also work out with my "I Am Moving" meditations).
10. Created new video scripts and shot them.
11. Made time to write about things that ignite my soul.
12. Checked in with people I love weekly.
13. Did date nights at home with my husband several nights a week (romantic home dinners, movie dates through streaming, sitting on our deck and talking).
14. Did a time of gratitude and breathing rituals every night with my husband before going to bed.

I don't know what is next, but I do know that continuing this practice will allow me to walk out of this and every challenging situation to come with a renewed sense of creativity and expression. I invite you to join me. Let's make the best of these times—and emerge from them healthy and restored.

CYNTHIA JAMES is a transformational coach and inspirational leader who guides people to make changes at a deep level for lasting healing. In addition to being a speaker, coach, and singer, she is the multiple-award-winning author of the books *What Will Set You Free* and *Revealing Your Extraordinary Essence*, as well as the #1 Amazon bestseller *I Choose Me: The Art of Being a Phenomenally Successful Woman at Home and at Work*. Her newest book, *Does My Voice Matter?*, will be released September 2022.

Prayer Poetry, Spring 2020

Jill G. Hall

I pray

For the homeless and those who feed them.

For John, who's been given only months to live but is determined to hang in long enough to vote in the fall elections.

For my loved ones who contracted the virus before we even knew what it was and are still trying to recover.

For those who died alone and their families who cannot bury them.

For my friend who can't stop weeping and watching the news over and over, witnessing George Floyd say I can't breathe, I can't breathe.

For the elderly I know sequestered in a downtown high-rise who step out on their balcony nightly at 8:00 p.m. to hear cheers for first responders, but who last night were traumatized by a cacophony of helicopter loudspeakers, pops of teargas explosions, and cries on the streets below their building.

For the protestors who shut down freeways. For the woman who visited La Mesa to provide comfort as the National Guard arrived among artists painting flowers and butterflies on broken boarded windows. And for the unmasked woman weeping nearby because she wanted to buy eyelashes and Sally Beauty Supply was closed.

For the man who wore a white hood to Santee Vons and claimed it was not a racial statement. And for the father pushing a shopping cart and his wife a baby stroller at Food 4 Less whose masks featured swastikas.

For the POTUS who refused to wear a mask, continued to build a wall to divide us further, and held up a Bible in front of St. John's Church for a photo op. For the unwitting who believed everything he uttered—that global warming, the Russian investigation, and the coronavirus were all hoaxes.

For my longtime colleague who said she'd been fighting Black oppression her whole life and accused me of not doing enough.

For my companions who are helping me find my purpose and path at this confusing, heartbreaking, but necessary-to-make-change time.

Amen.

JILL G. HALL is author of the dual-timeline novels *The Black Velvet Coat, The Silver Shoes,* and *The Green Lace Corset,* all about women searching for their place in the world who are connected by vintage finds. Like one of her protagonists, she fashions mosaics using found objects. On her blog, *Crealivity,* Hall shares her poetry and musings highlighting the art of practicing a creative lifestyle. Visit her at www.jillghall.com.

Never Too Late

Ashley E. Sweeney

I came to opera later in life, but not from lack of trying; my father blasted LPs in our Long Island living room every Sunday morning in the long-ago '60s while we kids ran out of the room, fingers plugging our ears. Even after my father coerced me to go to the Metropolitan Opera House in New York City to see George Bizet's *Carmen* when I was six (in exchange for dinner at Trader Vic's), I still was not swayed (it lasted about six hours, as I remember it).

Now, when I hear "Nessun dorma," Puccini's tenor aria from his 1924, final, and at his death unfinished opera *Turandot*, I can barely contain my tears. That someone could compose such sheer, heart-and-gut-wrenching beauty as this, and in tumultuous times, demonstrates Puccini's post–*La bohème* and *Tosca* and *Madama Butterfly* (and almost a dozen other operas) pure brilliance. That is the magic of music: how it transcends time and circumstance and touches us *just there*.

As for publishing—that, too, came later in life for me, after decades working in other parts of the world of words

(journalism and literacy and education). In all of my novels, I expose the underbelly of women's lives across centuries and ask how telling their stories can reach across time and space to impact women today.

In my third novel, *Hardland*, there's a tender scene between Ruby and her lover, Perce, where Ruby—as hard-edged a woman as you've ever met in literature—confesses her love for Perce.

> *"I love you, Perce," she says. "More than any man on this earth. I figure I've got to tell you before it's too late."*

> *Perce turns and burrows his head into Ruby's chest. "It's never too late, Ruby Girl. Never too late."*

I also came to love later in my life. When my now-husband walked through the door of a garden party a year into my post-twenty-eight-year-marriage single life, everything looked different; it was like I was seeing the world through a new pair of lenses tinged with kindness, respect, and honesty—traits we have seen shrivel in the past six years.

The life lesson learned: It is never too late to listen to opera, to pick up your pen, or to find love in unexpected places. Never too late to make a difference or to say, "I'm sorry." Never too late for anything that is burning inside you that needs to be set free. Never too late to have hope.

Over the past two years, we've been neck-deep in diapers and debt and disinformation and disease and despair. We may not be able to right all the wrongs in the world, but we can make art, like generations of artists before us, and all the ones to come behind.

And we can hope.

No sleep
Nessun dorma

No sleep
Nessun dorma

You too, oh Princess
Tu pure, oh Principessa

In your cold room
Nella tua fredda stanza

Look at the stars that tremble
Guardi le stelle che tremano

Of love and hope
D'amore e di speranza

But my mystery is closed in me
Ma il mio mistero è chiuso in me

No one will know my name
Il nome mio nessun saprà

No, no, I'll say it on your mouth
No, no, sulla tua bocca lo dirò

When the light shines
Quando la luce splenderà

And my kiss will melt
Ed il mio bacio scioglierà

The silence that makes you mine
Il silenzio che ti fa mia

Vanish, oh night
Dilegua, oh notte

Set, stars
Tramontate, stelle

Set, stars
Tramontate, stelle

I'll win at dawn
All'alba vincerò

I will win
Vincerò

I will win
Vincerò

—GIACOMO PUCCINI,
Turandot

ASHLEY E. SWEENEY is the Nancy Pearl Book Award–winning author of three novels. She lives in the Pacific Northwest and Tucson.

2020, acrylic on canvas, 30″ x 40″

The Awakening

Laura Basha

The call of our times is to awaken from the collective nightmare in which we are currently living and to rise above the limitations of our conditioned thinking. It is possible to experience an evolutionary leap allowing for an arising of enlightened consciousness. Go within, Center to circumference, and emerge with an inward outlook.

DR. LAURA BASHA is an organizational psychologist, a published author, a professional artist, and a compelling and empowering speaker. She holds a BA in fine arts, an MA in counseling psychology, and a combined doctorate in clinical and organizational psychology and has been an international consultant, educator, and personal coach for thousands of clients since 1978. She is also the author of the book *The Inward Outlook,* to be published in spring 2023 by She Writes Press. A mother, stepmother, and grandmother, Dr. Basha resides in Northern California with her husband and their hilarious Tibetan terrier, Bodhi.

In a Time
of Chaos

Denese Shelton

Her fever was high.
A cough like the heat of an Arizona summer, dry.
Hospital beds full.
No one understands.
Disease then death, empty streets, empty schools.
The sun rises on deer galloping down abandoned roads.
Tension is nigh.

Loneliness meets isolation like an old friend.
No more touches, no more whispered secrets.
Screens usurp human connection.
Its touch is colder than we're used to, but better than none at all.
We place our hands on the chilly glass, hoping for hands to
entangle into our own.
They're not there.

There's no one to long for.
No one to miss.
No one to ache for you.
Because they don't exist.

Humankind diverges farther and farther away from itself.
Testing its elasticity.
Will it break or snap back?

Worlds collide, creating chaos.
Long-simmering reckoning spills over onto a hot stove.
Angry words, angry times.
No compromise, only the assurance of righteousness.
No turning back.
Except.

Two ears, one mouth.
Listen!
And stand and hope.
Save us from ourselves!
Another hand emerges from the darkness.

 Agape.

DENESE SHELTON has been writing stories most of her life. She is the author of the novels *Lasting Love* and *Awaken*. She is currently working on other novels.

What We Do with Words

Donna Cameron

Some people collect stamps; others collect vintage comic books or tiny spoons from vacation destinations.

I collect words.

I started my quotation collection when I was about ten. I can't recall the first quote I pinned to the little bulletin board in my bedroom, but I'm sure to my fifth-grade mind it was profound.

Over the years, I've collected hundreds of quotes—inspirational, humorous, insightful, wise, enigmatic—by thinkers across centuries and cultures. They are pinned onto a corkboard that lines one entire wall of my home office. Many are yellowed with age or so faded that I can barely read them. I often stand in front of this assemblage and reacquaint myself with wise thoughts and the sages who voiced them. Whenever I come across a new quote and make room for it on the wall, it feels like I've welcomed a gem to my own display of crown jewels. There will be no magical tidying-up of this space.

I find myself standing in front of my quote board a lot these days. It's a place of comfort when I am gripped by fears for the future of our planet, my country, civility, and essential human rights. At a time when watching history unfold has given us all advanced degrees in uncertainty, these words offer strength and community.

Join me at my wall. See what resonates for you.

"One key to knowing joy is being easily pleased," says poet Mark Nepo.

As I consider a world in peril, I wonder if these words still speak to the times we are living in. Does "being easily pleased" mean accepting the unacceptable or not countering intolerance and injustice? Does it negate our need for activism? I'm pretty sure that's not what the contemplative poet had in mind.

It seems like such a simple thought: *be easily pleased*. But these aren't simple times. We're surrounded by threats that have brought our world to a precipice. Only those who are not paying attention can be relentlessly upbeat and cheerful.

Yet maybe being easily pleased is the exact response the world needs from us today. Not ignoring or denying our endangered planet and the war, pandemic, inequality, and greed that proliferate across it but opting for the kindness, compassion, engagement, and respect that also dance their quiet dance and resound with the clarity of a crystal bell.

Be easily pleased seems like a wonderful way to approach life. Years ago, I read a biography of the late comedian Jack Benny. In addition to being one of the funniest entertainers who ever lived and a master of comic timing, he was a kind and generous man, despite the show business persona that branded him a cheapskate. He was also delighted by life. A friend of

his told the story that every time Jack ate an apple, he would exalt it as the very best apple he had ever tasted. That was his approach to life: constant delight. Each day was the best, each experience—however small—was the finest.

How would our minutes, hours, and days be different if we chose to savor each moment rather than continually look for what's missing? Being easily pleased is delighting in the everyday wonders of being alive and choosing to appreciate what's before us, even while recognizing there is much in need of repair.

Being easily pleased is also about approaching life with less rigidity—expecting modestly and valuing what comes our way. Instead of being driven crazy by some habit or oversight of our spouse, child, or work colleague, we learn not to be bothered by their behaviors. It means keeping these things in perspective and recognizing how truly unimportant they are.

An essential element of being easily pleased is paying attention, being actively present. You can't notice the sweet crunch of an autumn apple if you're engaged in three other activities at the same time. You can't experience the peace of a quiet morning if you don't pause to listen to the birds and feel the faint rustle of the wind through the branches of the trees. You can't appreciate the minor miracle of a good cup of coffee if you're too busy doing other things to savor the taste and the way it seems to jump-start the blood in your veins.

"Tell me what you pay attention to, and I will tell you who you are," said Spanish philosopher José Ortega y Gasset.

What we choose to pay attention to creates the world we live in. If our radar is focused on dogs, we will live in a world of laughing labs, cuddly collies, and frolicking puppies. If we look

for slights and reasons to be angry, our world will be rife with insult and offense. If we pay attention to gratitude and kindness, we will find ourselves surrounded by things to be grateful for and endless opportunities to experience or extend kindness.

In a life full of delicious lessons, this has been one of the greatest. Where I direct my attention shapes my world and the attitude I bring to it. If I fixate on what's broken, what cheapens life, and what disparages others, I become ever better at seeing the broken, the cheap, and the scornful. If I follow darkness, darkness prevails. Ah, but if I look for the light, the texture of my life is very different.

There is evidence that our brains are actually shaped by what we choose to pay attention to. If we tend to dwell in negativity, fault-finding, and whining, our brains will rewire their circuitry, multiplying such thoughts, with the result that we become ever-more-expert pessimists and grumblers. But if we focus our attention on what's pleasing, what's good, what fills us with wonder and gratitude, those synapses will start linking all over the place. Instead of training our brains to complain, our default setting becomes appreciation.

If, indeed, our thoughts shape and reshape our brains, maybe we need to spend a bit more time thinking about how we want our brains to work. The challenge, ultimately, is to attend to the light and defy the dark without giving dominion to the darkness, to resist evil without fueling it. It's a challenge we face daily.

"You cannot get through a single day without having an impact on the world around you. What you do makes a difference, and you have to decide what kind of difference you want to make," said conservationist and primatologist Jane Goodall.

This awareness gives us responsibility for our world. We cannot control or shape everything, of course, but staying mindful helps us recognize how many things we can influence.

We have a choice in every interaction. Some might call it choosing the high road or the low road; others term it the choice between good and evil. I think of it as affirming versus debasing life. How I respond to you, to a stranger at my door, or to the person whose views are opposite my own defines me and constructs the world. When I speak harshly to another (and no matter how noble my intentions are, there will still be times that I do), it diminishes the world, it diminishes me. When I behave like a jerk in response to someone else's bad behavior, jerkiness wins. Newsman Jake Tapper wisely said, "Mean is easy. Mean is lazy. Mean is self-satisfied and slothful. You know what takes effort? Being kind. Being patient. Being respectful."

I also know that ignoring the myriad and unmistakable threats surrounding us cannot be an option, either. History has taught us the danger of turning a blind eye to the evils men do. We've seen what happens when good people stay silent.

In recent years, as I have increased my activism, I've often thought of it as resistance—to systems or people who seek to exploit or devalue others. To the greed and shortsightedness that endanger our planet. A *New York Times* essay by Michelle Alexander entitled "We Are Not the Resistance" offered me a new—and welcome—perspective. Instead of claiming to resist those who perpetuate intolerance and injustice, who seek to dominate through lies and threats, it is time to see *those people* as the resistance. In clinging to the fear that they lose when others win, they perpetuate belief in scarcity, they stand in the way of cooperation and equality. They hold back the light.

As Jane Goodall suggests, each of us must decide what we want the world to look like, and then we must act accordingly.

"Do the best you can until you know better. Then, when you know better, do better" is one piece of deceptively simple but deeply profound wisdom Maya Angelou offered years ago.

It reminds us that we—all of us—are works in progress. As we grow, as we engage with others, we learn to walk the earth with ever more care and compassion. We learn that we aren't defined by our mistakes but rather guided by them to do better. And we learn to forgive, to recognize that others are as imperfect as we are and that they, too, are learning from each interaction. This knowledge makes it easier to extend grace, to assume good intent.

If we offer our best whenever we can, and forgive ourselves when we fall short, our best will get better. And we will be modeling the world as we want it to be. Life is not asking us to be perfect, but it is asking us to care, and to learn and grow. And to understand that together we can create something magnificent.

"We're all just walking each other home," spiritual teacher Ram Dass reminds us.

This quote acknowledges the finitude of life and celebrates rather than mourns it. In our short time on this planet, we have one imperative: to love deeply and well, and without hesitation. This goes beyond romantic or familial love—though those are essential, too—to describe the enormous privilege of sharing with others the joys and sorrows of this brief journey.

We saw so many examples of this during our extended months of isolation in the coronavirus pandemic: neighbors checking in on neighbors, strangers offering assistance, stories of generosity and kindness.

We carry the knowledge that life will bring us loss and loss will bring us pain, and we love anyway. We temper inevitable loss by extending support to one another—however imperfect, however clumsy. We offer our help. We accept the help of others. We practice being easily pleased. *We serve.*

We don't have to be the best. We don't have to move mountains. We don't have to know what to do next. We don't even have to be brave. Whatever our service looks like, whatever we can offer is enough. There is no puny action. There is no wrong way to love.

As I stand at this splendid wall of words, I marvel at what humans can do with them. There will always be those who use words to hurt, belittle, and shame, but those are the few, the weak, the cowering. Let our words be wise and uplifting. Let them illuminate and heal. Among the many choices we make each day, how we choose to use our words may be the most lasting.

Stand with me here. Let us speak of the light.

DONNA CAMERON is the author of *A Year of Living Kindly: Choices That Will Change Your Life and the World Around You* and coauthor, with Kristen Leathers, of *One Hill, Many Voices: Stories of Hope and Healing.* She considers herself an activist for kindness but admits to occasional lapses into bitchiness. Donna lives in the Pacific Northwest.

Great Loves Among Great Losses

Lauren Wise

One of the reasons I became a journalist was a passion to reveal inspiration behind the work of musicians, artists, and writers. To share a creator's experience, be a conduit into different perspectives, cultures, and lifestyles, to immerse a reader into a world and broaden a mind—this, to me, is the meaning behind writing: to spark motivation, creativity, and understanding within other people. A thread of knowledge that will hopefully continue to weave through minds long after the ink has dried.

In my early twenties, I focused on music journalism, mesmerized by how, in the late 1960s, women in the US, Europe, and other places began to mobilize and actively change their lives, with much pushback and difficulty—raising questions about equality, birth control, and reproductive rights, fighting back against injustice—through song. In music, women stopped singing about broken hearts and started singing about their anger, sexual freedom, and power—or the lack thereof.

I intersected music journalism with working in book publishing at about the same time. To me, books equal strength and freedom; I believe that educating our youth, especially young girls throughout the world, is the only path to changing the world and the injustice that's come before them.

There's something about experiencing the strong words in music and in books; it takes a trowel to your chest and slowly digs, unearthing something from inside, bit by bit, until it finally shows us a part of ourselves we haven't met before. A part we can turn over in our hands, raw but pure, in wonderment and say, "Nice to meet you."

Unexpectedly, that same feeling hit me tenfold when I became a mother at the height of (or so we thought at the time) the COVID pandemic, in September 2020.

The common thread between every human being right now is that everyone has lost a great love during the pandemic: A spouse, a parent, a friend, a relative, a special someone. Freedom and personal space, which also accounted for many divorces. Countless jobs, investments, memories that were preplanned, holiday gatherings, funerals, births, milestones. A dulled passion for a hobby or inspiration due to depression—I know chefs who lost their sense of smell and taste, and it never returned. And, of course, anyone who had COVID and ended up suffering long-term or serious side effects will have to live with that forever.

But great loves were also born.

Relationships relegated to Zoom dates for months before meeting in person resulted in more grounded, connected partnerships. Poetry, novels, art, and ambition flourished. Hobbies turned to side hustles and then to successful businesses. The environment finally drew in a breath of fresh air, and wild animals took to streets. People finally realized that the world

doesn't revolve around them and their political opinions—and shouldn't. And, of course, beautiful babies—quarantine babies, part of "Gen C"—were born.

I was not *quite* looking on the bright side when I learned of my surprise pregnancy two months before COVID hit our side of the country. The future was then a solid unknown, but as a pregnant woman, being in Arizona had its benefits; I was lucky.

I read about a woman in labor who had to go to three hospitals in New York before finding one to take her in; women giving birth alone at home; women dying in birth alone. Sure, my doctors couldn't tell me anything, no one was allowed at appointments, the amount of which were decreased to stagger patients. One day, doctors would say I'd be giving birth alone, the next, that I'd have to wear a mask during labor with doctors in hazmat suits, and the next they'd say, never mind, you just need to show a negative test to get into the hospital once in labor. The birth plan changed daily, mostly without me But this being my first baby, I also didn't have anything to compare my experience to, so when the nurses tsk-tsked at me and apologized for no hospital tours or birthing classes or explained that I might have to give birth in triage or even the hallway— I just felt thankful that I'd be able to receive *some* type of medical care.

Work went remote, isolation ensued, but the worst parts of the pandemic, for many of us, were the differentiating opinions and constant divisiveness. My own family members were divided across the board, and it was terrifying—but not as devastating as it was when I was diagnosed with COVID at eight months pregnant in July 2020.

Exhausted, swollen, sick, and scared, I didn't even personally know anyone who'd been diagnosed yet. After coming

home from the doctor, all I could think while tears streamed down my face and I rocked in my baby's nursery was, *I can't even protect my baby from illness in my own womb.*

I turned to writing. I finished the first draft of a novel that has taken me years, a work that revolves around the importance of recognizing beauty in art, the world's art of nature, and how if we are not trying to love and help lift each other up, we might as well not even be here.

Less than thirty days later, in an unforgiving Arizona August heat, I decided to plant some rosemary, huffing and puffing as I "nested" my front-door area and tried to create a semblance of order. A few days after that, I broke out in a full-body rash and COVID symptoms again—but this time I was diagnosed with the rare Valley Fever, a fungal disease contracted by dirt spores. This affected my lungs worse than COVID ever did.

See if I ever garden again.

So . . . I wrote some more, in between blood work, chest X-rays, and ultrasounds as a veritable guinea pig for the Centers for Disease Control and Prevention—who routinely called me to check in. And thought about all the women around the globe and their varied experiences.

I've been lucky to travel to many parts of the world that most people don't necessarily care to visit, whether it's for fear of danger or disinterest in cultural differences, or just because it's not the template of a vacation that Westerners often have. I've walked alongside Cambodian women who have to travel miles on foot to get clean water from wells and Vietnamese children who have to do the same to get on a bus just to attend school, and I've observed firsthand the intersection of modern culture with persecution of women and resistance to education of young girls in Turkey. Alongside my own mother, visiting

Istanbul's gorgeous Hagia Sophia ("Saint Wisdom," seen as the personification of female wisdom in multiple religions) the spring prior to COVID and witnessing the sheer art and power of that Wonder of the Ancient World—stones from Egypt, black stone from Bosphorus, yellow stone from Syria, green marble from Thessaly—I felt a profound connection to it as if I'd possibly been there before, thousands of years ago. Even though I knew its existence was rooted in religious turmoil, there was this energy of hundreds of women who have influenced time and history and art, and I felt assured.

In September 2020, I was lucky enough to give birth to a healthy, if tiny, baby boy at full term, in a hospital, with my husband by my side and a doctor present. But since 2020, according to the Pan American Health Organization, one-third of pregnant women have been unable to access life-saving critical care on time in the Americas. It will take years to know how COVID affects babies, or what impact the overwhelming shift that occurred in the education during the pandemic has had on young children and teenagers, or the parents who had to homeschool them— particularly women, as COVID heightened the inequalities, large and small, that happen at work and home.

As of 2022, with persecution against women continuing all over the world, there is still much progress to be made, even with groundbreaking movements like Me Too, even with the uprising of matriarchy and of underrepresented voices, even with more female leaders in the world than ever before.

Much of the world is forced to handle extreme hardship with no complaints—battling daily against disease, little access to clean water, famine, lack of education, poverty, living in constant fear of militia. That's not to say that America doesn't

have its own atrocities (one being its having one of the highest maternal mortality rates among developed countries)—but it does at least have the means to address these issues in an efficient way, whereas many other countries do not.

So how do we decide *where* to act? We must identify the case we each want to help to make the world a better place. We must make a solemn vow for the next generation of our children to be a part of the solution, not part of the problem.

If you're able to start a foundation, allocate large amounts of money to help, or travel directly make a hands-on impact somewhere, more power to you. Many people don't have that luxury. But we can still help mentor the next generation of young females in art, writing, or music. Tackle childhood hunger by becoming a regular volunteer at a local nonprofit. Get involved in outreach and children's care programs. Help organize drives for that orphanage, refugee placement organization, women's safety shelter, or war-veteran center. We writers can write about the issues at hand, or be a resource for underrepresented voices seeking to become the next successful businesswoman, self-help coach, or inspiration for change. In our own way, we can all rally and fight against injustice, human trafficking, climate change, deforestation, appropriation of native lands. And as we do this, we can show our children the importance of prioritizing these actions and words.

For me, going through this pandemic and having COVID was just a small piece of the strife I've seen over these past few years—and it's made me a stronger woman and better mother. We must support the next generations of mothers, daughters, and—yes, especially—young boys to create a new vision. We may not be able to control illness, politics, and natural events

no matter how hard we try, but we can control our response to these issues and channel it into making us better people—and a better next generation.

LAUREN WISE is an award-winning journalist, published author, and associate publisher at She Writes Press and SparkPress. She's an avid traveler, reader, and volunteer and through work helps people find their next great read or influential music album. She lives in Arizona with her son, her husband, and 500-plus books.

This Heavy World

Katrina Anne Willis

Dead. Dead. Dead. You know how when you say or see a word again and again and again, it stops making sense? How the letters realign themselves into gibberish, and the meaning is lost? My mom died. My mom is dead. The one who gave me life, championed me at every turn, celebrated my success, and dried my tears is dead. Dead. Dead. Dead. My life has realigned itself into gibberish. Nothing seems real.

The funeral home director told me to take as much time as I needed at her bedside, but his gurney—the one that would take her away forever—was in the hallway, and her chiseled cheeks were cold. I held her hand, but she didn't hold mine back. She couldn't. Her fingers, chilled and stiff, were no longer hers. In life, she was warmth and kindness and laughter. She was the sun. In death, everything went gray.

Six years before she died, I told my mom that I was gay. That I had always been attracted to women.

"I don't understand," she said. "You're married to a man. You have kids. I will always love you, but I just don't understand."

I didn't either. Not yet. I'd spent thirty years of my life with a man I loved the only way I knew how. I'd given birth to and raised four children who were the best and worst parts of me and their father. I'd lived the white-picket-fence life, had sent my children to top schools, had mowed the lawn every Sunday after church, knew *Chicka Chicka Boom Boom* by heart.

And during those early years of marriage and babies, I'd also unwittingly fallen in love with my best friend, had stayed awake late at night wondering why she and I couldn't raise our children together, why I couldn't hold her as I fell asleep every night, our seven kids tucked safely in beds upstairs, whispering their own sacred secrets.

But I had been raised Catholic in a small midwestern town, and there were things you just had to do, rules you were simply expected to follow. You must marry a man. You must cook homemade chicken and noodles. You must bear children. You must teach them the Ten Commandments. You must confess your sins weekly. And I was most assuredly a sinner. Coveting another's wife? Absolutely. There were black marks on my soul every time I entered the confessional.

When I fell madly, passionately, dangerously in love with my Pilates instructor and fully embraced my true sexuality at age forty-five, I tore down every wall I had worked so hard to build. I made a beautiful family, and then I broke it. The fallout was swift, fierce, brutal. Friends stopped calling. Family members said they loved and supported me and then dined with my ex-husband and his new girlfriend. The in-laws I'd called mine for multiple decades unfriended me on social media.

My truth was too much.

I have always been too much.

But my mom? She saw me smile. She saw me breathe. She said to me, "Are you happy, Trinks?"

And I nodded, because I was. In addition to being terrified, lonely, unsure, and guilt-ridden, I was happy. I was learning me. I was beginning to understand that conflicting feelings can coexist.

"Then that's all that matters," she said, taking my hand in her aging, wrinkled own.

She always loved holding my hand.

In 2016, a monster was elected to run our country. He believed in belittling women and erasing homosexuals and mocking the disabled. He unleashed the fury of thousands of straight, white men who felt persecuted by those who looked and lived differently than they did. He instilled fear and loathing and anger in the hearts of Americans. Mine included. He divided us and brought out the demons that lived deep within.

In 2020, in the same month I turned fifty, the pandemic struck. People argued, fought, defended, accused, and, ultimately, died. Humans turned on humans. Masks became a political weapon rather than a means of supporting those of us who were sick, immunocompromised, old, or impaired. The true nature of too many humans reared its ugly head. *Me, me, me* became the battle cry of so many. Those of us who did not feel the same marched and argued and rallied and cried alone in our beds, devastated by the true, narcissistic face of humanity. Those who put *me* before *we*. The ones who would sacrifice your beloved grandfather for their "right" to make an unmasked trip to Walmart.

When the heaviness of the world hit the hardest, I surrendered to Oreos and wine and bread. I gained sixty pounds in the name of self-preservation, in the name of self-destruction.

I underwent scans on my stomach and my spine. I was cut open to fix what was wrong. Medical bills went unpaid when I lost a job I had barely begun. They piled up, up, up, while my ex threatened me with repossessions if I couldn't make things right financially. I spent three days in the hospital with an acute asthma attack so severe, I could not take a breath on my own.

Even my airways had failed me.

A friend I'd considered one of my best stopped communicating altogether. I asked why, and she said it was just "the regular hills and valleys" of relationships. But we never emerged from this particular valley. She didn't say it was because I was gay or divorced or that she didn't know who I was if I wasn't the suburban housewife she'd grown to love, but her silence spoke clearly. One night, when I was having dinner with another friend—one who had chosen me over societal expectations, judgment, or her own potential discomfort—the first friend walked by our table. Twice. She looked at me, but she didn't see me. She looked through me, rendered me invisible. She negated me, made me into an apparition with a glass of red wine.

"Do you want to leave?" my other friend asked as she witnessed the painful dismissal. "We can go. It's okay."

"No," I said. "I want to stay. I want to be here with you. I want to be."

My existence is not negotiable.

There is a bloody, violent war happening in Ukraine. Innocent children shelled on the streets, in their hospital beds, in their schools. The frail and elderly forced to leave their homes to seek safer ground. A madman intent on taking what he believes is his, making human lives disposable in the process. The photos are devastating; the reality, catastrophic. Why have we not yet learned that peace is more powerful than war, that

solidarity is more beautiful than division? Sunflowers will rise someday from the ashes of the scorched earth. But what will be lost before the flowers can grow?

I'm quickly closing in on fifty-two, and I don't know what to do with all my grief, with all the heaviness of the world. I should have it figured out by now, but the universe keeps sending me something new to learn. I used to say that my four kids were such a marvel—all so distinctly different, each one in need of unique mothering. So are all the manifestations of my grief. When I think I have figured out how to grieve *this*, I am asked instead to grieve *that*.

But today in Lexington, Kentucky, the sun rose over green hills. I snuggled in bed with my rescue pups. I watched my hamster stuff his tiny cheeks with broccoli. I laughed with each of my adult kids. I ate a rice cake with peanut butter and yogurt, and it filled me. Sustained me. I read pages of a gorgeous book that I will never again read for the very first time. Babies were born all over the world. Babies died all over the world. Humans loved and lied and celebrated and manipulated. A ladybug landed on my arm. I missed those I've let go of. I loved those who've stayed. I wrote, and I wrote, and I wrote some more. It both gutted and cleansed me.

Life went on.

Somehow, until it is no longer possible, to be alive on this beautiful, brutal planet must be enough.

KATRINA ANNE WILLIS is the author of *Parting Gifts* (She Writes Press, 2016). Her personal essays have been featured in numerous anthologies, including *Chicken Soup for the Soul:*

Think Possible, My Other Ex: Women's True Stories of Leaving and Losing Friends, and *Nothing but the Truth So Help Me God.* She was recognized as one of six distinguished authors at the 2016 Indianapolis Book & Author Luncheon and was named a BlogHer 2015 "Voice of the Year." She was a 2011 Midwest Writers Fellow and is currently on faculty at the Story Summit Writer's School. You can find her at www.katrinawrites.com.

Gardening: A Poem for Helen

U-Meleni Mhlaba-Adebo

Some mothers carry handbags
with endless assortments of lipsticks,
perfumes
receipts
scrunched-up dollar bills
credit cards
a cell phone
Hidden
in between the crevices
but mine
carries a small hoe and a box
always
On a search for plants
or flowers that need asylum
and I too
now a mother

mostly carry journal and pen
collecting ideas
Words
soil
hoping
they grow

U-MELENI MHLABA-ADEBO is a Zimbabwean American poet, performance artist, storyteller, and educator with an international reach and a transnational lens. Her debut poetry collection, *Soul Psalms* (She Writes Press, 2016), was hailed by David Updike as "a fearless female voice . . . tempered with optimism and healing possibilities of love."

Alvaro's Desert Memorial to the Unknown

Sarah Towle

It starts with a dot. A red dot. Which becomes a GPS coordinate.

"Ready?" asks Alvaro Enciso to no one in particular but to everyone present. Throwing me a friendly wink under bushy salt-and-pepper eyebrows, he rests a hand atop the open hatch door of the 4Runner. Piled into the back cargo area of the filthy, scrub-scuffed, gray SUV are two milk crates packed tight with 99-cent plastic gallon jugs of water, a construction bucket, a bag each of gravel and fast-setting concrete, several pairs of man-size, heavy-duty work gloves, a shovel, and a pickax. Topping the utilitarian stack—and looking quite out of place—are five or six crosses of two- by three-inch pine strips painted green, yellow, pink, and blue. Each is secured with a red metal dot constructed from a used bottle top nailed to the central meeting point. Some boast additional adornments of recycled metal trash, all simple.

"Yup," says David, heading to the passenger's seat.

"Vámonos," states Peter, buckling in behind the steering wheel.

Three doors slam, almost in unison. The final one, landed by Alvaro, brings into sudden reveal a red sticker, centered just above the ubiquitous Toyota logo of the vehicle's rear window, that shouts, "SAMARITANS."

Peter steers the SUV out of the parking lot and onto Tucson's S. Sixth Avenue. We're en route to Highway I-19, heading toward Mexico, as this three-man team has done each Tuesday for years. David powers up the GPS-tracking device in his hand and shows me the cacophony of red dots splashed across the map of the vast Sonoran—one of the most blistering deserts on Earth, rivaled only by Iran's Dasht-e Lut.

Many red dots mark locations far off the beaten path, often landing within the 2,900,000-acre area of the Tohono O'odham Nation Reservation. We can't reach those without advance permission from tribal leaders and a guide, neither of which we have today. So David directs us to the east of the Buenos Aires National Wildlife Refuge in the foothills of the thirty-mile-long, north-south running Baboquivari mountain range, the boundary of Tohono O'odham territory.

The range's granite monolith peak, which towers over the vista like a monumental thumb at a dramatic 7,730 feet, makes the perfect landmark for travelers. Though Baboquivari Peak is the most sacred place of the Tohono O'odham people—the home of I'itoli, the Creator and Elder Brother of the Tohono O'odham homeland—it has stood just outside the Nation's current territorial boundary since 1853, when the Treaty of Guadalupe Hidalgo divided the Tohono O'odham lands, giving mountain access to colonial settlers. Since 1998, the Tohono

O'odham Nation has fought to have the sacred peak returned to its custody. For now, it is the playground of hikers, climbers, and mountain bikers.

Our first stop this day will be a spot southeast of Baboquivari Peak and just north of the US–Mexico border at the "blink-and-you'll-miss-it" Nogales exurb of Rio Rico. We pull into the weather-beaten asphalt-and-gravel roadside lot of Ruby Corners Inc. Motorway Services and park discreetly in a far-flung corner, well away from the semitrailers lined up for repair. Using the bed of the 4Runner as a workbench, Peter pours a mixture of quick-dry concrete and gravel into the bucket, a recipe memorized from repetition. The rest of us grab water, tools, gloves, and a cross and follow David, now zeroing in on the sought-after coordinates, down a noisy, lonely length of highway.

"We try always to get as close as we can with the SUV," Alvaro explains. "Then we hike the rest of the way."

This hike will not take us far, for the red dot we seek marks the spot where Sergio Antonio Santiago, aged twenty-four, having successfully made it across the harsh Sonoran Desert and into the United States, collapsed by the side of I-19. Unlike most of those in search of life, he was found "fully fleshed," meaning his corpse was less than a day old when examined by the Pima County Coroner's Office (more typically, the desert critters and climate in this area eat up a body, along with the origin tales it conceals, fast). Still, while we knew his name, thanks to identification found among his few things, Santiago's dream remains unknown. Whatever it was, it was denied him and his loved ones when he fell by the side of Highway I-19, fifty-five miles from Tucson. Probable cause of death: hypothermia.

Despite sizzling daytime temperatures that can climb as high as 120°F, shivering is likely the first symptom Santiago

noticed—that and slurred speech or mumbling. Then his metabolism and heart rate surely slowed as his organs began, one at a time, to shut down. His breath grew shallow and his pulse weak, depriving his body of life-giving oxygen, as his cells set off chemical toxins. When these hit his brain, the irreversible damage began. He felt drowsy, clumsy, confused. He lost his memory, along with his coordination, and probably started to hallucinate, forgetting to keep focused on Baboquivari Peak, before losing consciousness altogether.

Symptoms of hypothermia manifest so gradually, you might not even be aware of your condition until it's too late. Sadly, it's always too late once hypothermia hits in the Sonoran Desert.

It's now up to the Colibrí Center for Human Rights to locate Santiago's family and reunite them with their lost loved one—that is, *if* they know to register him as "disappeared." Until then, his backstory will remain a mystery.

Until then, Alvaro, Peter, and David will follow red dots to remember the dead. Four, five, six at a time. Every Tuesday.

It starts with a hole, determined by a red dot on a map, marking where Santiago went from standing to fallen. A hole, not too deep, cut into the earth by David with pickax and shovel, and then filled in by Peter with moistened gravel and quick-dry cement as Alvaro stands and plants in the hole a simple cross made of rough two- by three-inch pine strips painted green. It's a solemn act, performed in silence, save the howling of traffic on Highway I-19.

I eyeball the positioning of the cross, indicating to Alvaro with a slight wave to the left, then to the right, the adjustments necessary to settle it, straight and tidy, before the cement dries. David piles rocks, collected from the roadside and tossed into

the now-empty bucket, at the base of the cross. They make it look pretty. They provide additional support. Peter draws a rosary from one pocket and drapes it over the cross. From another pocket, he pulls a vial of holy water. He sprinkles a bit on the fresh grave, makes the sign of the cross, and whispers a brief prayer.

"The majority of the fallen are Christian, so we don't want to forget that part," Alvaro tells me, breaking the silence. "But it's ironic that an infidel is doing this for them." He laughs; he's referring to himself.

For Alvaro, the cross represents more than just a Christian symbol. "You're also looking at a geometrical figure," he explains. "The vertical line represents the living person with a future dream, still walking. The horizontal line is when that dream died with the human who, unable to remain upright any longer, collapsed. The red dot in the middle, where the criss and cross meet—that is the moment of death, the moment when, in this case, Santiago went from living to dead."

Alvaro reminds me, too, of a pre-Christian legacy of the cross: "The Roman Empire used it to kill—to hang false prophets, enemies of the people, common criminals, and leave them out in the sun for days at a time, without any water, to die. That's exactly what's happening here. People dying from being exposed to the sun, without any water—and on purpose, because the US government has walled off the easiest points of entry, sending humans through the harshest, hottest, more difficult parts of the desert where they are bound to die."

Alvaro is talking about Operation Gatekeeper, launched on October 1, 1994, by the Clinton administration, which then caved to the same nativist, anti-immigrant fervor that squeezes the life from the soul of the US nation today. Operation Gatekeeper

erected walls and fences in easy-to-cross border areas with the express purpose of funneling human beings into dangerous and inhospitable terrain, where they would either perish or be more easily spotted. Walls and fences went up alongside a dramatic rise in Border Patrol agent hires, as well as surveillance technology purchases. Ports of entry were added to the walls, as were interior checkpoints within one hundred miles of the border. Guns were surged to the gates and checkpoints as prison beds were allocated for those "apprehended" before they could die.

As Operation Gatekeeper made its way east, from Imperial Beach, California, to Brownsville, Texas, it divided thriving bicultural communities, devastated natural ecosystems, and transformed the southern borderlands of the US into a militarized zone where law enforcement took on the job that would have, then as now, been better suited to humanitarians.

Policymakers theorized that by making the journey across the border as devastatingly difficult as possible—by ensuring that folks in search of life, like Santiago, would die a slow and agonizing death—family and friends back home would get the message: "Do not come." The policy even had a name: "prevention through deterrence."

On the one hand, Operation Gatekeeper has worked: it's caused the death, disappearance, and despair of tens of thousands. On the other hand, the policy is and always has been a miserable failure, as folks keep coming.

"The US government never understood," explains Alvaro, "that when you're poor and this is your only option, you do it. When facing the Sonoran Desert is a better path than a lifetime hiding from the gangs or watching your children starve to death, you do it. These people aren't looking for the tired 'American dream.' They're just looking for better, so they do it."

Operation Gatekeeper kicked off the nearly three-decade militarization of the US–Mexico border, turbocharged after 9/11. It has led to the ruin of an uncountable number of lives. In 1994, fewer than thirty people were known to have died crossing the border. By 1998, the number had quintupled to 147. Deaths more than doubled to 387 in 2000. And the trend continues apace.

Conservative estimates suggest a death rate of at least one person each day since Operation Gatekeeper began. That's more than ten thousand dead, to date. Meanwhile, a high of 17.7 billion taxpayer dollars were spent in 2021 on the morally questionable belief that the human right to seek a better life can be deterred through cruelty.

We mark four more red dots this sacred Tuesday, one located within a ranch we enter on foot and without permission. When the owner speeds toward us, his dual-cab pickup kicking up a cloud of red desert dust, Alvaro throws up his hands and plants himself in the truck's path. My heart races, wondering if this will be the day that Alvaro becomes a red dot on a desert map. But on learning our purpose, the rancher humbly allows us to proceed. We leave a bright red cross in the memory of one who is welcomed in death, though in life he was not.

What started as a dream—"to reveal to the world the US government's responsibility for turning the Sonoran Desert into a graveyard"—has resulted in Alvaro transforming the desert into a cemetery, an art installation, and a memorial to the needless suffering of the unknown. He has planted more than 1,200 crosses in vibrant colors, adorned with bits of metal trash found on the desert floor alongside the dead. More than 1,200—and counting.

SARAH TOWLE is a London-based author and human rights advocate who shares her journey from outrage to activism one tale of humanity and heroism at a time in her memoir, *The First Solution* (She Writes Press, 2023).

Art as Light

Debra Thomas

In the dark times, will there also be singing?
Yes, there will be singing.
About the dark times.
—BERTOLT BRECHT

For decades, I have been inspired by the motto "It is better to light a candle than curse the darkness." This reenergized me time and again through my years as a human rights activist, then as an English as a Second Language (ESL) teacher for adults struggling to make a new life in our country and whose heart-wrenching stories were seared in my heart, and finally as a Los Angeles public high school teacher, where my primarily Latinx and Black students faced both discrimination and the daily danger of gangs in their neighborhoods.

Find the light. Be the light. Don't focus on the darkness.

Lighting a candle has been central to every aspect of my life, so it was no surprise when it found its way into my writing, for that's the form of artistic expression to which I'm drawn. To curse the anti-immigrant sentiment in our country would only add to the darkness, so I hoped to shine a light instead. For art—all forms of

art—is a much-needed light in dark times. Without such beacons, how else would we be guided, informed, inspired, and sustained?

I think back on all of the novels I've read, all the poems and paintings, sculptures and songs, plays and films that have moved me deeply. Each was a work of art that left a lasting impression because it brought to light an experience I would never otherwise have known. Maya Angelou's *I Know Why the Caged Bird Sings*. Carolyn Forché's powerful anthology *Against Forgetting: Twentieth-Century Poetry of Witness*. Goya's painting *The Third of May, 1808*. Luis Valdez's Broadway play *Zoot Suit*. Steven Spielberg's film *Schindler's List*. Through myriad forms of art, I've been inspired by the courage of ordinary people and uplifted by the resilience of the human spirit.

Art places us at the scene and in the skin, so we feel, see, and imagine until we come close to knowing the real experience. And that is when the light of empathy and understanding begins to shine. That is when we acknowledge the connection and recognize that we are all one, despite our differences.

Art is the light that will guide us through the darkness.

Many years ago, some high school students and I created a group called Students In Action, only the "I" was replaced with a candle. Something like this: Students ⚊ n Action. Our motto was my treasured quote, "It is better to light a candle than curse the darkness." The students chose an issue that mattered most to them, learned everything they could about it, and then came up with actions that would bring awareness to others and, hopefully, lead to needed change. As expected, their interests were varied, so they broke up into small groups, each tackling different topics—from animal rights to human rights to better food in the cafeteria. What impressed me most were the works of art that emerged from their endeavors—highly

creative, colorful posters and banners; phenomenal rap lyrics; moving essays and poems. It reminded me that artistic expression is a part of being human. We tend to turn to forms of art to help us convey our deepest emotions, sometimes to understand ourselves and sometimes to inform and inspire others.

Art makes us human—and humane.

At the same time, art does not have to be *about* dark times. It doesn't have to focus on some form of social justice to add light to the darkness. Consider the poetry of Mary Oliver, which, even when it's simply about a grasshopper, trumpets such joy for life. An Agatha Christie murder mystery, any Van Gogh painting, a riveting series like *The Queen's Gambit* or *Game of Thrones*, even listening to Johnny Mathis's velvety vibrato in "Chances Are"— each uniquely illuminates our lives, adding moments of elation or escape that reaffirm our love of life or renew our depleted energies.

Art is most important when we are world-weary. In any time of unbearable crisis, art is needed more than ever—to shed light on the source of the darkness and to show us the way forward to a brighter world.

DEBRA THOMAS is the author of *Luz*, winner of the 2020 Sarton Award for Contemporary Fiction. Originally from Binghamton, New York, she has lived in Southern California most of her adult life. A writer, teacher, and immigrant-rights advocate, Debra is a former Los Angeles public high school literature and writing teacher and English as a Second Language (ESL) teacher. Her second novel, *Josie and Vic*, will be published by She Writes Press in April 2023. For more information, visit her website, www.debrathomasauthor.com.

What We
Have to Offer

Barbara Stark-Nemon

During these challenging moments in history, I find myself looking to my creative past as I consider how to move forward. I tell myself that I can't have written two novels encompassing the themes of love and resilience in the face of unspeakable loss and traumatic change and not have some artistic tools to bring to the present table. And yet . . . the questions that face all of us as artists and as human beings feel overwhelming. Will the pandemic ever end? Will our democracy survive or fail? Are all the divides in our society reparable or permanent? How can we be facing the nuclear threat . . . again? Where can we look for inspiration and comfort in these times? It is no wonder that so many have descended into a continuum from torpor to depression and anxiety. What do we, as writers and other creatives, have to offer?

The Oxygen-Mask Rule

In my own life, the assault of world news and personal and family anguish that threatened to suck the life out of hope and aspiration twice led me to write novels. In them, my characters move through and out of devastation, bringing me along with them. So, one value in producing art in times of trouble is as an intense form of self-help. My first book fictionalized the remarkable life story of a great-aunt's survival and the victory of love and redemption through two world wars in Germany. The second novel told the story of a contemporary woman's struggle to fulfill a dream after suffering through a shocking consequence of her infertility. No matter the obstacles and traumas, my characters showed that there is always the option to recalibrate, to redefine what reality can mean in a more propitious manner. They had to focus on a dream or a relationship or an opportunity rather than on the disaster and damage at hand. We are in another time for me to take a page from my own books . . .

Our Art Is What We Have to Offer

Some of us can hop on a plane and join a fight somewhere in the world where freedom is threatened. Some can donate money or supplies. Some can volunteer time and skills at local agencies. And some of us can meet the challenge of crisis with our skills as artists, writers, and musicians. It's what we do best, and it taps into the core of who we are as people.

Margaret Renkl recently wrote in the *New York Times*, "Great art of every kind allows people to place themselves, safely, into the larger world. It is transformative precisely because it is

one way we come to understand our own part in the expansive, miraculous human story." If we believe Renkl, then becoming part of such transformation is both the gift and obligation of the artist. The gift is to create the transformation you wish for yourself and for the world. As to the obligation—the Pirket Avot, a compilation of the ethical teachings and maxims from rabbinic Jewish tradition, teaches, *You are not obligated to complete the work, but neither are you free to desist from it.*

What We Still Have

I recently sat across the table from three young people in their late twenties to early thirties and asked them what role they thought art had in this moment of uncertainty and suffering. Their answers were eager and thoughtful. One of the young women admitted to allowing herself to get lost in books during much of the pandemic, creating shelter for herself. Another reported that in the midst of the invasion of Ukraine, a photographer's capture of a young couple in a bomb shelter posing with their new engagement ring held high had infused her with their transmitted joy, in sharp contrast to all the images of devastation that had filled her screens. The young man at the table asserted that the artist in times such as these is most needed to distill and express the zeitgeist—to deliver to viewers, readers, and listeners access to feelings, interpretations, and the possibility of hope. Shelter, interpreting reality, everyday moments of joy and hope—these are what our audiences look for from us in these times. And I'd like to add one more gift that art can supply in times of crisis: forgiveness.

First, we can forgive ourselves: for feeling stuck or worse in the face of the pandemic and the continued assault of dysfunctional

politics and social unrest. Then, we can offer artful forgiveness to others—a lens through which forgiveness is the focus. In so doing, we lighten our own load, along with theirs.

In an interview with Brooke Warner at the Bay Area Book Festival, the author Ann Patchett said, "Forgiveness is just such a gift . . . we think forgiveness is something we give to other people, and in fact I think forgiveness is really a gift we give to ourselves. Which is just that we carry this heavy burden of anger and hurt, and forgiveness means that you're putting it down." Patchett went on to say that she forgives herself for not being as good on the page as the stories in her head: "You'll never be as good as you want to be. You're just as good as you are . . ."

I have taken courage from this advice, and it has helped me climb out of the stuck place of feeling that in these critical times, I might not have anything to offer.

Hope for the Future

A final thought about producing art in the time of chaos and uncertainty comes from a profound experience I had with my father in the final days of his life. He had a visionary episode that perfectly reflected his deep spiritual connection to his faith and the joy he experienced as a human being. He had his own waking version of the biblical patriarch Jacob's dream in the desert. In the dream, Jacob sees angels traversing a ladder between heaven and earth and experiences God confirming that he has blessed Jacob and all of his descendants. When Jacob awakens, the Bible relates that he says, "God was in this place and I did not know it." Scholars have theorized many things about that dream, including themes of personal exile and spiritual distance.

My dad was not exiled from his spiritual solace or his relationship with his God. He was literally seeing the light as he approached death, and his first instinct was to share it with his children and grandchildren. I recorded his prayers on that dreamy day in the hospital and I have found great comfort in them. In his own words . . .

"Thank you, dear God, for having gotten me through to have the knowledge that we're all doing this together and we have meaning at the end. I appreciate the joy of it. Happiness has occurred; let us continue to live forever and ever."

Amen, Dad. The continuity of humanity—in its joy, in its pain, in its hate, and in its love—that's our job, our privilege, our obligation, our hope, and our joy. Create!

BARBARA STARK-NEMON, author of the award-winning novels *Even in Darkness* and *Hard Cider*, lives, writes, cycles, swims, does fiber arts, and gardens in Ann Arbor and Northport, Michigan.

One Step at a Time

Rita Gardner

March 2020: This is a story about a few women who found themselves among the millions suddenly quarantined and isolated by a mysterious virus, and at the same time beaten down by the vitriol of a science-denying president. We were friends united by a love of the outdoors, and one of us decided to combat the uncertainty seeping into her being by starting each day with an early-morning hike in nearby hills.

Soon more of us joined her at 7:00 a.m., escaping our bondage for an hour. Outdoors, we could breathe fresh air. We distanced ourselves from each other the requisite six feet, but our voices and laughter spun a web of safety around us. We found ourselves drenched in rain, awash in rainbows, or fading into fog. And we grew.

We gave ourselves a name: The Thrive Tribe. We drew close with an intimacy that emerged slowly, as our footing grew stronger each day. We witnessed the skies clearing as fewer vehicles polluted the air. We became present to our surroundings and to each other. We met a young crow raised by a local

family who liked to startle us by swooping and landing on us along the trail. We missed him when, months later, he flew away to be with his own kind. On winter mornings we started in the dark, our feet feeling their way up the well-worn trails. On sweltering summer days, we squinted against the too-bright sun or donned masks against the orange smoke-filled skies as wildfires raged not far away.

March 2022: By now, almost a million souls have perished from COVID in the US alone. Some of us have lost loved ones, lost jobs, or had to move away. Even so, the tribe grows. Today we can hug each other in the morning air as the virus wanes— for now. But new evils continue to emerge: Russia is decimating the nation of Ukraine as another madman holds the world hostage to a future we cannot imagine.

And yet, we continue. Now two young puppies bounce up and down the hills with us, oblivious to anything but the wild grass underfoot, the birdsong above, and the promise of a treat if they're a good dog. And we two-legged creatures keep giving each other strength, comfort, or a good laugh along the path to whatever comes next, step by rocky step.

RITA M. GARDNER is the author of the award-winning memoir *The Coconut Latitudes*, published by She Writes Press. She has contributed to several nonfiction anthologies, including *The Magic of Memoir*, edited by Brooke Warner and Linda Joy Myers. She lives in the San Francisco Bay Area and is also an artist and photographer.

2011, oil on canvas, 14″ x 18″

Hope Blooms

Barbara Rubin

Artwork has been a healing force in my life. Painting beautiful scenes in nature soothes me when tragedy threatens to overwhelm my spirit. I hope this painting brings hope and light into the darkness faced by survivors of the Russian invasion of Ukraine.

BARBARA RUBIN started painting in her adult years once the fear of failure no longer held a grip on her creativity. The same can be said for her writing. As a new author, she found a new outlet for her desire to continually reinvent herself and to enjoy the adventure that goes with publishing a book. She is the author of *More Than You Can See: A Mother's Memoir*.

Oxygen

Teresa H. Janssen

Earth Day 2021, the headlines are all about oxygen. I feel claustrophobic. I escape the living room for a breath of fresh air, circle the backyard in my bedroom slippers.

On earth, India reports the world's highest count of daily new COVID-19 cases (over 314,800), and Delhi hospitals fear running out of oxygen within hours. Crowds teem outside emergency rooms while thousands with drowning lungs perish waiting for ventilators.

That April day under the sea, the fifty-three men in Indonesia's KRI Nanggala-402 submarine that has gone missing have only enough oxygen for seventy-two hours. Six Indonesian warships, a helicopter, and more than four hundred people are involved in the search for them. I try to imagine the men, God help them, who know that they are so deep, it is simply a matter of time.

I feel a tightness in my chest.

Memories flood in of times I have gasped for air. A three-year-old, choking beneath the waves of Puget Sound, pulled up by a stranger's arm; a skinny little girl hitting a barrier of fists in a rough neighborhood game of Red Rover, unable to inhale, the

wind knocked out of me; and more recently, an adult woman thrown from a raft and sucked beneath an angry Utah river. There is also the year I have pleurisy, brought on by broken ribs after a fall. The two large layers of tissue that separate my lungs from my chest wall become inflamed, then effuse. It aches to inhale. It hurts to lie down, sit up, stretch, sneeze, or laugh.

Then I am on that MD-11 over the Pacific—smoke from an electrical fire filling the cabin, flight attendants rushing up the aisles with fire extinguishers, the captain wheezing through his gas mask. I hold my children's hands as the women across the aisle don life vests in case our air is eaten up by flames and we descend to the sea below. Our plane circles back to earth for a safe landing.

I take a deep breath. And then another. I begin another round of the yard.

In outer space on that Earth Day, a thirty-seven-pound, toaster-size unit on NASA's Mars rover makes five grams of breathable oxygen from the planet's carbon dioxide atmosphere for the first time. It is only enough to support an astronaut for ten minutes.

In spring of 2021, it feels as though we are running out of breath. Barely catching a wind before the next surge.

As we approach Earth Day 2022, more than 75 percent of India has been immunized against the coronavirus. Most mask mandates have been lifted.

I listen to the bark of my son's COVID cough through the thin wall that separates our rooms. I am grateful that he is young and vaccinated.

Soon, he is able to stroll the garden with me, each breath coming easier.

I read that the oxygen-making machine for Mars can breathe like a tree, inhaling carbon dioxide and exhaling breathable air.

After years of trials, the generator is being refined so that one day it might produce sufficient quantities of oxygen to sustain life on the red planet. The name of the Mars rover that carries the oxygen machine is *Perseverance.*

Within ten seconds of when we are birthed, our lungs are ready to inflate. Our first breath sounds like a gasp as our central nervous system adjusts to the shock of its new environment. Air begins to fill the 20 to 50 million air sacs. We take a second gulp and inhale again. We cling to life with every tissue of our body. It is our first instinct and our last—what all our other bodily functions depend on.

Most people can hold their breath for thirty seconds to a minute. The longest record is over twenty-four minutes, set in 2021 by a Croatian man to raise money for the victims of an earthquake that struck his country one year before. It took him years of conditioning to accomplish the feat.

For an average person, it is possible to increase one's lung capacity though nutrition, improved posture, better air quality, and exercise—including singing. Improved lung capacity can reduce inflammation, autoimmune conditions, and damage to the brain's stem cells, among other health benefits. It can prolong life.

Perhaps we will need to hold a collective lungful to get through future breathtaking events—another COVID variant, another environmental crisis, the next war.

Spring brings news of the invasion of Ukraine. Aerial bombs kill civilians. Cities and industries are destroyed, filling the air with hazards: toxic chemicals, asbestos, and smoke from burning fuels. Citizens hide in unventilated underground cellars.

I flee to the garden, where I pace beneath the trees, breathing slowly and deliberately to soothe my grief and frustration.

Ukrainians' stories of suffering are told; altars are erected with yellow flowers and candles; refugees are welcomed. I donate to the Red Cross.

I go to the city, where there is an anti-war gathering. In the train station, a girls' choir, maskless for the first time in two years, begins to sing in unison. The children's bright faces reflect a world map —Asia, Africa, the Middle East, the Americas, and Europe. They breathe deeply, expand their lungs, and fill the enormous hall with melody as sweet as birdsong. They sing "Hallelujah," written by a Jew, now chanted by the hope of the world. Their mothers smile. One cries as she collects donations for the women and children of Ukraine.

As I ride the train, one line—that every breath be a hallelujah—stays with me.

In the city center, people gather beneath blue and yellow banners and flags that flutter in the breeze.

The world is changeable, and I know that we can change it too. "Perseverance," I recite like a prayer as I walk home from the station, counting each miraculous inhalation.

TERESA H. JANSSEN's essays have appeared or are pending in *Zyzzyva, Parabola, Tiferet, Ruminate, Emrys, Camas, Catamaran, Under the Sun,* and elsewhere. A lifelong educator, she writes about teaching, social issues, and spiritual topics.

She Gathered It All

Ellen Barker

Two dark years of fear and worry and sadness,
Fever and chills, loneliness and grief, existential angst,
Anger and frustration and despair.
All of it.

She rolled it into a bundle the shape of a bear, a bomb, a bogeyman.

She fueled it with tear gas and lies and wildfire and blood from
the streets,
And she launched it.
She sent it out past Pluto, past Pleiades, past present and future.

When it was gone, she consulted with her oracles.
And then she took one step, she climbed the hill,
A tall, steep pile of everything lost and broken and left behind,
Watered with six million tears.

At the top of the hill she wrote a song, a simple tune,
And breathed it out with the evening breeze to gently encircle
the globe.

Turning, she sat on the ground, sat through the dark night,
watching and waiting.

Just before dawn, a bird sang a single note, then two notes,
And the sky filled with a thousand notes, a hundred colors,
A symphonic exuberance of love and life and hope.
She breathed it all in.

She went back down the hill, back to her home and her life
and her work,
Back to war and virus and the arguments of an unhappy world.

Everything was exactly the same.
And everything was completely completely different.

ELLEN BARKER grew up in Kansas City and had a front-row
seat to the demographic shifts, the hope, and the turmoil of the
civil rights era of the 1960s. She has a bachelor's degree in urban
studies from Washington University in Saint Louis, where she
developed a passion for how cities work, and don't. Her first
novel, *East of Troost*, will be published in September 2022.

The Terrible, Terrible Tale of When Suspicious Met Betrayed, As Told by the Wise Owl

Gita Baack

When I heard Betrayed met Suspicious
I asked Wise Owl, whooooo had heard it all,
 What happened? I'm brave, do tell.
Wise old Owl hooted his reply slowly and sadly.
 Suspicious is now gone
 Betrayed is now gone
 All bad feelings
 Still
 Unresolved

Then he hooted, really loud, wings waving,
> *Their voices got more strident*
> *Till it sounded like a cry,*
> *Then a shriek,*
> *Then shaking sobs*
> *And Fear settled in to stay!*
> *I fell off the branch where I was hanging upside down*
> *So scared was I!*

I asked, *Was there no hugging reconciliation?*
> *No*
> *Only*
> *Heartbreak*
> *For all*
> *Even for me*

The story became two stories
With angry alternate versions:
One version a story of betrayal;
The other of suspicion.

The story grew and grew
It became a national story now
Different nations now
Different versions now
Warnings now to all!!!

Suspicion warns against Betrayal
Betrayal warns against Suspicion
Both warning against the other:
"Don't trust them, they want to kill you!"

DR. GITA ARIAN BAACK has published a poetry book, *Poems of Angst and Awe*, and a nonfiction book, *The Inheritors: Moving Forward from Generational Trauma*, that is based on extensive research on and personal experience with processing inherited trauma and inherited resilience. Gita holds a PhD from Tilburg University, The Netherlands, and an MA from Concordia University, Montreal, Québec. Gita is available for speaking engagements, workshops, and counseling: www .gitabaack.com.

Underneath the Heartbreak . . . There Is Love

Elizabeth Kinchen

The challenges of the events and circumstances of our global community keep rolling on. We are probably not the first to declare, "These times are too crazy, too hard; there is too much suffering, fear, and uncertainty!" As challenging as these times are for us, such times are not unique to us. I suspect people around the globe have said and felt this for millennia—and they were correct for their times.

But these times are our times.

What are we to make of these days: the threat to American democracy; a global virus the response to which unleashed anger at and division between each other; the continued need for social, economic, and racial equity; the climate crisis; and now a sovereign nation undergoing blatant invasion with no provocation? People of Ukraine are dying, being maimed,

separated from their loved ones, losing their homes, experiencing fear and loss that no one should have to know. And, of course, they are not the first.

What are we to make of this?

We as a human species are trying to figure out life.

I sense we are in the early stages of this endeavor. Sometimes we know how to live together, care for each other, do the right thing. Sometimes we do not.

What I see happening now in response to the invasion of Ukraine by Putin is our species responding from the best in ourselves. We see global companies withdrawing business association with Russia and her oligarchs. Individuals from European countries are going to Ukraine to fight for their neighbor, and Ukrainians are courageously defending their freedom. At home, our current deep political divisiveness is taking a unified pause over this invasion. The world recognizes this act of Putin as being deeply wrong.

This heartens me—a lot.

It tells me that underneath the juvenile self-absorption of our zeitgeist, there is honest caring. There is a reservoir of love within all of us, and right now, we are tapping into it. I hate that it takes a war, shootings of schoolchildren, the unjust killing of young Black men, or toppling US buildings to unleash this reservoir.

We are trying to figure out life.

Even Putin is trying to figure out life. He may disagree with this; he may think (like others) that he alone has it well in hand, but Putin too is struggling to figure it out. Not doing a great job— in fact, doing great harm. But because even Putin is a beloved child of God, a human inherently imbued with Buddhanature, I believe he too has a reservoir of love; his is just so thoroughly

covered over and armored that he isn't accessing it. I imagine internally, and perhaps unconsciously, he is drowning in a dark realm of desperation, hatred, and vengeance.

This is in no way apologizing for Putin and his actions; rather, it recognizes there is a *both-and* here. We, humans, are capable of terrible things, *and* we are capable of love and compassion.

We are trying to figure out life—why we're here, what is important, how to live together, how to access our individual and collective reservoirs of love.

Underneath all the heartbreak of our broken world, there is still love. We are seeing it right now. We see caring, compassion, love in action. It is still here, and it invites us to meet heartbreak and suffering with love and compassion in any way we can.

We are all trying to figure out life, and that definitely includes me.

What do you think? Do you see, feel, sense, believe in that reservoir?

ELIZABETH KINCHEN lives in the greater Boston area with her husband of thirty-two years, with whom she raised three children. With graduate degrees in computer science and counseling psychology, Elizabeth has worked in corporate and nonprofit settings. She is currently a mindfulness meditation teacher and will be publishing her memoir of young betrayal and subsequent healing with She Writes Press in 2023.

Art in a Time of Chaos

Evelyn LaTorre

After decades of global climate chaos, years of pandemic, and months of a horrendous war, the earth seems to be sending us a warning: Human Beings Are Not Invincible. Species like hippos and polar bears are becoming extinct because people kill to obtain ivory and fur, encroach on animal habitats, and poison land and water. Meanwhile, we continue to burn and flood our own habitats, so perhaps we too are on the road to extinction. Danger flares when leaders fail to listen to what experts try to tell them—that lack of global coordination promotes virus spread, a hotter planet spells more destructive weather, and might does not make right.

At the height of the Vietnam War in the mid-1960s and '70s, when I was twenty-five, anxiety roiled in the pit of my stomach. It seemed the tensions caused by the war would never end. The destruction and death now taking place in Eastern

Europe have again kickstarted that ache in my gut. Along with the rest of civilization, I groan under the weight of a pandemic, climate chaos, and Russia's violent incursion into Ukraine. It feels like the world is in greater disorder than ever before.

I sometimes ask myself, *How do we make sense of this world gone awry?*

But I know the answer: *By creating and consuming art.*

We Write.

We learn who we are through art. My art is expressed in my writing. A search inside my mind and soul to produce musings on paper comforts me in times of peace and stress alike. Keeping a journal of thoughts and feelings opens up a deeper understanding and appreciation of the world and who I am in it. Keeping a pandemic journal and writing my memoirs relieved the strain and anxiety of quarantining in isolation.

Albert Einstein, Marie Curie, Frida Kahlo, Leonardo da Vinci, Frederick Douglass—they all kept journals. Research has shown that writing about oneself helps boost the immune system. Writer Joan Didion's said, "I write entirely to find out what I'm thinking, what I'm looking at, what I see and what it means. What I want and what I fear."

For me, I gain a greater sense of life's meaning—my own and others'—when I write out my thoughts and feelings. I comprehend better what has occurred and what it means. I wrote about becoming pregnant before marriage, a major "no-no" in the 1960s, in my first memoir, *Between Inca Walls.* The act of writing and sharing that trauma lifted a long-held guilt from my shoulders. Compassion for my twenty-three-year-old self flowed through me as I typed about my shame. Writing about

my brother's suicide in my second memoir, *Love in Any Language*, helped me feel compassion for his pain and recognize how important medication and therapy are for treating deep depression.

Exploring our lives and our world by using whatever skills and artistic talents we possess for creative expression has the potential to enlighten and heal others. Terrifying and lonely feelings can be shaped into poetry, literature, photography, paintings, and music, and thus transformed.

We Write and Read.

What others have written, painted, or sung helps me shape my thoughts about what is happening around me. Reporters in government offices, university laboratories, and weather stations tell me what they see on the battlefront, in medical institutions, and from climate stations. The words of journalists, world leaders, and scientists often produce more anxiety. In these cases, I write letters of complaint to our congresspeople and op-ed pieces to our newspaper editors to make my voice heard. I also learn about the history of a situation to better comprehend the present. Through exposure to multiple points of view, I decide how I will react.

The art I encountered on a 2019 trip to the Balkans— Poland, Latvia, Lithuania, Estonia, and Russia—has helped me understand more fully what is happening in Ukraine now. In Krakow, Poland, near the Schindler factory museum, was an open plaza with scores of sculpted metal chairs—chairs vacated when the ghetto's Jewish residents were forced to leave for concentration camps. My memory of that art piece helped me recognize the tactic being used by Russia today.

An outdoor museum in Lithuania displayed a railroad boxcar with an explanation on the door that said, in part: "In 1940 the Soviets deported the country's intellectuals. . . . People were put on cattle carriages and taken to places of exile and imprisonment. . . . About 400,000 people were exiled." With a real vehicle of torture displayed as art, the message hit home.

In St. Petersburg, a frank Russian economics professor intrigued me with his explanatory art. Young intellectuals leave Russia, he said, because the country won't change. The nostalgic conservative population that remains wants Russia to be heralded for its past art and literature and its present assertiveness in space, sports, and the military. The internet and social media have connected younger Russians to a different way of thinking that once gave hope for change—until the country's recent disconnection from the rest of humanity.

We Write, Read, and Connect.

The world's economies and people have become increasingly interconnected and interdependent through trade, travel, and social media. As a result, we know and care about other nations' pandemic death counts and climate disasters and the infractions of one country against another.

By the same avenues, we are inspired by the creativity, dedication, generosity, and bravery that has sprung up:

- scientists working to develop and test new vaccines against COVID-19
- health care workers caring for the dying and devising creative ways for them to say goodbye
- those who donated food, housing, and support to the displaced

- men and women fighting on the front lines to keep their country
- songwriters, poets, and reporters who lift spirits through their eloquence

We Write, Read, Connect, and Adapt.

New realities have come from a world turned upside down. Two years ago, we were sheltering in place. Streets and public transportation were deserted. Museums and theaters were closed, storefronts were boarded up, and the unemployment rate was 13 percent. Today, the number of public transportation riders is rising, actors and musicians are back in their proper venues, the labor market has recovered, new stores are appearing, and unemployment is in the low single digits. In the interim, we've also discovered new ways of eating, meeting, and working remotely.

Humans are adaptable. The turbulent times, like those we experience now, are the ripest for change. Transitional moments between the peace of the known and the dread of the unknown are pivotal times filled with new possibilities. We've been given a gift of time—a chance to stop and reevaluate our limiting beliefs, biases, and behaviors. We can practice self-care by taking things one day at a time, slowing down to nurture ourselves, communing with nature, and controlling what we can.

Because of our recent isolation, many of us who've used this time to reflect now view relationships, work, our art, and living from a different perspective. We have discovered greater satisfaction in nonmaterial possessions. I've rediscovered how to use my writing abilities for my own enjoyment, as well as

the enjoyment of others. In writing and creating, so in life: transitions signal the way we'll go forward. We can transfer the interrupters into artistic grist through creating new music, stories, paintings, photos, and sculptures that open up our lives and the lives of others.

DR. EVELYN LATORRE, a member of the California Writers Club, has published two memoirs with She Writes Press, *Between Inca Walls* and *Love in Any Language*. Articles she has written have appeared in *World View, Sanctuary, Storybook Reviews, Conscious Connection, Delta Kappa Gamma Bulletin*, and many others. Find other articles and interviews on her website, www .evelynlatorre.com.

Art Is the Antidote

Melissa Giberson

There are two roads in and two ways out of the residential development in which I've lived for a quarter century. No matter which way I go, I pass the political cheerleading of those who advertise their candidate preference long after the election cycle has ended. It reinforces the disintegration of the political cycle, replaced by a paradigm shift in how people behave, what's considered appropriate, and a loss of decorum. I am reminded of the organized effort to disempower, denigrate, and eliminate people like me. I have become prey to people whose values don't align with mine and who are making an organized effort to render me powerless and invisible. Those responsible, and the people enabling them, are threatened by my gender, my values, my sexuality, and, in some cases, my inherited faith.

The three separate categories with which I identify have seen a resurgence of animosity, resulting in widespread fear and harm.

I am a woman. I am a Jew. I am gay. Throughout history, it's been hard to carry any one of those labels; these days, it's nerve-racking to be all three. I am desperately seeking a new Renaissance.

The noxious response I experience each time I pass these houses, mere walking distance from my own, is a stark contrast to the fond memories I have of walking my young children to school or around the neighborhood trick-or-treating on Halloween. Dwelling within these flag-draped abodes is someone who feels as strongly about how undeserving I am of my basic rights as I feel strongly about preserving them. My neighbor's staunch convictions justifying public displays of ridicule for the elected representative they oppose or support for the party that represents their values. Their clear disdain for those who are different from them spurs a razor-sharp churning in my core. It prevents me from taking after-dinner walks alone or with my partner.

Pushback from people who feel entitled to express their disapproval about my life choices and identity isn't limited to my little geographic corner of New Jersey. On a recent walk on the grounds of a university, still masked from my work as a healthcare provider, I was shocked when a woman rolled down her window to shout her revulsion at the sight of my mask. There was no demonstration of curiosity regarding my choice, and the only impact my wearing a mask had on her was self-imposed, and yet she felt strongly enough about it to reprimand a perfect stranger.

Is this what we've become? Where has grace gone? I desperately want to resuscitate kindness.

The toxicity wafting in the air throughout the country and in my little neighborhood, the one in which I no longer feel safe, is so prevalent that I can only look away as I approach these flag-waving houses. To reset my nervous system, I escape to America's oldest continuous art colony—and the birthplace of American theater—in the northeastern corner of Massachusetts.

Here, everyone is welcome and art abounds. The only flags waving are rainbow. In this picturesque cocoon, I don't worry about juvenile-type attacks on my house or comments from passersby; I don't have to wonder about the piles of dog poop on my lawn (I don't have a dog) or whether the LGBTQ flag on the church a half mile away has been destroyed again. On this small spit of Cape Cod, I find peace and beauty and duck behind the proverbial curtain to ward off the poison that has infiltrated our lives, pitting human against human if they dare have an opposing opinion. Where tolerance once seemed a last resort on the way to a preferred acceptance, it's now an unrealistic expectation. I desperately long for a rebirth of compassion. I'd settle for a resurgence of compromise.

Shrouding myself from the onslaught of misinformation, shocking revelations, and heartbreaking realities consuming the airspace, I have turned off the news I was once glued to and in its place have immersed myself in art. I am restored, if not reinvented, by spending time in nature, with its mosaic of colors, textures, and design. I take pictures and bask in the uniqueness of surroundings that have inspired so many for so long. I'm humbled by their majesty and inspired to create my own art, the antidote to these modern, suffocating circumstances. Reveling in the inherent beauty and softness, I soak in the colors of the town, the precise lines of the sculptures, the century-old architecture, the street performers, and the paintings and photographs depicting street scenes, portraits, and landscapes. Art's healing power is felt in her gentle embrace.

To counteract the simultaneous culture, political, and real wars taking place around me, I lose myself in books, deep-diving into the words and ideas of iconic writers as well as folks like me—people who write for catharsis, to release the pain and

joy taking up real estate in our hearts and minds. I take pen to paper and write my own stories, expressing my fears and wants, hoping to have some small impact on another human being navigating through these harsh days and toward a place where we will once again thrive instead of merely surviving.

It's the artwork adorning gallery walls, as well as my own, that calls to me when I'm in need of solace. The colors, textures, unique lines, and thick layers of the artists' chosen media draw me in; I am easily lost in someone's rendition of a forest, or swept into a seascape canvas, Alice in Wonderland–like—feeling the grainy sand on my skin, mesmerized by the rhythm of the water that comes alive from its static stance. Natural beauty and produced art—words, music, photographs, and paintings—grant us refuge from the current onslaught of hate, war, poverty, illness, and unnecessary death. Art is the rescuer; as we release laughter and tears produced by the pages of a well-written book, as we feel the rise and fall of emotion from deep within as the orchestra reaches its climax, as the dancer tells their story with fluid motion, and as the song begging to be replayed becomes the day's soundtrack in your mind, we are liberated from the chains of despair.

Dating back to prehistoric times, people have long expressed themselves through art. Optimistic me hopes the fraying edges of the present-day world will one day soften and reconnect. In the meantime, it's art in its varied forms that will pull us in like children after playing in the snow, wrapping a blanket around our shivering shoulders and pressing a cup of hot chocolate into our hands to soothe our cold and weary bodies. Art swoops in, surrounds us, and saves us time and again. And in this moment in time, we desperately need saving.

Change is inevitable, but art remains the solid foundation upon which we stand. It grounds us, seduces us, connects us,

reinvigorates us, and returns us to the world a little more resilient than before. Art is the balm for the wound formed from self-imposed censorship, guarding against those who see me as "less than" because of my gender, sexual orientation, or values. Art eases my grief from unseen but deeply felt losses: of hope, of camaraderie, of feeling safe. I grieve for those of us who feel invisible, who question if we matter in the world. Where am I when they talk about a country forged in Christian-only values? Where am I when bills are passed barring the very word that identifies my orientation? Where am I when they criminalize access to health care and restrict safe choices about my body? To where am I to turn after they've banned the books—and what will they go after next?

The principles of art embody balance, rhythm, contrast, and unity, paving the way for diversity and perspective. Yet in this climate of fear, art itself has become a target of hate and distrust. When did we lose these vital pieces of our own humanity?

Let's invite art fully into our lives and treat her like a lover: adore her, appreciate her, seek her, engage in her, and share her gifts. Let's all be a source of inspiration for others. Because now more than ever, we desperately need art—and she desperately needs us.

MELISSA GIBERSON is an emerging writer with published articles in *Kveller, Highly Sensitive Refuge*, and *Dorothy Parker's Ashes*. She is the author of a forthcoming memoir depicting a late-in-life sexual awakening and her subsequent journeys through grief, loss, love, and self-acceptance. She's the proud mom of two children and shares her love of art with her partner and their two cats.

Poetry in the Time of Paradox

Nancy G. Shapiro

"Each thing with its own way of moving,
of coming together, of coming apart."
—EMILY SEKINE, "BAYOU SUTRA"

When we left Mexico and began the search for a new home in the spring of 2018, the word "untethered" best described my sense of the upcoming journey. It was an adventure of incredible beauty and dark doubts—a paradoxical time I now know is expected when leaving what is known—to venture out into who-knows-what. Writing haiku was my anchor to earth, helpful when driving across the Bay Bridge during rush hour with a forty-foot truck and camper rig.

After a year of planning and construction in the time of masks and fear, we moved into our new house last May. Tucked up against mountain views, our intentionally small home in the Sonoran Desert provided and still provides a much-needed

sustenance and quiet in unsettled times. Isolation is easier at the edge of the desert.

Jesús and his uncle Hugo were pivotal in shaping and beautifying the area around our home. Days before the New Year, we spent the morning placing stones into the recently planted and graveled garden. They lugged the heavy rocks to and from a wheelbarrow and I pointed to a spot, their patience welcome as I took what time was needed until the stone and the earth settled into a whispered "yes."

Three hours had passed by the time they drove away. Hours that became part of a day that flowed with the collaborative energy of the morning. I was surprised by the happiness I felt.

Happy is the opposite of untethered, dark doubts, the unknown. Over family conversations during Thanksgiving week, I came to realize I've lived under the shadow of dysthymia for decades. Happy doesn't live there. It's also known as persistent depressive disorder. Twenty-five years ago, a therapist mentioned dysthymia to describe how I was feeling, saying it was like living with a chronic, low-grade fever or feeling like a part of you has died. Back then I didn't have the energy to even look it up. When I did read about it in November, five decades fell into place.

I've been mourning the possibilities I couldn't realize over the years and celebrating the ones I did. A huge relief continues to sink in—I am finally understanding the old shadows while staying attentive to a heightened sensitivity of all things that speak of grief and loss. Tears of sorrow and powerlessness fight to see through and beyond the weighty melancholy of today's world.

Somehow the innate truth found within Emily Sekine's words found me years ago and led me step by step to my family,

friends, nature, coaching, and poetry—all making up the connective and spiritual perspective I told my sister is "the boat that keeps me afloat" above the river of dysthymia.

It has always been poetry guiding that boat. Poems are expansive—ready, able, and willing to hold as much truth as we can find within ourselves, to open doors where once stood walls. This winter and spring I took ten weeks of poetry making from Rosemerry Wahtola Trommer, former poet laureate of southwestern Colorado. In those hours of listening to others' stories of loss and trauma, disbelief and rage, I birthed a compassion I did not know I could carry. It grows each day, a small yet powerful mending with each word, with each story. Still, some days dawn empty of promise. Ravens circle overhead.

Things are coming apart. They are also moving in their own mysterious way and coming together. The three are inextricably entwined. I'm guessing you, in your own way, have mourned and retreated, then stepped once again toward something stronger than the dark shadows during the last twenty-four months. It is too much to hold an ever-mutating virus, our planet dying in front of our eyes, and a genocidal war aired each night on TV, all the while attempting to live life with its everyday challenges. It is too much to grieve, too large to fathom, impossible to ignore.

Despite everything, I've found solace can be gathered on the page. Writing the day into being, it's okay to be calmly chaotic. Sharing with others shines light on the truth. Friends for life have been found because I love how they give space to the gritty. Smiles or devastation, our words will keep us afloat.

"On the Road to Calm" sprawls across the back of the Shapiro camper. Little did **NANCY G. SHAPIRO** know anxiety would haunt her as soon as she and her husband hit the road four years ago. The universe laughed, and she learned how deeply trauma and grief reside in the body. Now she coaches a few intrepid clients and writes while enjoying the quietude of their home in the Sonoran Desert.

Requiem for My Uncle

Sarah Relyea

In early April 2020, as the pandemic was raging through New York City, transforming my home into another Ground Zero, I awoke to an ominous email: my uncle would be having back surgery. Although he was in the Hudson Valley, a place less overwhelmed by fear and death, the local hospital was on lockdown. My uncle Eric, a lovely man of eighty-five, would face the ordeal alone. The five-hour surgery would begin that morning at ten.

I thought of calling him to offer comfort, but alas, it was already too late.

Eric and his wife, Nancy, were both artists—he a photographer, she a poet and creator of creatures made from found materials. Nancy had passed away in 2017. Her memorial was overflowing with family, friends, colleagues, and former students. There were readings of her poems. During my recent visits with Eric, he'd spoken with undiminished feeling of their ten-year

courtship. No wonder—despite the lengthy prologue, their marriage had been as loving and companionable as any I've ever seen.

Back surgery at eighty-five is enormously risky. With ambulance sirens wailing through my Brooklyn neighborhood and death hanging—so it seemed—in the pollen-laden trees, the news was hard to grasp. What rhyme or reason was there for such surgery *right now*? I'd spoken with Eric just a week before, and he'd sounded good—inexplicably cheery, I thought at the time, for an elderly man enduring a quarantine alone, with his only son a thousand miles away. He was adapting, though—he'd given up his morning outings for fresh coffee and the newspaper. I'd promised to call again soon, but in the urban crush of the pandemic, I'd delayed for a few days. I'd thought he would be safe up there in the Hudson Valley.

Soon after our phone call, the pain my uncle had long suffered suddenly became acute, and a new round of doctors and diagnoses had begun. Alone and suffering, he'd finally agreed to the surgery recommended several years before. Yet the circumstances had changed. He was older, and the hospital was on COVID-19 lockdown. Nevertheless, the doctor had reached a sobering conclusion—in the absence of surgery, Eric would lose the ability to walk.

Although death came to my uncle during the pandemic, his death was not sent by the pandemic. He succumbed to something less newsworthy, though similarly fraught with danger. Aware of the jeopardy he faced from many sides, he chose to leap—stepping westward, it's been called. As they were administering the anesthetic, he spoke a final hope of life, of death: "If anything happens, let me go. I want to see my wife."

In these pandemic days, there can be no memorial for my uncle. Even his son cannot go to the family home. Yet my

uncle Eric is not simply gone. The house—full to breaking with books, photographs, and fantastic objects, many of which he and Nancy created throughout their richly inventive lives—is not empty.

While the pandemic rages, we honor the dead any way we can.

A pandemic season feels dark and cold. And yet, on the day of my uncle's death, the earth bloomed in benign indifference as the blows fell on us humans. On the day of my uncle's death, I fled the rough slap of solitude for the healing touch of our green spaces. There, in the park among a masked and fearful crowd, I sought the sun on my face. I welcomed the sun even as my uncle struggled with the angel of affliction, seeking his wife.

When I reached home, and through the long evening, there was no news about Eric, only a sense of foreboding. But as with the waxing and waning of ambulance sirens, no announcement was necessary. Death is its own announcement. We read its signs where they fall.

SARAH RELYEA is the author of *Playground Zero*, a novel set in the late 1960s. Sarah grew up in Berkeley during the counterculture movement of the '60s. She would soon swap California's psychedelic scene to study English literature at Harvard. A PhD who has taught at universities in New York and Taiwan, she has long addressed questions of identity in her writing, including in her book of literary criticism, *Outsider Citizens: The Remaking of Postwar Identity in Wright, Beauvoir, and Baldwin*. Sarah lives in Brooklyn, New York, and continues to spend time in Northern California.

Snow Falling on Ukraine

Marian O'Shea Wernicke

It's late. I turn on the news.
A fair-haired man with blue eyes
and an Australian accent
speaks into his mic, his breath rising
in the frigid morning air. In the background
sun glints on gilded domes, towers, and churches.
Smoke rises as dawn breaks in Lviv.
The city sleeps, calm, serene.

The scene shifts now to black night
lit up by bombs, fire, flashes of orange and gold.
Tanks rumble through streets. I close my eyes.
When I open them, I see the family,
two children in pink and brown puffy coats
lying sprawled on the grass. Their mother lies
on her back nearby, her coat thrown open,

her foot twisted beneath her at an impossible angle.
A man is running toward them, his mouth
twisted in a silent scream.

I turn away from the screen, close my eyes.
Snow, like our prayers, falls now on Ukraine,
gently, silently, it falls,
on all the living and the dead.

MARIAN O'SHEA WERNICKE is the author of *Toward That Which Is Beautiful*, a novel published by She Writes Press in 2020. It was a finalist for both Literary Fiction and Romance Fiction in the 2021 International Book Awards and a finalist in Multicultural Fiction in the 2021 American Fiction Awards. Marian's second novel, *Out of Ireland*, will be published in April 2023 by She Writes Press.

Art Will Save Us All

Christina Vo

During the pandemic, I moved from San Francisco to Santa Fe—
a city with a deep history of creativity and creative exploration.
I rented a casita—which, I later learned, was built by Fremont
Ellis, the youngest member of Los Cinco Pintores, the 1920s
society of Santa Fe artists. After moving to Santa Fe from around
the country, the five artists created a collective with the goal
of taking art to the people by exhibiting in schools, hospitals,
factories, and even the New Mexico State Penitentiary. Their
art was inspired by the New Mexican people, their lives, and
the beauty of the natural environment.

I knew immediately when I arrived in Santa Fe that it was
a place that revered creativity, and that creativity and art were
therefore part of the ethos of the town.

Not only was I surrounded by creative spirit in my casita;
I was also surrounded by it at work. I'd gotten a job at a
well-known contemporary art gallery right on Canyon Road—
the home of more than eighty galleries, art studios, and small
design shops. I had no prior experience in the art world, but it
felt natural to me to be surrounded by beauty and to speak of

this beauty daily. As I weathered the pandemic alone in a new city, I found a burning truth in my heart that I'd never before known existed: writing saved me, and art can save all of us.

Since my late twenties, I have known that I wanted to be a writer. But it took years, turning forty, and a global pandemic to help me claim this. From the ages of thirty to thirty-five, I wrote almost daily and worked as a writer at a university. Even though I was regimented in my writing, I didn't have the courage to truly commit to my craft; I hadn't published anything beyond blog posts, and for whatever reason, I didn't have the confidence in my writing to move forward. With a nearly completed manuscript in hand, I stopped writing because a man in the industry told me that I'd be working on this manuscript for a long time, and that felt daunting to me. That one-sentence statement gave me permission to stop writing—and I listened. I still pursued art, though—shifting from writing to floral arranging, which nurtured my creativity but in a different way.

It took me until 2020, just after I turned forty, to return to writing. Why it took me so long, I wasn't sure, but I had faith that this was divine timing. There was no better time than now—a time when the world had turned inward, our mouths covered by masks and socially distanced from one another. Only now was I able to go deep into my center.

When I was younger, my father told me that I could do anything I wanted if I just learned to sit still; he recognized my desire to do many things at once and that actually sitting, without distractions, would be the key to my getting where I wanted to go. During the pandemic, I sat. For long periods of time. Alone. I committed myself to my writing; I took a memoir-writing class, submitted a chapter every two weeks, and slowly completed a manuscript that will be published next

spring. I loved writing consistently, and the practice changed me: it grounded my soul, connected me to my inner wisdom, and helped heal a lot of my childhood wounds.

Even though writing is a solitary endeavor, there are still many ways to connect while going through a creative process. That part of art—the community—also saves us. Publishing and awards and accolades are the icing on the cake, but the real heart of what matters about writing and the creation of any art, in my opinion, is what we gain from the process, which can indeed be a lot of healing.

Beyond an individual level, art heals us collectively. Every day at work, I was able to witness the way art impacted people in real time. Whether their intention was to purchase something or not, I saw the way people stared at paintings they loved. The way a single piece could have so many different meanings to different people. I was able to interact with mid-late-career artists, unquestionably my favorite part of the job. I learned about their creative lives and histories, and I recognized—quickly—that no matter how successful an artist looked on the outside, building a significant body of meaningful work requires time, dedication, and commitment. I recognized that art, like anything beautiful in life, requires our whole heart and, like a nurturing relationship, gives us in equal measure what we give to it. The more we commit to our art, the more it will return to us on a soul level.

As I listened to the stories of the artists represented in the gallery, I started to think (regrettably), *If I had only committed myself when I was younger, where would my writing career be now?* I quickly banished those thoughts from my mind, however, and shifted the narrative to: *I'm only in my early forties and I have decades left to create and now, decades of*

life experiences to inform my writing. But I knew the pandemic was offering me time; it was the only thing that was on our side.

For months, we were encouraged to sit indoors and to socialize less. For all of us, this sudden imposition of extra time begged the question, *How will you use those extra hours in your day when you're no longer commuting or attending events you don't really want to go to?*

Writing saved me during the pandemic—and it has in the past, too, even if my work was never published. The process of writing is where I found my truth. Completing my first memoir during a period of life when the world slowed down allowed me a deeper sort of reflection. I would write for a few hours, go for a walk, and then go to work. It was a routine that I will carry with me for the rest of my life. But also, during this time of writing, I worked through my story. Granted, I don't believe anything can ever be completely healed or resolved, but somewhere during that process I found peace, and a deeper sense of myself. Nothing in my life—not jobs, not romantic relationships, not friendships—has ever given me that sense of satisfaction. Only writing—which, over time, became my spiritual practice as well—has shown itself to have that power. It's my way to connect to my most profound truth.

Beyond that, as I alluded to earlier, it is not just that writing and art can save one soul, it's that it can save others as well. It helps others find healing, too, whether because they see themselves or a part of their lives in a piece of artwork or because witnessing an artist finding their own truth and healing allows them to find *their* truth and healing as well.

Art also gives us an opportunity to connect and create with others—to form relationships around our commitment to our work, to pushing it out there in the world and sustaining our

practices. During the pandemic, I have developed so many rela-
tionships—simply through the connection around writing. I
discovered that my neighbor is an aspiring novelist, so we now
share information and update one another on our weekly prog-
ress as we chat over coffee. I connected with former colleagues
who were also aspiring writers, as well as former gallery staff
who were also artists or writers. More than work, we share a
connection about our own creative practices.

Truth, meaning, and community are foundational aspects
of a good life.

There's chaos in the world—this is one truth. But has there
ever been a moment in history when there hasn't been chaos?
We are just witnessing more than we have ever experienced in
our lifetime. That chaos and destruction is part of our collec-
tive consciousness, but so is art, hope, compassion, and love.
While I personally believe that we are shifting the narrative,
albeit slowly, we have to carve through all the gunk and grime
so more and more of us can see the truth. We all find truth in
different ways, but for me, art is essential to our individual and
collective healing.

You see, the real truth that I have found is that by practic-
ing and pursuing our art, we actually get better at living life. A
life that's lived drenched with beauty, meaning, and seeking our
true selves. I'm confident that if we all pursued our art, even
just as a weekly practice for a few hours, we'd live in a better
world. Because art, in many ways, is the heartbeat of life itself.

CHRISTINA VO is a writer who previously worked for international organizations in Vietnam and Switzerland and also ran a floral design business in San Francisco. She currently resides in Santa Fe, New Mexico. Her forthcoming memoir, *The Veil Between Two Worlds*, is her first book.

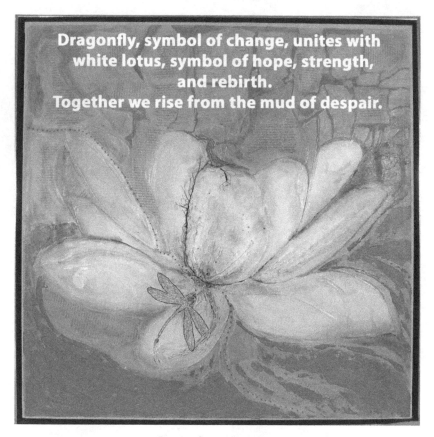

Dragonfly and Lotus

Dragonfly and Lotus

Karen Lynne Klink

KAREN LYNNE KLINK was born and raised in Akron, Ohio, received a Bachelor of Science in Education from Kent State University, and studied art at San Diego State University. She edited legal documents and government reports in Colorado and California and wrote artist biographies and articles for an art gallery website in Durango, Colorado, before moving to Tucson, Arizona, where she now resides. A child-abuse survivor, artist, and writer, Karen hopes her stories give readers the confidence that their lives can become as fulfilling as hers did.

The Act of Giving and Receiving Compassion

Suzanne Marriott

Often when we think of compassion, we think of compassion for others. Yet how much more compassion we will have to give if we remember to have compassion for ourselves? In this time of need—the need to help others facing loss through COVID-19, the loss of life and home through both war in Ukraine and global warming—we need to remember to care for ourselves in order to care for others.

I know that as the caregiver for my husband, Michael, who suffered from multiple sclerosis, I often felt guilty when I took some time to focus on my own needs. Gradually, however, I found that when I did, I had more to give to him. Some of what I did for myself was just small stuff. For example, during Michael's frequent stays in the hospital, when I could take a break from being at his bedside, I would go to the cafeteria and relax with a latte. My decaf latte became my reward for paying attention to his needs. I might have only ten or fifteen minutes,

but those few minutes of offering compassion to myself were enough to recharge my batteries.

Occasionally, when Michael was able to be home alone, I would spend time with a friend, going to a movie or taking a walk. Sure, Michael felt some resentment, but he came to realize that these times were important to me and beneficial to him too. Gradually, I learned not to feel guilty for these taking-care-of-myself times.

When I made the transition from being Michael's wife to being his caregiver too, it meant that I had to bring compassion to our new situation. If I could feel and maintain compassion for Michael, in his suffering, *and* for myself, I knew I would succeed. The physical and logistical tasks of caregiving are vital, but to perform these well I had to have compassion. Without it, in all the day-to-day tasks, I would be doing for my husband, but not caring for him.

So just what is compassion? According to Merriam-Webster, compassion is a "sympathetic consciousness of others' distress together with a desire to alleviate it."

Well, that's what it is—but how do we develop it? Maintain it? How do we feel it in our hearts?

In my case, I found it through my Tibetan Buddhist practices. Before Michael was ill, he and I were part of a sangha, or community, in which we learned and practiced meditation. One time as I was meditating on a very large thangka (a pictorial representation of Padmasambhava, who brought Buddhism to Tibet from India in the eighth century), I saw a diffused white light emanating from his body into mine. At the same time, I felt a wonderful warmth in my heart, as if I were receiving love directly from him. The thought *That's compassion* immediately entered my mind. It was a very real, visceral experience.

It didn't turn me into a compassionate person overnight and for always. But it did give me an experience that inspired me to act from compassion, as well as a deep, inward sense of how compassion feels.

There are many and varied spiritual practices that teach compassion, and I believe we all have the capacity to feel compassion and to act from that space. There's one practice in particular that helped me become a more compassionate person: a Tibetan practice called tonglen.

One does tonglen alone and in silence; it has to do with intention and the breath. It's sometimes best to start by feeling compassion for ourselves, though that can be the hardest task. With each in-breath we take in our own pain, whether physical, mental, or emotional; with each out-breath we send relief and healing to ourselves. It's helpful to pause, for just one mindful moment, after each exhalation. We can repeat this practice until we feel a shift, however slight, or until it feels right to stop.

The next step is to do this practice for others, taking in their pain and sending them relief. In essence, our body becomes the vehicle for transformation. I find this to be a meditative practice, one that brings me serenity and a sense of compassionate connection. As Buddhist nun Pema Chodron puts it, "In tonglen practice, we visualize taking in the pain of others with every in-breath and sending out whatever will benefit them on the out-breath. In the process we become liberated from age-old patterns of selfishness. We begin to feel love for both ourselves and others; we begin to take care of ourselves and others."

In these times of so much discord and turmoil, let us reach out to others with love and compassion, but let's not forget to care for ourselves, too. As Pema Chodron tells us, "We work on ourselves in order to help others, but also we help others

in order to work on ourselves." I have found that the practice of tonglen is a way to have compassion for myself *and* to have compassion for others who may be in need. And goodness knows there's a lot of need in this world today.

SUZANNE MARRIOTT's memoir, *Watching for Dragonflies: A Caregiver's Transformative Journey*, will be published in June 2023. Suzanne is also the author of *New Life Through Travel: Finding Wholeness After Loss*. For more information on compassionate caregiving, visit her on Facebook and at www.suzannemarriottauthor.com.

The Artistry Within Us

Jessica Winters Mireles

Until I almost lost my young daughter to leukemia, I never considered myself an artist. Before I experienced the life-changing event of having a seriously ill child, it never once occurred to me that I was a creative person, even though I'm a classically trained pianist and music teacher who has performed and taught extensively throughout my adult life. Making music every single day certainly meets the criteria for being an "artist," but being a purveyor of the arts was never listed on my résumé. In my mind, I was merely a hardworking wife and mother of four children, a piano teacher, and a gardener with a green thumb. I was too busy to be creative. Or so I thought.

What I didn't realize then was that I'd really been an artist all along—someone who pretty much created art in every moment of every day. I was an artist while on my knees in the garden coaxing delphinium, larkspur, and sweet pea to burst into a spectrum of vibrant pinks, blues, and purples so that

passersby could view the free impressionist exhibit in my front yard whenever they wanted. I was an artist when I folded tiny baby blankets, warm and fragrant from the dryer, into perfect little bundles and stacked them neatly in a drawer. I was an artist when I demonstrated to my piano students how to lift their wrists to shape a musical phrase while projecting a singing melody, how to gradually increase their sound to a *forte* and then taper it to a delicate *pianissimo*. I was an artist when I lovingly made my children peanut butter and jelly sandwiches (something they were certainly capable of doing themselves) because they claimed mine always tasted better. I was an artist when I held my daughter's head and murmured soothing words into her ear as she vomited into the toilet bowl—a side effect of chemotherapy.

After almost three excruciating years of cancer treatment, my daughter was considered cured, and I discovered I was no longer the person I'd been before her diagnosis. I'd fallen to the bottom of that dark and frightening pit, and clawing myself back to the top had been arduous, but also exhilarating. I could now see clearly, perhaps for the first time, and I realized that there was no time left for procrastination. I erased "someday" and "if only" from my vocabulary. What I had was the present, and it was time for me to fulfill my lifelong dream of becoming a writer.

And so I wrote. For ten long years, I wrote—I wrote blog posts and articles, and somehow I even managed to complete a novel. After more than 150 rejection emails from agents and publishers, someone finally said yes. A book signing and launch party were circled in bright red on the calendar. After all I'd been through, I was just about to celebrate my big moment in the spring of 2020.

Then came the pandemic.

There's no need to explain what happened. All of us have lived it in some form or another. Normal life was canceled. We locked ourselves in our homes and despaired. My excitement turned to gut-wrenching disappointment, and that familiar dread returned and began to settle in like an unwelcome guest.

Luckily, I wasn't the same woman I'd been when I fell into that abyss the first time around. I had learned from my experiences that in times of crisis, a shift in thinking could instantly change my perspective, and that forming a deep connection with others was what gave me hope and stability.

I had already learned that looking for the beauty around me was the key.

This time, I deftly skirted the edges of the pit with the skills I'd honed over the years. As I fought off the despair, I searched out ways to find beauty in the supposed insignificant things. To my surprise, they were like ripe fruit ready for picking. I found it at my dining room table where our family gathered for daily meals and great conversations. I found it on a computer screen where I continued to teach my piano students through remote lessons. I found it while cutting spring blossoms from the garden and arranging them into bouquets to leave on the doorsteps of our neighbors' homes. I found it sitting in front of a sewing machine and stitching together cotton masks with my daughters. I found it conversing with strangers while standing six feet apart in the line at Trader Joe's, or anonymously paying for the car behind me in the Starbucks drive-through. Beautiful works of art were everywhere; it was just up to me to notice them. And noticing them helped me cope with all the distressing changes that had pervaded my daily existence.

Our post-pandemic life seems to be heading in the direction of semi-normalcy for the moment, but we can't escape the

misery taking place in other parts of the world. The images that flash across our television screens every day show us the devastation occurring in Ukraine. Sometimes it hurts so much, I must look away. Some of the images are inspiring and hopeful—like the Russian cosmonauts arriving at the International Space Station wearing yellow and blue, the colors of the Ukrainian flag. Or the eighty-year-old man showing up to enlist in the Ukrainian army to fight for his grandchildren. Most distressing are the images of pregnant women being carried out of a maternity hospital, bloody and injured, and the hundreds of empty baby carriages lined up in the city of Lviv to commemorate the children killed since the Russian invasion began.

As much as we want to, we must not look away from these images; even in their awfulness, they are significant, because they make us feel something. It is not a good feeling, but we must be made fully aware of our inhumanity toward others. Only then can we make the necessary changes in our own hearts.

As humans, we are all artists in some form or another. While we may not all hold a paintbrush to a canvas, stand *en pointe* on toe shoes, or sing arias effortlessly, all of us engage in acts of simple artistry in our everyday lives through selfless acts of love and generosity. This form of artistry has the ability to connect us with one another, to shape us, to teach us to be human. And when we are human, our capacity to love grows exponentially.

We may still struggle with despair, but the beauty of the art around us and inside us buoys us with hope—a hope that we cling to with all our might as we begin our ascent out of the chasm of darkness and into the infinite possibilities of the light.

JESSICA WINTERS MIRELES is a classically trained pianist who began her second career as a writer after her young daughter's cancer diagnosis. She is the author of the novel *Lost in Oaxaca*, the story of a piano teacher who travels to Oaxaca, Mexico, in search of her missing student.

Be Beauty

Marianne Lile

"Be Beauty."

This is what I silently say now when I get up out of bed. And I say it with a capital "B."

Not "be strong." Not "be brave." Not "you've got this."

"Be Beauty."

Be Beauty as a verb.

I arrived at this outlook recently when I decided to participate in an online salon.

It was posing the question, "What if beauty was the purpose of life?"

The description was—to quote the facilitator, Tatyana Mishel Sussex—"(A salon . . .) Think of it as a collective inquiry. We're like beauty scientists in a lab, exploring, sharing our findings and reflections. Poking and prodding, delighting ourselves, learning, having fresh experiences."

A salon? I thought. *The purpose of life?*

The idea tugged at me. A thoughtful discussion with strangers. When was the last time? There are so many descriptions of

these past years whose ingredients include a pandemic, political shenanigans, anger, and imbalance. But a salon combined with interesting questions? Yep, that sounded intriguing.

So, there I was, Tuesday mornings on the West Coast, talking with women on the East Coast about beauty. Which led to discussions about fragility. Collaboration. Tension. Strength. Human connection.

When the salon ended, these thoughts stuck. Beauty is about being awake and alert.

Be Beauty as a verb.

Toss it out there in the air. Be Beauty. Better, perhaps, than hope. Certainly better than anything else I've come up with the last few years.

The first months of COVID were so quiet. The usual noise—cars, shouts, the "busyness" of life—replaced by small bird song and kids excitedly pointing at stuffed animals in the neighborhood windows during evening scavenger hunts. I crossed streets without looking both ways. I marveled at clouds in a bluer sky.

Our vocabulary changed to include the words ventilators, personal protective gear, and hand sanitizer. My extended family negotiated the meaning of social distance and masks. We settled in to wait it out. We hoped.

Then COVID dragged on, and the sounds of that new silence were deafened by shrill anger. Stomps of feet. Wide-open mouths spewing toxins and wild fists in the air. The streets filled with protesters, agitators, and police. Garbage and homelessness were on every corner, mixed in with drugs, boarded windows, and the mentally ill. Restlessness was in the air. Tempers were short. The news was despairing as daily death tolls rose to incomprehensible numbers. Hope seemed more like a wish.

Please be over soon.

It seemed as if everyone was expecting a day to come when there would simply be a collective closing of a door, and all would be normal again. But that day wasn't arriving at a pace that met the desire. Impatience and intolerance. More words to add to the daily vocabulary.

Internally, I wondered what normal looked like and, like many, wondered if this might be a good time for a reset. Maybe the old normal should remain at rest. Described in some future historical record. I felt a personal resistance to that old way of doing things that had resulted in the current days' events.

But with game faces on, my husband and I looked forward. And as certain restrictions were lifted, the roads less traveled seemed reasonable to try to explore.

We pulled out a calendar and began to fill in dates. Plans were tentatively made.

Only to come home from Costco, armed with toilet paper and roasted chicken, to find my guy bent at the hip, trying to move.

Emergency room. Sick folks. Really sick folks. Waiting. Heaving. Pressing for assistance, among all the ones who needed assistance.

Finally, a room. A nurse. A doctor. A nurse. Another doctor. Finally, a small knock on the door, again a doctor and a nurse.

"Sir, we've found a mass. Probably cancer. I'm sorry."

As it felt with COVID, the view changed without any advance notice.

Internet searches. WebMD. Bad news. Ten months average.

Kids. Faces. Me.

Sunrise. Sunset.

Dogs acting bewildered.

The past years of not seeing anyone in person, of breathing stale mask air, was morphing and twisting into a new and deep

fogginess. I didn't remember weather, time, or dates. I didn't know where I put my keys or my socks. I walked, seeing but blind.

We met with the experts. We discussed the options. We made plans—a treatment plan. The calendar, empty for many, many months, was now filled.

The doctor said to be realistic, but hopeful.

And then an attack on the innocents. Premeditated brutality. Women. Children. Men and boys.

Song and tears. Power-mongering over long conference tables. More is the premise. Violence the way to get it.

COVID. Cancer. War.

What is this dance? I swirl.

There are times, sometimes standing, sometimes driving, sometimes sipping morning coffee, when I feel a raw fear.

My body seizes up. As if I am only made of bones. No skin. It feels as if my knees are bent, up to my chest and closed in. I feel my skeletal self. Alone. Set. A silent, white-bone panic.

It never lasts long. Although it feels long. I know deep down I need to come back. Put my skin back on. Unwrap my arms and unfold my knees.

Look at him. See the sky. Feel the ground.

Hope. Art. Beauty.

Be awake. Be aware.

And I see.

The collaboration of scientists, the camaraderie of neighbors, the morality of the single person standing against the toxic venom. The hands from border countries helping frightened refugees. A thirty-year union. A small bird that sings on the branch outside.

Beauty is the conversation. The human connection. The tension between fragility and strength.

The fear. The effort. Life.

From the nurses weeping in exhaustion to the songs sung in bomb shelters to the nourished feeding those who are not. From the delicate paint strokes on a plate in my office to the kind man who reached out to open my car door as I sat in the parking lot at the cancer clinic.

This has been in the background the whole time. In the dirt. Like small wildflower seeds.

Growing here and there. This is art.

And the purpose?

To see the beauty is to stockpile the moments internally. To be the salve when the world—the one you read about, and the one you live in every day—breaks you down.

This is my awareness in full view. No longer diminished by the fog of a shocked brain. The vulnerability to move into the change. To be the beauty of it all.

Be Beauty.

To Be Beauty gave me permission.

I don't have to be strong. I don't have to be that gal whose God has chosen to only give her what she can handle. I don't have to be brave.

I can be scared. I can be angry. I can cry. I can silently stomp my own feet on walks with my confused dogs. I can lock the front door and not want to open it.

And I can be the hand that reaches out in the middle of the night. The provider of meals carefully planned out. The small seed of laughter on the couch before dinner. Facing each other.

Face-to-face.

This will be okay, I say. *This is part of the beauty. The beauty of healing.*

Part of the magic of life is what I really mean. Even when faced with the possibility of dying.

Oh, the beauty of it all. Oh, the magic.

And so it goes. And so it goes.

Be Beauty—the verb of it all.

MARIANNE LILE lives in Seattle. She is the author of the memoir *Stepmother*.

A Grandmother's Love Story

Esther Erman

I was named in memory of my maternal grandmother, Estera. She was named for the biblical Queen Esther, who risked her life to save the Jews of Persia—condemned to genocide in the fifth century BCE. Both women came to critical moments when they faced great risks and had to make life-or-death choices. I often look to both stories, but especially to my grandmother's, for inspiration.

Grandmother Estera was born and raised in Garbatka-Letnisko, a village in east-central Poland that lies about ninety kilometers southeast of Warsaw. "Letnisko" means it was a summer resort, and visitors remembered the village as having clean mountain air fragrant with the scent of pines. However, Garbatka was not a summer resort for its Jews; they all lived on the wrong side of the tracks year-round.

Estera was born in the 1880s to a poor and pious family. She fell in love with Benjamin, a merchant, and the two young

people wanted to marry. But back then, in that part of the world, parents arranged marriages—and poor as everyone was, Benjamin's parents required his bride to bring to the marriage a dowry. Estera's father asserted that if he must provide a dowry, his daughter would marry a scholar, a much more prestigious occupation than a merchant.

As was expected of her, Estera obeyed her father and entered into an arranged marriage with the scholar Meyer. Benjamin subsequently married a woman who, evidently, came with a dowry that satisfied his parents. Were Benjamin's wife and Meyer aware that they were not their spouses' first choices? Did people then even expect their marriages to be happy?

Several years passed, during which Estera and Meyer had a son, Moishe, and a daughter, Gella. For reasons now shrouded in mystery, Meyer ended up visiting Jerusalem. When he returned to Garbatka, he announced to his wife that the whole family had to leave Poland, which was not a good place for Jews, and make new lives in Jerusalem.

Estera, who did not share her husband's concerns about their home country, was devoted to her extensive family in Poland. No longer an obedient young girl, she told Meyer to go on ahead, to establish a home in Jerusalem, and then to send for the family.

Meyer did as Estera directed. He went to Jerusalem alone and set up a home. He then tried several times to convince his wife to bring their two children and join him there, but Estera repeatedly refused. Finally, he sent her two things and demanded that she choose between them: tickets for travel and the offer of a *get* (a Jewish divorce, which only the husband had the right to initiate). Many men who emigrated abandoned their families back home and left their wives in the untenable

position of being essentially without a husband and yet not able to remarry. Meyer's offering Estera a *get* showed him to be a true gentleman.

In an extremely unusual move for a pious woman in her time and place, Estera chose the *get*. Might part of her motivation have been that Benjamin, her first love, was now a widower? In any case, Estera and Benjamin wed and had two children together—a son, Mendel, born in 1915, and one year after that a daughter, Gittel, who would eventually become my mother.

I hope Benjamin and Estera's love had endured through their years apart, and that they experienced great joy in their marriage. What they did not have was the gift of much time together, because Benjamin soon died, very likely during the 1918 Spanish flu epidemic.

With Benjamin's death, poverty gripped the family even more. Estera had a mill for grinding buckwheat, which allowed her to eke out a living through backbreaking work. Gella, Estera's daughter from her first marriage, earned some money as a seamstress. Close relationships with friends and relatives in Garbatka's Jewish community helped Estera's family deal with their difficult lives.

In 1933, Moishe, the son from Estera's first marriage, decided to join his father in Jerusalem. On the occasion of Moishe's departure, a family photo was taken—perhaps the only one ever.

Blitzkrieg. In the month of September 1939, the Nazis crushed Poland. The Jews in Garbatka, just like those all over Poland and in the other defeated places, were torn from their homes, ghettoized, and forced into slave labor—a prelude to genocide.

The Jewish men were quickly murdered or deported. Estera now lived with both her daughters and her granddaughter in

Pionki, a ghetto created by the Nazis twenty kilometers west of Garbatka. Deportations from the ghetto became more frequent. In dread that their family members' names would appear on lists of those to be transported, the women checked each new posting. One day in September 1942, both Estera and Surele, Gella's eleven-year-old daughter, appeared on the list, supposedly to be relocated to another ghetto for "work reassignment." Neither Gella nor Gittel was on the list. One could add names, but not remove any. Gella, refusing to be separated from her daughter, immediately added her name.

Gittel went to put her name on the list also, to go with her mother, sister, and niece, but Estera stopped her. Gittel fought with her mother, arguing, "You all are going. Gella volunteered to go. I want to go with you."

Estera was adamant in her refusal. "Gella is going to be with her daughter, with Surele."

"But you will be separated from me, *your* daughter," Gittel protested.

Estera shook her head and put her hand on Gittel's shoulder. What love it must have taken for Estera to insist, "You are older than Surele and can work—maybe because of that, you will survive."

As Gittel watched in unbearable loneliness and grief, her mother, sister, and niece—all that remained of her family in Pionki—were shoved into a train filled with frightened people.

The destination, Gittel would later learn, was Treblinka—direct from train to gas chamber.

Against the odds, and as Estera had hoped, Gittel *did* survive the war. Her survival entailed separation from her loved ones; years of slave labor, abuse, and starvation; transport via cattle

car to Auschwitz in 1944; and a winter death march from Auschwitz to Bergen-Belsen in January 1945. For the next half-century, until she died in 2003, my mother shared just the bare bones of the story of her survival. I can only imagine the horrors.

Following her liberation from Bergen-Belsen in April 1945, my mother met and married my father—also a survivor of ghettos, Auschwitz, and slave labor—in a displaced person's camp in the British sector of Germany. I was born just eighteen months after their liberation—a testament to my parents' amazing recovery and resilience.

The three of us immigrated to New York in 1947.

Earlier, when the war had broken out, all the members of my mother's family had agreed that any who survived would contact Moishe in Jerusalem as a means of reconnecting with each other. My mother was the only one he ever heard from.

In the summer of 1962, my mother fulfilled a dream: she reunited with her brother in Jerusalem. At that time she also met Moishe's father and Estera's first husband, Meyer, who had never remarried.

Unlike Queen Esther, the source of her name, my grandmother Estera did not save the Jews. She could not save herself, her daughter Gella, or her granddaughter Surele. But she did save one person: my mother.

I thought of this story on a Friday evening in 2019 as I stood overlooking the walls of Jerusalem, golden in the setting sun at the start of the Sabbath. I suddenly was overcome with sadness and regret that my grandmother had not saved herself by following Meyer there. At the same time, I knew that had my grandmother not stayed in Poland and married my grandfather, my mother would not have been born.

Choices. If only the decisions motivated by love always brought joy. For my grandmother Estera, the decision she made not to join her husband in Jerusalem, for reasons of love and family, doomed her to suffer the loss of her loved ones and her home, and then perish at the behest of a genocidal tyrant.

I am grateful to my grandmother for her sacrifices, and for her insistence that her younger daughter not go with her on the transport. I am grateful to Gittel, my mother, for surviving. I am grateful to them both, as well as to my father and his survival, for my life, for that of my brother, and for those of the children and grandchildren each of us has.

In 2022, the world now shudders to see yet another, tragic chapter of war and loss at the behest of yet another tyrant. I acutely feel my connection with Estera as, once again, innocent people have to make impossible choices. My thoughts and prayers, and the actions within my grasp, go out to the heroes and the victims—those who die, as well as the scarred and traumatized survivors.

The words ring a bit hollow these days, but I repeat them with fervent hope that we can one day make them come true: "Never again!"

ESTHER ERMAN learned English as a second language in kindergarten. This inspired her to study languages and earn a doctorate in language education. A writer, teacher, mother, and grandmother, she lives in the San Francisco Bay Area with her husband. Esther's latest book is *Rebecca of Salerno: A Novel of Rogue Crusaders, a Jewish Female Physician, and a Murder.*

Beautiful Books

Patricia Ricketts

My mother ruled over our home with unusually high energy, unfiltered opinions, and unbridled passions for the arts, music, and books. Passions, you know? Like where you are swept away with the flow of something much grander than you thought you were capable of being. We were swept away daily by the sounds of Gershwin, Porter, Vivaldi, and Saint-Saëns floating through the air, by our bookshelves loaded with Funk & Wagnalls volumes, classic novels by Flaubert and Austen, the complete works of William Shakespeare, and many heavy, beautiful art tomes. Yes, ours was a home bubbling over with passion, where each of us six children shied away from our mother's arched eyebrow but thrilled to the experiences she afforded us.

Nonetheless, we learned not to lie around on the couch watching black-and-white Shirley Temple movies on Saturday mornings, or else we'd hear from the kitchen, "Turn off that television! I have a job for you."

But one gloomy summer morning, just after we'd moved away from a neighborhood filled with our best friends, I—a

self-conscious preteen of ten—made the mistake of saying, "I'm bored," within my mother's earshot. Big mistake. I realized, too late, that I was in for a dust rag and a can of Pledge. But instead of saddling me with an arduous chore, my mother walked into my bedroom and said, "Go read a book."

With that, she walked away. Quickly, however, she came back and said, "Go to the library and find *Beautiful Joe*."

Well, I was that bored. So I did.

Carrying Marshall Saunders's book under my arm like ill-gotten lucre, I headed up to my boring old pink-and-white bedroom and started in. It was my first *real* experience with reading. And with being swept away on a magical carpet of wonder. Oh, sure, I'd read the Dick and Jane series and many of those orange-covered biographies in our school library, but they were mundane, utterly predictable. But this . . . *this* was different. We'd always had dogs in our house, too, but *this* dog, this Beautiful Joe, introduced me to what he was feeling through his voice, with his pain and trials and empathy. I was swept away into Beautiful Joe's world of unutterable love flavored by sorrow.

As I recall, I finished it by nightfall. And when I did, I cried for his suffering and triumphs. My self-conscious self broadened that day into something much grander than my previous one. Perhaps reading *Beautiful Joe* was my first connection to the wonder of the eternal through the eyes of another.

Isn't that what reading is about?

A couple of years later, I became bored. Again. This time it was my sister Sally who encouraged me to read a new title—*Gone with the Wind*.

After lifting it off our library shelf, I realized that while it might be good, it was exceptionally loooooooong. Still, I trusted

Sally's advice—Sally, who'd shepherded me through many of life's small treacheries, like the time she held her hands, horse-blinker-like, at the sides of my eyes to shield me from the screaming obscenity splashed across the viaduct's cement as we passed under on our walk to the beach.

So, once again, I dug in, slogging through the first fifty-page rationale of the Civil War's genesis, thinking, *I'll never like this book like* Beautiful Joe. But then, oh then, *she* came on the scene. Dressed in a small-waisted white frock dotted with green appliqués and a picture hat tied with velvet, surrounded by boys eager to sit by her side and even more eager to run off to battle to "end this fight fast," Scarlet captured my soul. "Fiddle-dee-dee" and "I'll think about that tomorrow" swirled about me. Margaret Mitchell's lush descriptions of Rhett Butler's womanizing and bon vivant ways, Melanie's shy but soft-spoken kindness, Mammy's great, expansive, fussy love of both Scarlett and red petticoats, and even Ashley Wilkes's weak-sistery old-South manners danced in a rapturous waltz inside me for days. After reading *Gone with the Wind*, I understood the initial excitement, then horror, of a battle's blustery carnage; of tramping raw feet and bleeding loyalties; of near starvation and unnecessary death brought on by the destructive impact of war; of the selfless love required for a soul to grow into something grander than it started out to be.

I don't think I emerged from that hot and stuffy third-floor bedroom for two weeks, not until Rhett's cutting farewell—"Frankly, my dear, I don't give a damn!"—left me breathless, swept away by the enormity of lost love and a world forever changed.

Throughout the years, many books have swept me into the wonder of something eternal. Books like Abraham Verghese's

Cutting for Stone, Barbara Kingsolver's *The Poisonwood Bible*, John Fowles's *The Magus*, Joyce Carol Oates's *We Were the Mulvaneys*, Brian Doyle's *Mink River*, Richard Powers's *The Overstory*, John Irving's *A Prayer for Owen Meany*, Toni Morrison's *Beloved* . . . I could go on and on.

But I would be remiss if I didn't specifically talk about Pat Conroy's *The Prince of Tides* as something that swept me away, whose prologue itself is so moving that I used to insist upon reading it to my AP English classes every year. "Come in. Sit down and get comfortable. I'm going to read you something that will shuffle you off this mortal coil . . . and give you pause." Conroy's artful yet truthful use of language, his tales of savior tigers, of fraternity fails, of grandparent idiosyncrasies, made me howl with both laughter and pain. Every time I read it, *Prince of Tides* carries me, body and soul, into both the salt flats of South Carolina's Low Country and to the city of Manhattan, where the hubris of the North clashes with the tattered soul of the South—in love, in perspective, and in abuses through Tom Wingo's troubled soul. Which, I came to find out, was Conroy's own. I heard him speak a year before he died of pancreatic cancer, and was fortunate enough then to get the chance to tell him what he meant to me, to my AP English students, and to my mother and siblings, who loved his novel as much as I did.

A book breaks open the heart so that love—and shock and grief and growth—can start to pour inside. Novels are like hands clasped tight to the chest in prayer. Fuel for something to ignite us, grander and brighter than anything we ever thought we could be.

The middle child from a rollicking Chicago-area household, **PATRICIA RICKETTS** inherited a lifelong love of music, the written word, the arts, and arguing from her parents—and has tried to pass those loves on to her own children. She has short stories published in *New Directions*, *Slate*, *The Metaworker*, and *The Blue Hour* and published her debut novel, *Speed of Dark*, in May 2022. She's currently working on her second novel, *The End of June*.

The Great Reckoning

Donna Stoneham

Rays of hope flicker
through the darkness
in a stormy world.
Shimmering stars
in defiance
of hatred,
autocracy,
and division
light the way
for what is possible
when people of conscience
link hearts, minds, and hands.

Voices rise in unison
speaking truth to power,
refusing
to be silent
anymore.

Humanity's wall of unity
built of steel resolve—
an impenetrable force
interminably stronger
than the illusion of protection
created by a psyche
of evil and projection.

Standing shoulder to shoulder
with our brothers and sisters
in Kyiv, Kharkiv, and Odessa.
Carrying sunflowers,
bearing flags
of blue and yellow—
symbols of hope
that democracy
will flourish
in all nations,
and their homeland
will be spared annihilation
by a madman's ego
bent on ruin.

From Barcelona to Boston,
Warsaw to Winnipeg,
Oslo to Osaka,
we gather,
committed to shift the tide
of mutual destruction,
as millions of warriors
in this army of love
enlist in the final crusade.

Our power
to mend the world
is palpable.
Inspired by the
courage of our comrades
across the Baltic Sea,
we watch
as they blanket the wounded,
shelter mothers in need of comfort,
offer bread and hugs to displaced children,
needing a place to rest.

Arm in arm,
we chant prayers
that reason prevails.
Black, brown, yellow, white . . .
Muslim, Buddhist, Christian, Atheist, Jew . . .
A rainbow of inclusion
lights up the clouds,
offering solace
for what is possible
when the world
we share
is in peril
and our fates
are indivisibly intertwined.

Gazing into strangers' eyes,
their courage broadcast
on Sky TV,
we see humanity's greatness.

Not in trite words
on a tyrant's red cap—
another lie
we must lay to rest.
Fear of carnage,
a construct
we no longer allow
to divide us
from what is just and true.

In this great reckoning
that's upon us,
we choose love
as our guiding compass . . .

Tough love to fight injustice,
Raw love for another's anguish,
Big love that builds a tent
where all are welcome.
And hard love
we must rally
to bridge this great divide,
and recommit
to building a world
where our planet is protected,
our children are nurtured,
and our elders
are safe from harm.

A sea of light
is infinitely more powerful

than hatred;
empathy,
a mighty force
for hope.
Arms linked in solidarity,
we set our sights
on freedom,
and our détente
on peace.

DONNA STONEHAM, PhD, is an executive coach, poet, and writer. The author of *The Thriver's Edge: Seven Steps to Transform the Way You Live, Love, and Lead* (She Writes Press, 2015) and the upcoming book *Catch Me When I Fall: Poems of Mother Loss and Healing* (She Writes Press, 2023), she lives with her wife and rescue dog in Point Richmond, California. When Donna's not coaching or writing, she loves hiking, sailing, skiing, and communing with spirit and nature outdoors.

Bombs Away

Cerridwen Fallingstar

"There are those who are trying to set fire to the world, we are in danger . . . there is no time not to love."
—DEENA METZGER

"He is singing the end of the world again . . ."
—JUDY GRAHN

January 18, 2018, I'm in my condo on the Big Island of Hawaii when the emergency message comes through on my cell phone: *"Ballistic missile threat inbound to Hawaii. Seek immediate shelter. This is not a drill."*

Well, shit. Fucking toddler Donald Trump called toddler Kim Jong-un fat, and now, instead of flinging sand, Kim is flinging nuclear weapons at Hawaii.

Where Trump is not.

But where I, innocent bystander, unfortunately am.

Is there a bomb shelter nearby? A quick search online reveals a tsunami shelter at an inland gymnasium. Compared to a nuclear holocaust, a tsunami now seems like the most charming of threats.

Unfortunately, once we're talking nuclear blast and subsequent radiation, a gymnasium in back of the high-water mark isn't going to cut it.

I start filling the bathtub and bathroom sink with water. The bathroom is the one room in the condo without windows. I can shelter there without worrying about a cyclone of glass shattering in on me. The worst of the radioactive particles will settle in a few days, and I will have water and shelter for those few days.

Assuming the town of Hilo doesn't take a direct hit.

Water supply secure, I haul blankets and pillows into the bathroom, along with a notebook in which to inscribe my final thoughts. Then I take out my cell phone and call my adult son, Zach.

He answers on the first ring.

"Hey, Zach, I have some . . . bad news. The Hawaiian State emergency line sent a text. Bombers have been sighted coming from North Korea to Hawaii. They will be here in half an hour. I filled the tub with water. So, if I survive the initial blast, I have a chance. I'll do my best to survive, Zach. But in case that doesn't work out, I wanted to call and say good-bye."

"Mom—Mom. It's gotta be a hoax."

My heart breaks for his need to be in denial.

"It looks really official," I whisper sadly.

"Maybe somebody hacked the site," he insists.

He needs to hope. Let him have twenty-five minutes of hope.

"Yeah, maybe," I concede. "But just in case—thanks so much for being my son. You and your dad have been the best parts of my life. And whatever happens, love doesn't die."

"Mom, I'm going online to research this. Don't worry, I'm sure it's fake. Just hang on, I'll call you back."

My beautiful young man. He needs to feel like he's doing something.

"Okay."

He hangs up. I gather a few food items and put them under the sink in the bathroom.

Zach calls back. "I can't find anything yet. Read the warning to me—what does it say exactly?"

I read the ominous text to him.

Fifteen minutes left.

"I'm going to look again."

"Oh, sweetie—just stay with me for a moment," I sigh. "I love you. It's okay, I'm not afraid. As long as you and Loryn and the babies are okay in Seattle, I can manage. I've had an interesting life. I'm not afraid. Love doesn't die. It'll be all right."

Zach stays on the phone while using his computer, determined to research my fate into something survivable.

Ten minutes left.

I have to hang up when there are three minutes left, I decide. *I don't want him to hear me dying.*

I stand out on my balcony lanai, gazing at the lagoon. If I'm not killed in the initial blast but I do develop radiation sickness, it is comforting to think that I can walk to the lagoon and drown myself. I won't have to suffer agonizing burns, long strips of skin sloughing off, uncontrollable, bloody vomiting and diarrhea. There is an out, an easy out, right there, sparkling in the sun. It's a beautiful day to die.

And it's possible the bombs are just heading for Honolulu, to wipe out our navy and the big population center there, and not directed at this island at all. Depending on how the wind is blowing, radiation might not even reach us.

Of course, it's equally possible that a demented sociopath like Kim Jong-un would be thrilled to drop a nuclear bomb down the throat of an active volcano like Kilauea, only half an hour away from here, to see what will happen.

No one knows what would happen in that instance.

But we can assume it wouldn't be good.

The only thing worse than lava racing toward you at high speed would be *radioactive* lava hurtling toward you at high speed.

Five minutes left. Four. *Oh, my son, I'm so sorry I won't be there to help raise your daughters. And now I need to hang up . . .*

"Mom! I found it!" Zach cries jubilantly. "It was an accident! The officials sent it, but they sent it by accident!"

"Are you sure?"

My phone beeps. Another official message. *"There is no missile threat or danger to the State of Hawaii. Repeat. False Alarm."*

"You're right," I say, dazed, "they just sent a message saying the original one was in error."

"I knew it had to be fake!" Zach rejoices.

"Well, thanks so much for helping—and being there," I tell him. "Looks like I will live to fight another day."

I say goodbye and walk out onto the lanai again. My numbness starts to fade. All the colors of the lagoon and its surrounding trees and vegetation become saturated and bright.

Being alive is exquisite, breathing in the flower-scented air.

Well, it's Saturday morning. Now that I'm not dying, I might as well go to the farmers market in downtown Hilo.

When I get there, only about a third of the stalls are occupied, but slowly the vendors trickle in. I go to the stall where I always buy their delicious lilikoi drink. A local woman in her sixties hands it to me with a smile.

A boy of about six is with her. "Tutu," he says, "are we not going to the gymnasium to be safe now?"

Her eyes crinkle as she smiles at him. "No, we don't need to. It was a false alarm. Everything's fine now." Then she cups his chin in her hands and says, "Oh, that little face . . ."

White-hot rage explodes through my body. The only reason I could calmly face my own death was because I knew my family was three thousand miles away, safe. What of this woman, of all the mothers and grandmothers who believed their children and grandchildren were about to die?

To think that the most dysfunctional, unloving males on the planet have the power to murder us all. Males who have never cupped a child's face in their hands and murmured, "Oh, that little face." Sociopaths who care for no one but themselves and their own egos—the Putins, the Trumps, the Kims of the world.

I walk, shaking, to the nearest restaurant. It is thronged with old white tourists, and it is all I can do not to scream, "Which of you assholes voted from Trump? Who voted to kill us all?" I want to drive them into the sea, I want me and all the Hawaiian people, all the parents and grandparents, to chase the Republicans into the sea, deeper and deeper, until they drown.

Fuck, I want to hold them under.

But I'm not Kim Jong-un–type crazy, so instead I sit down and order an iced tea.

I realize I must be experiencing what my father experienced when he went to Florida during the Cuban Missile Crisis to try to avert World War III.

My father was an engineer with Aerospace; he designed rockets. Unlike most engineers, he was very socially adept, handsome, and charismatic. With his hail-fellow-well-met,

impish sense of humor, he was the perfect emissary to explain technology to politicians. He made many trips to the White House and the Pentagon to demonstrate to politicians and generals alike how superior our rockets were, both for winning the space race and for nuclear deterrence.

Then, on October 16, 1962, an American U-2 spy plane photographed secret nuclear missile sites being built by the Soviet Union on the island of Cuba. President Kennedy called the Executive Committee of the National Security Council together. They called for experts. My father packed his bags.

My Republican father was no pacifist. Once, at a dinner party, Wagner's "Ride of the Valkyries" playing in the background, my German father clapped his nephew Chris on the shoulder and said, "Ah, Chris—music to invade Poland by!" He was only half joking. He had painted the double-headed axes of our German family crest on my kindergarten lunch box, partly to counter its deplorable Scottish plaid pattern, and partly to show the little boys I was not to be messed with.

But my father understood that nuclear capacity had changed everything. There was no courage or nobility in setting fire to the atmosphere. He understood that war now could mean annihilation of our species—and most of the others. So he found himself racing from general to general, trying to persuade them out of their hardline insistence that war was the only solution to the Soviet incursion. "So, General LeMay—see which way the wind is blowing?—let me explain to you how radiation works."

The generals—"those brass-hat dinosaurs," as my father called them—continued to call for war. "We'll bomb Cuba back to the Stone Age," LeMay threatened. We had more nuclear bombs than Russia! We'd show them a thing or two!

My father began to despair. He would die alone on the East

Coast, and his family would die three thousand miles away. He would not be there to hold and comfort his beloved wife and children at the end.

But Jack and Bobby Kennedy listened. My father privately held the Kennedys in contempt as a pair of spoiled rich boys. But when he was with them, he showed nothing but respect, patiently explaining everything he knew about nuclear warfare. And whatever else he thought of them, the Kennedys had young children they loved. They, like my father, had held their children and thought, "Oh, that little face." And my father played that card, that "leave a world for our children" card, with everything he had. And in the end, although every member of the Joint Chiefs of Staff continued to insist on war, Kennedy held firm to taking the path of negotiation, finally agreeing to remove our own missiles from Turkey and not to invade Cuba, providing that Khrushchev would remove the nuclear missiles from Cuba. Khrushchev agreed, and the world was saved.

We can't all be in a position to talk to presidents.

But if, like my father, we have the opportunity, we can remind someone in power that without the children's lives and future, there is no victory.

We can call the people we hold dear and tell them we love them.

We can remember that love doesn't die.

We can write our story until the end.

We can have compassion, remembering that it is always, at every moment, the end of the world for someone.

And like poet Judy Grahn, we can remember our history:

. . . I remember five full worlds
and four of them have ended.

CERRIDWEN FALLINGSTAR is a Wiccan priestess who lectures, teaches classes, and offers counseling sessions utilizing tarot, hypnotherapy, soul retrieval, and other techniques. She is the author of *The Heart of the Fire*, a past-life novel about witchcraft set in sixteenth-century Scotland, and the White as Bone, Red as Blood series, set in twelfth-century Japan. Her latest book, *Broth from the Cauldron*, is a magical memoir that has been described as a "Wiccan Soup for the Soul."

Breathing Ukraine

Jeanne Baker Guy

I weep
I write
I pause
I cry

I watch the news
I look away

I breathe
Grateful for a connection
Through the breath

I pause
I breathe again
Hoping for clarity
I reach out
I write love messages to you

I offer
My words
This poem
My breath
May it be a loving vibration
Felt round the world
It is yours

I shall cook and clean
And send you blessings
Each day, every day

Choosing despair doesn't help
Breathe with me
As we train for peace
And empty the war out of our own hearts
Though we may not live to see the results
Our vibrations emanate and matter

I will not look away
Breathe with me

JEANNE BAKER GUY is the author of *You'll Never Find Us: A Memoir*, the story of how her children were stolen from her and how she stole them back (She Writes Press, 2021). A graduate of Indiana University and Leadership Austin, she is also the founder of Jeanne Guy Gatherings and a coauthor of

Seeing Me: A Guide for Reframing the Way You See Yourself through Reflective Writing (2015). Guy has also contributed to *Writer's Digest* and multiple Story Circle Network anthologies. She and her husband live in Cedar Park, Texas, where she is working on a second memoir. Visit her at www.jeanneguy.com.

Don't Tell
My Husband
I'm Lonely

Sheila Grinell

My husband was diagnosed with Parkinson's disease in 2011. I had noticed the first sign of his decline six years earlier: he kept dragging his bare feet across the tile floor of the bathroom, making a sloppy, floppy sound that got on my nerves. When I protested, he seemed oblivious. I learned to avoid being in the bathroom with him when he was barefoot.

Tom had had an "essential tremor"—his right hand shook for no obvious cause—for decades. In 2008, though, he noticed that other things weren't right and it was affecting his driving. So we went to a neurologist, who sent us to a neuropsychologist to assess Tom's mental capacity.

Diagnosis: "mild cognitive impairment," which means your mental functioning is not quite up to age-adjusted norms, but your daily life can proceed.

Tom was seventy at the time. He went back to work, and I went about my business.

Three years passed. One day, Tom found himself in his car in the middle of an intersection near our home, at a complete loss as to what to do next. He got scared. Back we went to the neurologist, who looked at him and said, "You have Parkinson's."

At home, I got online. We read. We talked to people in the know. We signed him up for classes at the Muhammad Ali Parkinson's Center here in Phoenix.

Life began to change.

I had to drive Tom to classes at the center because he couldn't negotiate the highway safely. Ten months later, he quit his job. I took over management of his daily activities because he couldn't read the calendar anymore. When he looked at a page, the markings didn't mean anything—he couldn't identify a specific activity without my guidance. This was a man, my man, who'd begun his working life at IBM fixing machines.

Most people think of Parkinson's as a movement disorder; they visualize Michael J. Fox bouncing around when he talks. Yes, "PD" affects movement, but it affects everything else, too: automatic processes like digestion and swallowing, cognitive processes like planning and spatial orientation, and emotional processes like mood and dreams. PD causes neurons in a particular part of the brain to die in a particular way and diminishes the available amount of the brain signaling chemical dopamine. With a weaker signal, it's harder to turn circuits on. A PD sufferer has to push hard to compensate; he has to feel like he's shouting in order to raise his voice above a whisper. And PD is progressive and incurable. There is a medicine that restores

dopamine to the brain that helps most patients—until too many neurons have died for the drug to make a significant difference.

Tom's biggest deficits are cognitive, not motor or emotional. When we watch a movie together, I have to pause every so often to explain the plot twists. He hates needing help, but he's glad when the movie starts to make more sense. Odd, unpredictable things happen in his brain: once he hit the switch to close the garage door just before I backed out (he thought he was opening the door, although it was already open). That misconception cost $1,900 for a new door, not to mention the psychological wear and tear. (Why didn't he check? Why didn't I double-check?)

Sometimes our day feels like business as usual: I buy food and cook; we eat and he washes up—he leaves blotches here and there, which I remove later—and we both tend to the dog. Then I notice that he's asking the same question twice, maybe three times. When I call him on it, he says he can't remember what I've said. But there's nothing wrong with his memory (it's been tested). It's that you can't remember what you haven't registered in the first place.

Why, you ask, do I call him on it? He can't help not being able to focus. But it's an instinctive reaction, a feeling that surely, if he tried hard enough, he could pay better attention— to me, his constant support, the one who ensures he takes his medicine on time and calls the Uber driver when required. I deserve all the effort he can muster! Then I ask myself, *Is it reasonable to expect him to make an extra effort all day long?*—at which point I cool off and get contrite. I say nothing, he says nothing. We resume business as usual.

The hard part comes at bedtime, when I start to talk about little things that have populated my day, or big things that loom

ahead, and I see that Tom's not following. I take a breath and start again, laying it out slowly, carefully, and sometimes he responds with the empathy and people smarts that I fell in love with thirty-five years ago. (Recently, a neighbor asked us to his wedding. Tom said to me, "I sense he wants us to say no." Sure enough, the promised invitation didn't arrive.) But often I can't get through. He looks at me, puzzled, as if I'm telling a joke and he's waiting for the punch line, which doesn't come. He's not the companion he once was. I sorely miss that man. Without him, I'm lonely.

A friend whose husband died young from a brain-wasting disorder told me she used to ask herself what percentage of time her husband was a helpmate versus a dependent. Right now, Tom is fifty-fifty. He is so unsure of himself that he checks in with me constantly, rechecking things he knows, like when the PBS NewsHour starts, "just to be sure." He walks three steps behind me in airports and department stores so he won't have to worry about getting lost. We still love each other; we still share values and sympathies (not to mention children and grandchildren). But there's less substance to our marriage than before. We can't go on physical or imaginative journeys together. And everything we *can* do together takes so much more time.

A little while ago, after someone prodded me, I realized my discomfort goes deeper than day-to-day frustration. At bottom lies the knowledge that I have lost the future I once assumed I'd have. I have lost the freedom to plan the last decades of my life. I grieve that loss—not actively, but steadily. My grief is like the buzz of a fluorescent light, mostly ignored but always in the background. Each time PD steals something new from me—Tom just gave up "happy hour" because he can't keep

up with the conversation (he had already given up drink)—I grieve a little more.

I know I'm not alone. Women everywhere are caring for someone with damaged cognition. Far more women than men wind up in charge of a declining parent or spouse. Most of the time, they shoulder the burden willingly. But it takes a toll. More than 60 percent of caregivers die *before* their demented relatives do. (I've asked Tom what would happen if I died first. He said, "I'll survive." He doesn't really appreciate the level of organization that would be required.)

I have two remedies for what ails me. First, I retreat from my husband's needs for a few hours every day when I sit behind my computer, writing. Tom sometimes pokes his head into my office and asks, "Are you still at the machine?" He'd rather have my company, but he knows I need to do what I do—to engage with my whole self in the wider world—without him. Right now, he can handle the closed office door, and he's proud of my accomplishments. As he continues to decline, I hope I continue to feel good about ignoring him for two hours at a clip. I need to share my truth with readers and other writers, no matter the obstacles.

And then there's my second remedy: a support group of PD spouses, twelve women and four men, that meets once a month. No matter what I blurt, everyone "gets it"—they've been there or are going there—and their compassion is boundless. Sometimes we exchange tips on caregiving, like how to give your loved one a shot of oxygen before a long flight to compensate for the effects of lowered air pressure. Or where to find a special kind of door hinge that makes the doorway a few inches wider so a wheelchair can pass through.

Sometimes we talk about our own needs, and for once *we*, not the disease wasting our partners, take center stage. We say

things we wouldn't dare say to our adult children when they ask how it's going, scary things they shouldn't hear. A few of us have begun to meet for lunch, sharing our dreams and cheering each other on. These wonderful new friends will be with me for the long haul. I cherish them. They keep loneliness at bay.

SHEILA GRINELL moved to Phoenix, Arizona, in 1993 to serve as founding CEO of the Arizona Science Center. Toward the end of her forty-year career in the science museum field, she began to write fiction. She Writes Press published her debut novel, *Appetite*, in 2016 and her second novel, *The Contract*, in 2019. To learn more, visit www.sheilagrinell.com.

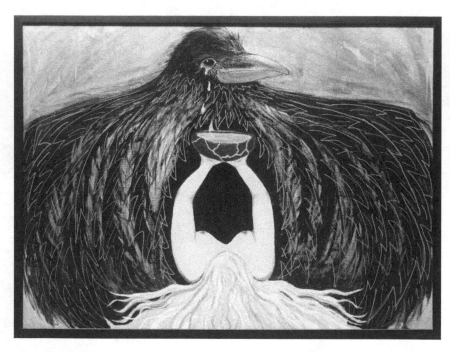

Being Held in Deep Grief and Unbearable Beauty, acrylic painting, 23" x 31", inspired by a pandemic shamanic journey via Zoom in February 2021

Being Held in Deep Grief and Unbearable Beauty

Glenda Goodrich

GLENDA GOODRICH ("GG") is an artist, art doula, author, and SoulCollage® facilitator living in Oregon. She is a mother, grandmother, and great-grandmother and devoted practitioner of the ceremony of wilderness vision questing. She finds joy in helping others explore, discover, and birth their full creative potential.

The Comfort of Art and Routine

Mary Camarillo

The St. Bonaventure Church and Catholic School occupies the southwestern corner of our Huntington Beach, California, neighborhood. The first church bells ring Monday through Friday at eight fifteen. The bells chime a hymn before the eight thirty mass. Then the bells toll five minutes before mass and at mass time and every hour from 9:00 a.m. to 8:00 p.m. On Sunday, first bell is at nine and then bells ring before the ten thirty, noon, one thirty, and five o'clock masses.

We've lived here more than twenty years, and before the pandemic I'd grown so accustomed to the bells that I'd stopped hearing them. Now, after two years of COVID-19, blatant racism, a chaotic election, a divided country, war, and the threat of even more war, the bells are part of our daily routine.

They're actually not real bells—they're recordings. Even so, the eight fifteen hymn was lovely last Saturday as I walked past

the church. I recognized the melody from my own Methodist churchgoing days.

We don't usually notice the hourly bells as our day unfolds. The daily after-breakfast cleanup, the den-tidying, the cat-feeding, the litterbox-cleaning, the making of the bed. The choreography of unloading the dishwasher. The weekly grocery shopping. The rowing and stationary bike riding in our garage because I still haven't gone back to the gym. The yoga on Zoom twice a week. The addressing of envelopes for birthday cards, sympathy condolences, and articles we've cut from the newspaper that we think friends and family should read. The dropping off of mail at the post office.

We have turned into our grandparents.

After lunch we drive to Leisure World to check on my ninety-nine-year-old dad, who still lives independently and has his own set routine. When we come home, I write fiction, my husband practices ukulele, and then we read. In the past two years I've published a novel and started a new one. My husband has a songbook of tunes ranging from Johnny Cash to Tom Petty that he can play from memory.

When the weather is nice, we sit outside and listen to our own collection of bells. When the ocean breeze picks up around 4:00 p.m., we find the sound of ringing bells comforting. Hopefully our neighbors do too.

We realize our privilege in owning a home with a garden and having a comfortable pension after working forty-some years for the postal service. We and our loved ones are mostly healthy and mentally sound.

And we have our art. That is everything.

By six o'clock, if we can't find a musician or an author on Eventbrite or Instagram Live, we watch last night's Trevor

Noah and Stephen Colbert and eat our chicken-salad dinners. After the dishes are put away, we turn to Netflix. During early pandemic days we embarrassingly got hooked on the ultra-violent *Queen of the South*. In those days, cartel mayhem was somehow easier to watch than CNN. Lately we've loved *Station Eleven*, another pandemic story, with (spoiler alert) an uplifting ending.

I try to remember to go out on the front porch to listen for the 8:00 p.m. bells. We eventually go to bed. We ultimately fall into sleep. Then there is the routine of waking up at two, and three, and four in the morning. There is the giving up and getting up at five or six.

And, of course, there's the constant email/Facebook/Instagram/Twitter checking that I know I should curtail—I've seen *The Social Dilemma* on Netflix—but to which, frankly, I became completely addicted during the pandemic. I'm learning now to stop reaching for my phone all the time. It's a hard habit to break.

So much hardship and so many lost in these last terrible years, too many to name. Two that come immediately to mind: John Prine and Ruth Bader Ginsburg. They'd both tell us to carry on—Mr. Prine with his irrepressible optimism and deep comprehension of our human condition, Ms. Ginsburg with her amazing work ethic and devotion to justice and equality.

I hear twelves bells now, which means it's time for lunch. The afternoon will progress. I'll put some more words on a page and my husband will learn a new song. It'll be evening and sunset, and eventually this day will be over.

Tomorrow is another chance.

MARY CAMARILLO's award-winning debut novel, *The Lock-hart Women*, was published by She Writes Press in June of 2021. Her short fiction and poems have appeared in publications including *Sonora Review*, *166 Palms*, and *TAB Journal*. She lives in Huntington Beach, California, with her husband and their terrorist cat Riley.

The Gift of
No Escape

Dayna MacCulloch

I met a guy at a wedding and he asked me if I wanted to sail around the world with him. I had just spent most of my money on a plane ticket back to Israel for a dance program I'd been waiting years to get into.

The guy looked like Jude Law and was charismatic and adoring in all the right ways, but after a week together, I knew his facade had cracks. The day before we were due to set sail he confessed that he was most likely a sociopath—not the kind that murders, he explained, just the kind that can't feel emotion and is highly skilled at manipulating people. But don't worry, he said, he only manipulated the bad people.

I wasn't convinced.

But I got on the boat anyway.

It would be the beginning of the darkest, most difficult years of my life. I would lose most of the things that I loved, one after

the other in quick succession: a beloved partner, a home, a job, a fetus, my car, my best friend. A car crash would give me two years of debilitating pain. I would fall into a nest of bad boy-friends; the last one of them would become particularly fixated on my boat trip. No one would ever trust me, he would say, because I made terrible decisions like that one where I decided to sail around the world with a stranger. "That choice shows me you are neurologically wired to chase your own destruction," he said. The words rolled off me without wounding the way he intended them to, and I left him soon after that.

I was able to leave because of the boat trip.

I knew at the time why I got on the boat and I knew it every day after, even while I was stuck in the dark years that choice had spun out for me.

I got on the boat because my body said *yes*.

I had spent the previous ten years studying with the world's master teachers on how to follow the body. How to wake up in the body, listen to the body, trust the body. I'd trained for hours and hours, in multiple countries, via multiple disciplines, for years and years. Maybe I'd been training for this moment, I thought, for the courage to follow such a senseless divergence in my life path, when reason said no and every other part of me demanded yes.

My mother cried at the marina as I stood there with my bags. She begged me not to go. I said I have to do it, I don't know why, I'm so sorry. And I went.

On day three, when land was gone and the sea was everywhere, a storm hit. The ocean was suddenly furious, arching one hundred feet above our heads and then whipping back into the side of us; the sound was awful, like a mountain cracking. The

autopilot broke and we had to hold the bucking wheel steady, like they do in the movies, as the howling wind pummeled us miles and miles off course. The terror made it hard to breathe, hard to move. I told myself, *It's just a storm, it will pass, they always do*. But it didn't. There were breaks, sure, but then it came back, louder, harder. In the quiet moments, the sociopath followed me around the forty-nine-foot sailboat and tried to make me cry. He had quickly sussed out my deepest fears and in a calm and gentle lilt he assured me they were all true and I couldn't get away from him. There was nowhere to escape to but the boiling sea. But I was not ready to die.

My body said, *Just dance*.

There was nothing else to do. So I let the boat move me and I let the waves move me and I let the wind move me and I let my terror move me and I let my body show me what it wanted to show me.

Join that storm, my body said, *move inside the scream of it*.

Fear had had me fighting what was happening. When I joined what was happening the fear left. The power of the wind and the sea surged through me and I faced down the sociopath with blazing eyes and he never bothered me again.

We were stuck out there for twenty-eight days; when I finally got to land, my legs didn't know how to walk on solid ground. But I knew how to dance and I would never forget. Even as my life plunged me into terrible darkness from that day forward, into a kind of unending storm whose sunbreaks were fleeting, taunting glimpses of peace that were soon ripped away again, I did not forget how to keep moving. No matter how stuck I was, in whatever impossibly small space, I did not forget how to move whatever I could move, in whatever tiny way I could

move it. The ocean lived in me and danced in me, and every time I saw her she reminded me.

And then one day I opened my eyes and I was in a quiet place. The trees were heavy with pink blossoms. My son was running through the field behind our home, a pure embodiment of joy. My strong and gentle husband was holding my hand.

My husband and I have traced the events back many times: There's no way I would have met him if I had not gotten on that boat. There are too many things directly linked to that decision that all had to stack up precisely in order to put him, a Scottish health economist living in England, and me, a dancer-writer who only went to the warm countries, face-to-face.

If I had not lived in a terrible place and endured terrible things, I would not have been ready for him when we did meet, five years after the boat, on a beach in California, the waves beside us like bright light breaking on the shore. Talking to me. Reminding me.

If I had not learned how to be stuck for a very long time in terror, in a tiny space, in huge weather, I would not have known, as I know now, how to navigate the inevitable storms that shake a marriage. That shake parents. That shake friendships. That shake the earth.

I would not know, as I know now, how to be peaceful, how to be grateful, while the world seemingly breaks around us.

I was forced to be stuck and from that stuckness came a wild kind of freedom.

It wasn't something I could study. It was something I could only learn when there was no escape from where I was.

Now all of us, the people of the earth, are stuck on a boat together. We always have been, but we never knew it like we know it now. The storm is raging and shows no sign of stopping.

May we move together. All of us—those we love, those we hate, those we fear.

Feel together. Listen together. Cry together.

Heal together.

And may the dance show us the way back to the heart of ourselves, to that quiet place in our body where life's most elusive secret dwells. May we hear it whispered, as simple and as bold as sunshine. *Even in the blackest center of the wildest unknown, there is, and will always be, light.*

DAYNA MACCULLOCH is a somatic wellness coach based in East Sussex, England. Learn more via her website, www .waterstoriesthebody.com, or by following her on Instagram: @WaterStoriesTheBody.

The Borneo Challenge

Linda Moore

Options to end the misery vanish with the fading light. Relentless rain soaks through my hat, poncho, and clothes, deep into the skin. I abandon any thought of staying dry; instead I worry about my feet, about the leeches in the mud oozing over my boot tops as my feet sink with each step.

Orangutans, the reason I am here in Borneo, gaze from their perches into the soul of this, their lost cousin, amused by my struggle and that of other seekers who don't belong here. We cease checking lists of exotic birds with color-coded names like lavender cuckoo and black-tailed hornbill. The surprise deluge (surprise to us but not the creatures) cancels efforts to record them with photos and in journals. Gibbons and proboscis monkeys strain the branches of slender trees. Ferocious ants and snakes, so many that I can't remember them well enough to be afraid, cover the rotting leaves on the floor of this tree cathedral.

Orchids, vines, and carnivorous flowers strangle tree trunks in search of air and light. Darkness steals the light, the

essence of survival in the dense forest. In tandem, light and rain compete as two opposing forces; this day the water is winning by releasing volumes and generating oppressive humidity. Wild pigs with high-heel hoofs create trails that quickly disappear and become river channels. Termites grind up what remains so that it can all begin again.

I wear a long cotton scarf, soaked and useless, to mop the sweat from my face. I smell. My signature scent includes the sweat from the relentless heat and days without a shower. I fear the bacteria-infested river water fed into the shower head more than the unpleasant smell. The DEET scent offends malaria, dengue, and Zika-carrying mosquitos—at least it did before the rain washed it away.

I walk on, now in the darkness, asking if we are lost. No one answers.

You ask and so do I: Why? Why leave comfort and safety, abandon the familiar to face the unknown? You expect me to provide some insight, some revelation about the meaning, something like getting back to basic human struggles, becoming humbled and releasing the illusion of control over . . . well . . . over everything, anything.

Doubts about my ability to continue onward grow with the volume of the primordial ooze that flows over the top of my footwear.

It's hard, and I am weak and whiny. I am smacked in the face with the reality I want to deny: Only these mud-soggy feet and exhausted legs can walk me out of here. No one will rescue me—no taxi, no search team, no airlift. Only me and whatever power I can muster will end the misery.

Like those challenged with far worse—the devastation of fleeing a home and a country destroyed by a madman, losses

and disappointments in family and friends, a world and weather gone crazy from humans' wrongheaded decisions—I must deal with the questions, the limited choices, the pain, the discomfort, the hunger, the heat, the misery, and the fear and find a way to survive.

Hardship births small kindnesses—a dry handkerchief, a peppermint candy to remove the bitter taste of the foul air, a smile. Misery spawns gratitude for what I once had and for what I still cling to. Yearning yields hope and it is hope that pushes me onward. A singular truth remains: Pick up my mud-and-leech-crusted feet and trudge forward.

The rain gets heavier—an impossibility, I'd thought—and shelter remains elusive in the shadows. I keep moving. I must. The light shines somewhere in the distance.

LINDA A. MOORE, the author of *Attribution*, a literary novel of intellectual survival, has traveled to all seven continents multiple times and completed sweltering jungle hikes and freezing Antarctic excursions to places where no human had been recorded to have set foot. She and a group of fellow travelers hold a Guinness record for having sailed farther south than any other vessel of any type. Learn more at www.lindamooreauthor.com.

Connections

Linda Ulleseit

War, social and political strife, climate change, homelessness, fire and flood, the pandemic—the news is full of tragedy. I try to do my part by participating in drives for canned food, socks, money, clothing, books. We no longer have single-use plastic bags in my house. Our front yard boasts drought-friendly plants with drip irrigation. I recycle. I vote in every election. Still, I am emotionally as well as physically removed from most of the stories I see on television and the internet. They don't affect my daily life and at times hardly seem real. There must be a deeper humane connection between people in order for them to truly help one another through the current crises and work to prevent future ones.

When I was a teacher, my school held a canned-food drive every year. It always embarrassed me that our school, in an upper-middle-class neighborhood, was unable to fill half as many barrels as the schools in the lower-income neighborhoods. To increase donations, I asked my students to each bring in two cans we could use as one-pound weights for PE

and we'd donate the cans afterward. One parent emailed me and said her daughter had already brought in a few cans, and I couldn't make her bring in any more. I was shocked that someone could deny a request that would not adversely affect them but would help someone else. My students didn't know anyone who was truly hungry. Unlike the schools who gave so much, my students didn't have the personal connection that made them empathetic. I tried to provide that for them.

One year, just before Christmas, I discovered that one of my students had recently become homeless. In this upper-middle-class community, a homeless student was rare. He was living in a car with his mother and older brother. Working with my principal, I was able to get them into a temporary shelter. All three sixth-grade teachers started a drive to support "a homeless student at our school" that was very successful and still respected their privacy. I'm sure some of the students figured out who it was, but no one discussed it. We collected gift cards for restaurants, clothing, toiletries, and even Christmas gifts. It felt good to give one homeless family a happy holiday, and it felt good to create an experience for my students that showed the importance of empathy, of doing what you can as an individual, and how close they really were to these issues.

In 2018, the Camp Fire destroyed the town of Paradise. At the time, my mother, my brother and his wife, and my niece and her young family lived there. I remember being glued to the computer as the fire approached the town that morning. I watched evacuations through hellish tunnels of flame with my heart in my throat. All of my family survived, but they lost their homes and possessions. At school, I told my class about my family—about my niece's children, who had lost all their toys and everything they held dear. Sharing my personal

tragedy connected them to the destroyed town. Spearheaded by a student in my class, we launched a fundraising effort that made it possible to send a significant relief package directly to my family that made Christmas possible for them that year.

Before vaccines were available, a friend of mine got very sick with COVID. She recovered without needing hospitalization, but it took her several months. She's what they call a COVID long-hauler and still has effects from her illness more than a year and a half later. I've seen how she struggles with unexpected brain fog, spells of exhaustion, and even partial hearing loss.

I've done all the vaccinating, boosting, masking, and distancing required, and it shocks me that so many people protest the mandates and refuse to follow guidelines. It seems everyone should be motivated by a personal COVID horror story by now, but apparently that's not the case. Rather than learning from scientists and survivors, anti-maskers insulate themselves and refuse to listen to survivors. Connecting needs an open mind, and minds can be hard to open.

Lately the US has seen terrible instances of police mishandling cases involving mental illness. They claim to have no training on how to deal with these individuals, so they go to their guns. I suffer from depression myself, and I have an adult son who struggles with crippling anxiety and depression. Boarding a recent flight, my son's anxiety caused him to violently shove his carry-on into the overhead rack, cursing the tight space in a loud voice as he did. I watched the flight attendant's eyes widen with fear. I knew she was worried about his violence escalating. I was able to calm him, though, and all was well for the flight.

I wish everyone with mental illness had someone nearby to help.

I recognized that flight attendant's fear because I've seen it

in the public school classroom. During the last few years of my career as a sixth-grade teacher, there was quite an increase in student depression, including two suicide attempts. One new student arrived in my class after the year started. She came with a long list of documented mental health issues in private schools. Those schools had kicked her out, but we were a public school and thus had to enroll her. She talked and wrote about committing suicide and used explicit sexual language. She even faked seizures while in class. I had never been taught how to help a young person that damaged! I didn't know how to help her.

One day, the student leaped across the desk to attack the school psychologist and was removed from my classroom to a more restrictive environment. When the other students asked about her, I—remembering how important it is that we change the dialogue about mental health to make it less of a stigma— talked to them openly about how their classmate needed some help and was going to get it, and I encouraged them to ask for help if they needed it. Going forward, I hope this experience will help them to be aware of the people around them who might not be able to voice what they need.

Issues that resonate most with me, I've discovered, are those with which I have deep personal experiences, and I'm convinced that the same is true for most of us. To solve and prevent major world catastrophes, then, we need to create connections with people across the globe, people of different backgrounds and experiences, people struggling in ways different from our own. But how do we do that?

My mother's racial prejudice was based in ignorance rather than hate. I say that to explain, not to excuse, her. Once, while the two of us were shopping at a local mall, we stepped into an elevator with a well-dressed Black couple and their baby.

"I just love little Black babies," my mother said.

I was too embarrassed to even look at the young mother. Why couldn't Mom just say the baby was cute, minus a mention of her race? I am a white woman who tries to treat everyone without prejudice or preference. It's only recently that I have begun to examine my own actions and words more closely, and to seek out novels and memoirs of Black women and other women of color. Through their words, I can build an understanding of their struggle.

The day after the presidential election of 2016, I had to face a class of stunned sixth graders who felt everything they'd been taught was right had been repudiated. Devastated myself, I felt tears run down my cheeks during the Pledge of Allegiance. How could I give these children hope for their future? We talked openly that morning, discussing what we knew to be true about how people should treat each other, sharing our fears and hopes for the future. Copying an idea from the internet, I had each student make a sign about their vision for the future and hashtag it 2024—the first year they would vote for president. They wrote statements like, "I want to be able to go to school with friends from all backgrounds" and "I want to be able to afford a college education" and "I want a fair chance at a career of my choice." They held their signs in front of their chests and I took photographs. Those photos were put together into a powerful film that made the principal cry. Although for privacy reasons I never posted it on social media, the film truly touched everyone who viewed it; it gave us all hope for the future.

When war recently broke out in Ukraine, I watched with horror and disbelief as civilians ran for their lives. I've never been to Ukraine, never known any Ukrainians, and, to my knowledge, don't even know anyone who has been to Ukraine.

I understood the politics of what was happening, but it wasn't until I saw a young boy in a Mickey Mouse shirt that I felt the wrenching in my gut. That pop-culture artwork connected me to every photograph I have of my own sons at Disneyland. Suddenly I was that mother, dragging her child through the rubble of our neighborhood. That one familiar image did more to put me in the middle of the conflict than any journalist's report.

The Metropolitan Opera staged its Concert for Ukraine on March 14. It didn't matter that the words were in a foreign language when Vladyslav Buialskyi sang the national anthem of his country; everyone watching could see his love and concern for his country. It's easy to relate to that sort of patriotism since in our own country we have seen attacks of a different kind on our democracy. The singer's emotion showed that he wasn't so different from any other American with ties to faraway homelands. Heartfelt connections were made that night.

As a teacher, I was in a position to create empathetic experiences for children, to teach them how they could help others, even if only in a small way. I'm no longer a teacher—but as an author, my words reach farther than the walls of a classroom. Books, together with artwork, films, music, and dance, can open the hearts of the world.

Right now, all across the world, people from all walks of life are telling us their stories via many kinds of media. We need to explore life experiences different from our own and begin true change by listening to these stories with our hearts. I believe in the power of the arts to grab people's deepest feelings and create profound change. By building empathy in ourselves and modeling it for our children, we can set the groundwork for connections that will truly change the world.

LINDA ULLESEIT writes historical novels based on family stories. Her most recent novel is *The Aloha Spirit* (She Writes Press, 2020). Her next novel, *The River Remembers*, will come out from She Writes Press in 2023.

Embracing Grief Might Be Just What We Need

Rica Ramos-Keenum

I didn't know my dad was dying until my sister sent the photo. I was living in Florida, watching Netflix on the sofa with my husband. Dad was in a hospital bed in Milwaukee, a puppet strung to life with tubes and wires. It seemed a sobering juxtaposition. But death happens every day; it steals the young and old while the rest of us curl up in warm beds beside snoring spouses or grumble about household chores, unwashed dishes, or dingy piles of laundry. It happens while we savor sunsets, toast friends, and snap selfies or peruse the internet for the perfect sling-back sandals.

I admit I wasn't deeply affected when my sister told me Dad's news. I thought more about how she was suffering than how the cancer-stricken man in the photo was faring. It took a while for the information to settle in my mind, a slow seeping

of sand in the hourglass. A trickle of blood from a wound that was opening.

I had never thought about Dad the way a daughter might think of her father. Certainly not the way my sister had thought about him. I hadn't spent Sundays with him in the sunny back-yard as he worked his magic with metal tongs behind the smoky heat of the grill. Those were my sister's memories. The ones I had were few and far between. Dad and I had a working knowl-edge of each other, and that had been all I needed. Until he died.

I'd imagined Dad during my teen years—dreamed about finding him again—because life was turbulent and I was searching for something to help me feel grounded. Wasn't he a significant member of the family tree, a part of the root system that had grown my siblings and me? I thought that knowing him would give me a sense of self, a sense of history. What stories would he tell, and how might they change my perspec-tive? Who might I be if the paternal void in my life were filled?

I was fourteen, maybe fifteen, when I found the divorce papers. I stood in front of the hall closet, the louver doors gaping, as I gawked at the forbidden metal box. Finding the paperwork was in many ways like finding Mom's unlocked diary. There were things I already knew: Mom had been sixteen and pregnant, and she'd married Dad because it was the '70s, her parents were God-fearing people, and having a baby meant taking a husband. Later, my aunt and uncle would tell me my parents' marriage was all wrong from the very beginning, a train that was meant to derail.

My memories seemed remote and uncertain, like folklore passed through generations. I was so young when they were together. As I grew up, I wondered if the images in my mind were real: the blue-gray halo around Mom's eye, the sunglasses

she wore to conceal it, Dad's rage, Mom's rage, high-heeled shoes flying across the room, along with Spanish curse words. My parents had three children together by their early twenties. More mouths to feed; more reasons to fight. And they did. But then came the great upheaval.

What followed was, in summary, a new dad who didn't drink himself sideways but did other, unspeakable things to me and my siblings. That he treated Mom well was enough for her, however, and despite the damage her new husband caused, she remains happily married to him. I've struggled to understand her paradoxical behavior—how a mother could be vigilant enough to warn her kids of the perils of strangers even as she serves pot roast to a predator at the family table. As for my ability to accept the situation as an adult, I ride a seesaw of conflicting emotions. I both love and miss Mom, even as I bid her good riddance. Sometimes maintaining distance is an act of self-preservation.

After Mom and Dad divorced, Mom forbade me to talk about their relationship or say my dad's name in any context. She'd gone to great lengths to pretend he no longer existed. This only made me want to know more, want to understand all the things Mom had buried in the soil of her hatred. It wasn't until my early twenties that I'd found Dad by way of my sister, who'd met my cousin in a bar in Milwaukee. When I finally saw Dad again, he was dark-eyed and charming, with brown skin and white teeth that shone bright when he smiled.

I'd envisioned our reunion as one of celebratory, fireworks-in-the-sky excitement, but it was sadly anticlimactic. I stood on the other end of my sister's kitchen, watching a stranger who looked vaguely familiar, like a face in a fogged mirror. Our conversations were casual, not deep or intimate. Did I believe

we could spontaneously, magnetically connect? Perhaps I was hoping that at least one of my parents would have the qualities described in the Hallmark greeting cards.

Dad and I had dinner once or twice, and took a trip to the pumpkin farm with my little boys on another day. I have a photo of my son riding a horse in circles around a fenced-in plot of gravel and grass. I'm not sure who had the camera. When I look at it now, I smell the haystacks and brisk fall air. I see the painted wood cutout that kids had poked their heads through to look like farmers and scarecrows.

After a few outings together, the fantasy of my father faded, as fantasies tend to do when they're no longer shrouded in the glitter of mystery and imagination. My sister forged a meaningful relationship with Dad, while I kept busy trying and failing to stay married, and to understand why my husband had taken a mistress. I attempted to restart my life, a newly single, working mom raising sons. The mistress had moved into my former house with my former husband. The plants died, the family photos were divided into two separate albums, and I went on without the interference of men—my father included. I lacked the emotional bandwidth for anything more.

I don't want to be a wallowing woman. When you're a certain age, it's just not a good look. But when I think of Mom and Dad, the word "nurturing" does not come to mind, and the pain sneaks up on occasion. How different my own experience as a parent has been. Yes, there were the "I'll trade these rotten kids for feral cats" years, and my son likes to tell a story about the time I stabbed him with a fork (it was an accident, I swear), but I've always circled back to love, and my heart could sharpen to a blade for their safety. Life would surely be unbearable without my sons. And now as a grandma (a very young one,

ahem), the sentimentality I feel as I dress my granddaughter in frilly skirts or sequined dresses borders on obsession. I have to fight the urge to parade her down the street like a Macy's Thanksgiving Day float each time.

My dad never saw my granddaughter, and he didn't get the chance to see my sons as adults. Though alive and healthy, my mom does not see us either, and hasn't expressed any interest in doing so. Sometimes I think about that and become outraged at the scathing rejection by these people I love so much. I can't comprehend it; even monkeys, tigers, spiders, and whales are fiercely devoted to their young. I see proud parents and grandparents everywhere, licking ice cream cones at the gourmet chocolate shop next to my office, sharing pictures of trips to the beach, or holding first-day-of school signs on social media, and it seems that the whole world is crazy about their children and grandchildren.

The obituary called Dad a beloved father of six, which means I have three half siblings somewhere. He died in March, a few days after my sister sent me his hospital photo. By the end of the year, the global pandemic had infected 83,832,334 people and caused 1,824,590 deaths. Cases were rising, and the headlines were screaming *death, death, death.* Call it dissociation, or grief, but what I felt was the sensation of falling. I'd landed on the other side of everyday life, my fingertips pressing against a glass barrier as the whole world moved out of reach.

Suddenly, I was locked up with shock, shame, fear, and grief. My father was gone forever, and I had nothing but the thin ghosts of a few memories and secondhand stories. As the word "death" drummed all around me, I wanted to die too. It seemed to be the least painful option.

I was seesawing again, but this time, both ends were loaded with sorrow. I sought counseling for the first time in many years,

but I was angry with myself for needing the help. I'd already done all the requisite trauma work. A few years prior, I'd written my first memoir about the hard years; it felt like ice-picking my insides—but it had been cathartic, too, and I'd filled the pages and closed the book thinking that was the end of that story. I thought trauma was well behind me. Now, newly married with a career I loved and a perfect princess granddaughter, wasn't it time to look forward with a sense of gratitude?

"I thought I was a strong woman, so why am I falling apart?" I asked my therapist. The silence between us was thick with foreboding. Was she going to say something cold and clinical, offer a diagnosis that would cut me down to size? *You're not as strong as you think, dear. The truth is, you are self-indulgent, a whiner. You might even be a narcissist.*

Thankfully, she was far more helpful. She gave me advice that felt like oxygen. Permission to breathe after a period of near suffocation. She said everyone responds differently to stress, tragedy, and hardship. Sometimes we're so tangled up in our busyness, blowing through life like tumbleweeds, that we don't notice what we're carrying.

Perhaps my father's death, followed by the pandemic, had jolted my pain awake. My therapist urged me to embrace my feelings, to feel what I needed to feel. Turns out, I had another memoir to write—a new tidal wave of words rising inside. Because there is no last chapter when it comes to grief. We don't grow up and age out of sadness, out of our right to cry until we feel whole again.

Some people mourn for years; others seem unchanged by their losses. They stuff it all down, hold it in their bones, so they can go on smiling, working, raising families, and baking birthday cakes. It was hard not to look around and watch how

others moved through life with grace, buoyant and hopeful. I was ashamed of my depression, embarrassed to stand in the pharmacy line waiting for my bottles of antidepressants. Wasn't I coddling myself? Couldn't I be more resilient? I didn't want to be the kind of woman who needed pills to get out of bed.

But I've learned to honor my feelings, and to stop berating myself when other people appear more agile than me. "Let yourself feel what you need to feel," my therapist told me. "There's no right or wrong way to grieve."

I try to remember that when I'm tempted to judge myself.

While I can't say my dad taught me to ride a bike or held my arm as I walked down the aisle to "Canon in D," he did leave me with a valuable lesson—the same lesson the pandemic has taught so many of us: death is inevitable. Of course we knew this already, but perhaps we can walk more intimately with the knowledge now. We can see the ways death's shadows make life appear more vivid, make love feel more urgent, and bring forgiveness a little closer.

My therapist recently asked me how I would feel if my mother died.

"I don't know," I said. "I really don't know."

"That's okay," she replied. "I just want you to think about it."

I pulled a tissue from the box in front of me—just in case I needed a good cry.

RICA RAMOS-KEENUM is the author of *Petals of Rain* and a forthcoming memoir, *Nobody's Daughter*. She is a full-time journalist, dog mama, and grammy of two toddler princesses.

Hand of Sorrow, 2022, oil on canvas

Hand of Sorrow

Susan J. Godwin

My family is from the region where Russia, Ukraine, and Belarus intersect. Those that remained behind were exterminated by Nazis. Today I am feeling a heartache, relived, for my people. This time I can watch, at least, and feel and care and hope. "*Never again, never again, we must never forget,*" was ingrained in us in synagogue Sunday school. I thought the adults were overreacting. *Impossible*, I thought. Now we know. It only takes one person. Remember that in 2024.

SUSAN J. GODWIN is an educator, author, and freelance artist who formerly taught English, creatively, at University School of Nashville in Nashville, Tennessee. She is a recent Oxford scholar with writing awards from the University of Michigan, Middle Tennessee State University, and Bread Loaf School of English. A columnist for *The Tennessean* once dubbed her

"Renaissance Woman," a nickname that close friends still use with humor and affection. Susan lives in the Tennessee hills outside Nashville with her supportive husband and loving Rotty.

Music of the Heart

Jennifer Katz

For much of my life, love songs seemed silly—overly sappy and sentimental. But after my husband's sudden, unexpected death, I began to understand these songs in a new way. Many love songs viscerally arouse the pain of disconnection. The sad, stricken lyrics describe an intense, unmet longing. Someone we yearn for is gone. Still, we long to touch this person, to hold them close. The slow, steady rhythms of the music vibrate like the thrum of a beating heart.

When I had been a widow for about eight months, a friend and I attended a live one woman musical review. Her show included a gentle, distinctly feminized cover of Don Henley's "Heart of the Matter." This classic love song about the aftermath of a breakup strikes universal chords. Who hasn't felt rejection or regret after the end of a relationship? Regardless of how or why a relationship ends, we grieve.

The poignant lyrics spoke directly to my loss. Hearing the lines about how to build a new life, alone, created a surge and swell of pressure under my collarbone. My chest tightened

further when hearing lyrics about relearning lessons from the past. By the final line, in which the singer mourns no longer being loved, my tears flowed freely.

This statement suggested a terrible new idea. I still loved my husband, intensely, with my entire heart. And he had loved me too. But could he love me still, now, in death? Now that he no longer existed? *No.* He would. But he couldn't.

Deep grief reflects deep love. I'd been incredibly lucky to love an extraordinary man. My husband was sometimes silly, sometimes serious, but always caring, even when he made mistakes. He valued closeness, without crossing boundaries, without demanding sacrifice.

For a long time, my husband's loving nature struck me as foreign and unfamiliar. As a child, I'd often felt disconnected from my dysfunctional, discordant family. Dad was rarely home, but when he was, he singled me out for intense affection and adoration. Our relationship inspired jealousy, separating me from everyone else. Mom punished me for my "favored" status. Possibly, she was trying to restore a system-wide balance. Also possibly, we just resented one another. Regardless, in different ways, each parent taught me that intimacy could be dangerous—distance was safer.

The effects of these early lessons lingered for years. Although I loved my husband, early on I also mistrusted his acts of love and generosity. Irrationally, unfairly, I caught myself wondering, *Is he using me? Will he take advantage of, manipulate, or trick me?* At times, I viewed his sweetness with a cynical eye: *Why is he being so sappy, so sentimental?*

Over time, I began to release my misplaced suspicions and irrational fears. My husband loved me completely and consistently, in ways that were unconditional and unselfish. By

the end of almost two decades together, I had opened to the beautiful rhythms of a harmonious love.

Even today, almost four years after my husband's death, love songs still pierce my heart. Maybe they always will. These songs carry me back to the precious time we spent together. Even if he doesn't love me anymore, he once did. And his love changed my life. Our years of harmony healed me. His soft voice of love vibrates in my memory, an unending melody.

JENNIFER (JENNY) KATZ is an adoptive mom and stepmom currently living in Western New York. As an academic clinical psychologist, she teaches and learns about gender, sexuality, and helping relationships. Her book, *The Good Widow: A Memoir of Living with Loss*, was published in August 2021 by She Writes Press.

Fighting the Boogeyman

Rita Sever

I have been texting with a friend in Russia. Amid sharing reactions to the last season of *Project Runway*—how we loved the diversity and hated Christian Siriano as the mentor—she gives me updates about life in Moscow during the war. There is still food on the shelves but there are limits to how much sugar and flour one can purchase. She is reminded of life as a child, when there was scarcity and people had to use coupons to purchase goods. Once she told me about her twelfth birthday, when her parents gave her a choice between a pineapple or Tolkien's Lord of the Rings series. She chose the books—and was ecstatic when she received both.

My friend now ponders how to respond to the world at war while she lives in a country that is sponsoring that war. She realizes that she is stuck in the frozen stage of fight, flight, or freeze. She tells me that she can't make any decisions, her thinking is fuzzy, she is literally hiding under blankets.

I feel maternal toward my friend. She tells me the options she is considering. I want to yell, "Get out of there—it is scary and unsafe!" But I recognize, even as I think these words, that it is also scary and unsafe here in the US. Where is it not scary and unsafe in the world? Especially for a Russian that the world identifies with their leader . . . or for a Ukrainian, a Black man, a Latina woman, a queer person, a poor person of any identity, a trans person trying to simply be their true self? The world is scary and unsafe.

Not so much for me. Scary, yes—but unsafe, no. I am a white, solidly middle-class, cisgender, straight woman. I am safe from most of the prejudices that drive hate. And in that safety, I can choose to look away. I can rationalize that I cannot directly impact the troubles in the world. Yes, I thoughtfully donate, and I stay tuned in to the world. I offer my mother heart and love to all the mothers in Ukraine and in Russia. And to all the Black and brown mothers who intimately know the pain of lives lost—and the ongoing pain of injustice and lost opportunity. But . . . none of that is enough.

We all face various Bogeymen in our lives. The Bogeyman is an archetypical character recognized throughout many cultures around the world. He typically is used as a threat to punish children for misbehaving. In the Russian version, he hides under the bed and grabs children by their ankles to steal them away. His name personifies the deepest dangers and fears that we confront in the dark. This mythic beast is almost always masculine. He is larger than life and comes in multiple shapes and sizes, but he is always terrifying.

Right now, Putin is the most obvious global Bogeyman, but he can also be seen in the police officer shooting Black and brown people. He can be disguised as an ultrarich businessman

hoarding resources and not paying his fair share of taxes. He can be the mean-spirited author of legislation outlawing health services for women or trans people. These are all very real and present dangers that are logical to fear.

I must also recognize and confront the personal Bogeymen that keep me hiding under the blankets in my life. These Bogeymen present clear and present dangers, as well as learned and practiced responses that create fear. The Bogeyman is tricky, too; sometimes he presents himself not as fear but as caution and contentment. He may even seem to be offering to protect. This Bogeyman will take on whatever guise keeps you safely frozen in fear or doubt.

Buried inside of me, this Bogeyman temps me to turn off the news so I don't have to think about war or oppression or injustice. He invites me to ignore racist or homophobic comments from family or friends under the banner of keeping the peace. The Bogeyman is definitely the part of me that prioritizes easy contentment over justice. He whispers rationalizations in my ear, telling me that I have nothing to do with the injustices of the world. He is the part of me that shrugs and says, "What can I do?" while the world burns around me.

The Bogeyman has been used historically to keep children in line. But he wields extreme power when he can also keep adults frozen. When we are afraid, we tend to hide in quiet. And when those of us who are not directly impacted by the war, by the pandemic, by police violence, by unjust laws and racist practices, remain silent, we are complicit and reinforce the power and the very real threat of danger to other people.

Bogeymen are born from fear . . . fear of the dark, fear of saying the wrong thing, fear of being uncomfortable, fear of making a wrong decision . . . so many fears. But when we are

able to look under the bed and name the truth, the Bogeymen start to disappear.

We must start by facing our own Bogeymen and acting to deny them the power they are so desperate to claim. When I acknowledge my privilege and take steps to make reparations, I slaughter a Bogeyman. When I decide to take an action in support of those who are experiencing true danger, another Bogeyman is silenced. When I realize that my contentment needs to be disrupted because it is built on unjust benefits, I reduce the Bogeyman's power. When I support radical self-care as a tool of revolution (which is very different than hiding in the dark), I shine the light under the bed.

These are not one-time actions. I have to keep acting, because when fear or love of contentment rises up in me, the Bogeyman is reborn.

It is not enough to dismantle my own Bogeymen. I must also respond to the world with compassion and I must bear witness to the courage and compassion of others in spite of the Bogeymen under the bed. When we can reclaim our communities, we will find power in solidarity. If we can join together and recognize our strength, we too can rise up and banish the Bogeymen. We can care for each other across our differences and across cultures.

Our weapon is compassion. When we lower our shields and raise our compassion, however, we will no doubt suffer. We will be recognized as a threat by the mythical and the living Bogeymen, and as a result some of us on the front lines will no doubt be killed, while others will be injured or imprisoned. This is not another fairy tale to counteract the dark myth. The Bogeyman will not be slayed easily or quickly—but the only way to create a just world is to raise our love and act with courage and compassion and unity.

Eventually, the power in the world will slowly tilt. It will not be a magical victory; it will be tiny, gradual steps toward equity, made possible by unharnessed compassion. Our work will never be done, because there will always be those who lean against us and toward fear and power and extension of the status quo. But eventually the tide will turn and the world will once again celebrate humane values, and the world will bloom anew.

We cannot realistically know whether or how or when this will happen. But in the dark, when the Bogeyman is trying to drag me away, I choose to act in the belief of compassion and justice. I refuse to live in any other manner. In that moment, my fear abates and I can see my next step more clearly. I can poke my head out from under the blanket and see others doing the same. I can remember I just need to take one step at a time. And then, as I take a deep breath, I feel the grip of the Bogeyman loosen around my ankle—and I keep on keeping on.

RITA SEVER is the author of *Leading for Justice* and *Supervision Matters*. She works as a consultant with social justice organizations throughout the US and is proud to be a member of Roadmap Consulting, whose mission is to strengthen social justice organizations through capacity building, peer learning, and field building.

Time

Antonia Deigan

This is war.
This *Time* is war.
This is hands on deck, hands on enemy fire, hands on the
enemy's armored tank.
This is war on drugs and war on hate and war on
disease, where the enemy will disguise itself and censor
reality, or reshape, or mutate, or regurgitate nonsensical
gobbledy-gook,
and torment,
pestilence,
murderous death.
This is war on us.
Choose love.
Deal compassion.
Embody art.
With *Time* as your commodity and witness, offer touch,
solidarity—improv;
riff the good stuff,
cast out your soul.

Fancy life.

Destruction began forever ago, men conquering civilizations, bullying, bloodshed and blindsides, for what?

COVID started when? With HIV? At last look, it joined a list of twenty (that we know of) with typhus and bubonic, influenza, cholera, smallpox. It isn't as though the ones with the intellects and passions discovering how to combat these diseases aren't trying. It takes *Time*.

At the bedsides of our dying loved ones, we hold hands and offer prayers,

we hum, hum, hum

and sing for each other,

we paint

and rock

and stretch

and lift,

we dance.

In spite of the IV drips and poisons meant to heal.

In spite of the awaited rattle.

We become connection.

We kneel and tinker with deep hope. We turn conversations toward our hands that dive into our pockets to drop coins and dollars into millions meant for those in crisis because sometimes,

if enough,

if enough,

if enough, astonishment, cherishment, ravishment stirred by holy thought and compassionate minds, we

load up

sync up

rise up

speak up
draw out
color wild
feel purpose
feel the injustice
seek peace
seek peace
seek peace
for fuck's sake.

There is evil and there is plague,
And there is opening your heart in the morning just after
lifting eyelids
to blink
and bet on beauty
rip open love
silence fear
pray.
There is *Time*.

ANTONIA DEIGNAN is a mother of five adults and a She Writes Press author. Her memoir, *Underwater Daughter*, will be published in May 2023.

Finding Home

Linda Joy Myers

We all remember when the world stopped spinning. March 2020. Lockdown. Orders to stop everything: Parties, weddings, graduations. Eating in restaurants. Commuting and working in offices. As a therapist, the life that I'd known for forty years came to an end.

The lockdown of the pandemic forced us to reshuffle our lives. "Zoom" became a buzzword that didn't mean "move fast." A new life evolved: online. We all lost so much, but for many of us, hidden opportunities and gifts revealed themselves. Still, each day presented a challenge: how to cope with feelings and losses, and how to welcome new doors opening in our lives that we could never have predicted.

I began an early-morning routine—making coffee, whirring foam for my latte, making cinnamon toast. Staying at home for many long days in a row, I found myself meditating on the shape of the day as the light illuminated my house. The angles of sun, the silence without traffic, were foreign and interesting to contemplate. Though I appreciated the blessings that

appeared, I wrestled with the idea of letting go of a life I'd taken for granted.

Being forced to stay home and do without the joyful moments of sipping a latte while writing, or treating myself by going out for a glass of wine or a nice dinner, seemed the cruelest punishment. I live alone with my kitties and had long looked forward to going out each day to exchange banter with waitresses who'd become close acquaintances. We'd talk about travel and my next trip to France, or theirs to some exotic place. We'd discuss the state of the world or my new novel—they recognized me by my notebook and pen on the table.

I accepted intellectually that being out with other people was dangerous, but being forcefully imprisoned brought up old memories. When I was a child, I was indeed a prisoner in my grandmother's home. She'd rescued me from my practically orphaned state when I was six years old. For a time, we were friends, but as the years went on, her unexpected rages, the danger of a slap or an assault of endless words of criticism about me or my parents, made me tiptoe around the house. She had utter control of my movements until I left for college. To disobey or to have ideas that did not fit with her wishes and distorted beliefs was dangerous.

As I grew up and married and lived in homes of my own, I always needed to find ways to escape. I had to get away, even if things appeared to be happy and peaceful. I would spend hours in a café multiple times per week.

When I had children, getting away was more problematic. If possible, I'd take them on long car rides or trips or treats to the beach or the hills. If not, I would steal time away, just a little more time for me. Guilt would wash over me, but I had to go, had to get out—or else. I couldn't breathe, I felt unbearable

anxiety. Keys in hand, the car offered me a quick respite, and then I could return, feeling freed from the sense of imprisonment at home.

But during the pandemic, escape was not an option. None of us could escape from the fear of the disease and the unknown. Something scary was waiting to strike. Many of us are still coping with the effects of this incarceration—depression, loss, and grief for all that was lost.

Now the long, languorous days of the sun's arc over my house are a gift. My garden has become my palette. The new flowers I began planting when the pandemic began lift their faces to the sun. I began to see the artistry of the petals, how the baby leaves and new flowers reveal the essence of our own creative journey. The flower will open in its own time. A flower is the exalted moment of the plant, a sign of thriving. Of joy. The flower reaches upward toward the sun. To produce the flower, the plant must labor to create in underground, invisible realms.

I began to see this as a parallel to the creativity hidden in our unconscious minds. In dreams. The plant needs fertile conditions to encourage its flowering, as do we. Creativity, in life and art, has its own timetable. I learned to surrender to the unfolding of my own development and healing, even as I was unaware it was happening.

During quarantine, there were many hours in which to contemplate new layers of thought and consciousness. And the unfolding of the creative process. This flowering became part of my life in unexpected ways. I always had various writing projects going, and even more ways to escape digging into them. Now the pandemic offered me hours of uninterrupted writing time.

My new project was writing a novel about France during

World War II (interestingly, the theme had to do with escapes and imprisonment!). I'm a memoirist, but I'd always been fascinated by World War II, having grown up with adults who frequently reminisced about those years. My grandmother, who'd traveled to England in the thirties, encouraged my interest in history—one of her many positive qualities. We watched documentaries about the war—the fiery Blitz on London, the fall of France, and shocking stories of the Holocaust. My fascination about that history grew, and in my twenties blossomed into an obsessive curiosity: How could such a terrible conflict have happened? How had Hitler come into power? How had the whole world gotten involved?

I read deeply into that history for the following forty years, which led me into exploring the complexities of France during that war. History books hinted that France's official story about that time was not the whole truth.

There's nothing like a mystery to get me further obsessed.

Eight hundred books and two trips to France later, I discovered that a novel was beckoning me. *Me—write a novel?* I thought. *I'm a memoirist—I teach memoir, I have a memoir organization.* "Novelist" was something I'd long aspired to but ultimately rejected, convinced that it wasn't me. But it beckoned to me, especially after my encounter with Cesar.

My research took me to southern France. I stood on top of the Pyrenees at the border where the *Retirada*, the retreat of Spanish refugees fleeing from Franco, took place in the dead of winter in 1939. It was a tragic event: many died on the road, machine-gunned by Franco's air force. A memorial by the road tells the story.

From where I stood, Spain and France and the big blue Mediterranean Sea were spread before me. It was a place of

history, of memory. I've always believed that on the earth, a place where something significant happened carries its own memory traces, its own imprint. As the wind caressed me and the scent of rosemary and dirt filled my head, someone, a being from who knows where, started whispering in my ear. He told me his name was Cesar and he asked me to write his story—the story of the refugees who'd made the trek over this mountain to France.

My shoulders dropped and anxiety filled me. *Me—write your story? Am I capable of this?* I closed my eyes and tuned into this sacred place. Here, people had died as they fled for freedom and democracy. How could I say no?

Being forced to stay home and discovering ways to tune in to what had seemed impossible—writing a novel—taught me to stop escaping. I began a practice akin to mediation: I'd sit down and face the feelings that were uncomfortable. I practiced a consciousness of staying home and discovering that it *was* my home—I'd created it. Home became my place to *be*, my sanctuary. I found myself finally, for the first time, feeling safe. Everything around me was something I'd chosen—a thousand books I love, fine art prints on the walls, happy plants, two purring kitties, and comfort. Sunlight poured in through my windows. And all around me, my huge garden of trees, roses, and flowers were my companions. The daily mantra "I am here, I am in my home" turned into a gift.

Home was no longer a prison. I was freed from the past by simultaneously entering it through my novel and paying attention to the dark moments of my own history. I learned to sit with all that, like a friend. I embraced the anxiety and the old fears. Sometimes I let it all fill me, and then relief would

overcome me in a rainbow of colors. This kind of meditation—a sitting with and being with myself—allowed a transformation.

My novel is on its way to completion. I've learned to embrace my characters and their stories. No doubt they are all aspects of me: an artist, a musician, and a healer. They are imprisoned in their struggles for freedom. They must face a war and Nazis. They discover that they have to draw upon creativity and love to find their way.

This spring, I'm free to go where I wish. The mandates are gone, and we can hope that COVID is nearly vanquished. But even though I'm free to leave—to go have coffee in a café or eat a meal in a restaurant—for the most part, I don't. I choose to stay at home. Released from the bondage of the past, I'm free here now, where flowers and the smell of earth announce their place in my healing story.

LINDA JOY MYERS is the president of the National Association of Memoir Writers and the author of two books about the craft of writing memoir. Her own award-winning memoirs, *Don't Call Me Mother* and *Song of the Plains*, were published by She Writes Press. Linda Joy looks forward to the publication of her first novel, *The Forger of Marseille*, in spring 2023.

Flight

Joan Cohen

Death seems to reach out and touch us from our high-resolution, wide-screen televisions, tuned as they are to the twenty-four-hour news cycle of cable TV. Every video I see reminds me of my grandparents, who fled the Ukraine over a hundred years ago. One couple brought two children across the Atlantic with them and had one more—my father—here. The other had their children in this country, including my mother.

As a kid, I thought my grandparents were ancient, yet when they came to America they were in their twenties. All four of them arrived in the first decade of the twentieth century. They were escaping the pogroms, anti-Jewish riots, and officially mandated slaughter of Jews taking place across Eastern Europe and Russia. Had they stayed in the Ukraine and survived, they would have eventually perished at Hitler's hands.

Ukraine wasn't a country then. It was part of the Austro-Hungarian Empire ruled by the Habsburgs. My grandparents lived in a territory of western Ukraine and southeastern Poland known as Galicia. When I tried to locate on a map the

towns and cities my grandparents came from, I had to first deal with myriad spellings that were heavy on consonants. One grandparent came from Czernowitz (now Chernivtsi), another from Kolomea (now Kolomyia). Lvov was the easiest because it's now Lviv, but I couldn't even find Gwozdziec, about twenty miles from Kolomyia, until I learned it is now Hvizdets.

The young people in my family want to know where my grandparents thought they came from. I wish I had asked them while they were alive. I know one said he was from Austria—understandable, since Vienna was the capital of the Austro-Hungarian Empire until it fell in World War I. Another grandparent spoke Polish and lived close to the border with Poland. They all spoke Yiddish and all mastered English once they were in the US.

My grandparents—Joseph and Jennie, Louis and Pauline—weren't always the old people I remembered from my youth. They were at one time young, fresh-faced, and seeking a safe home. Yet I never thought much about them that way until now. Now, I ache for the Ukrainians I see on my television as they run for the border amid shelling, or even die, while I watch, safe in my living room.

Has anything good come from this war? There is much to write about in witnessing the heroism of the Ukrainians, the generous help provided by caring people around the world, and the selflessness of journalists risking their lives so we can see what they see.

On a personal level, though, this war's value has come from an awakening of interest among the young. I'm not sure my young family members could have picked out Ukraine on a map before this war. It was one of many European countries in their history books. Now I can be the bridge between generations

with stories—stories of our family—that make the history real.

My grandparents fled Eastern Europe over a hundred years ago, yet people who look like them are still fleeing. Maybe they always will be, or maybe those who are young today will be inspired to end the flight.

Originally from Mount Vernon, New York, **JOAN COHEN** received her BA from Cornell University and her MBA from New York University. She pursued a career in sales and marketing at computer hardware and software companies and after retirement returned to school for an MFA in writing from Vermont College of Fine Arts. She has been a Massachusetts resident for many years; she now resides in Stockbridge, in the Berkshires, with her husband and golden retriever.

Hope from Simple Fruit

Kathy Elkind

Have you tasted an olive right from the tree? It's bitter like tar. Even dust tastes better.

My husband and I have been walking through olive groves for hours on this late November afternoon. We're on a walking adventure in southern Spain.

In the distant hills, motorized olive-branch whackers drone on and off. A new way to harvest olives. Yesterday we saw a tractor with an attachment that grabbed the tree trunk and shook it like nothing I had seen before.

Who thought to brine olives? Who thought to squish them and collect the oil?

The tiny bit of black flesh I nipped with my front teeth lasted four seconds in my mouth before I spit it out onto the dusty farm track.

Jim smiles at my antics.

"Here's an almond tree," he says, reaching up and snagging a handful of nuts off the straggly tree. He places one on

a boulder that marks the edge of the orchard, then smashes the tan shell—the same color as the dust—with another rock. He carefully peels two layers of shell and husk away. The dried-up nut enters his mouth but it, too, comes out in less than four seconds.

He tries again to bash the outer layers and get to the inside. Two out of six of the nuts are edible. One for him. One for me. That one almond is a prize.

We connect to the struggles of all the people who have come before us in gathering food. In our world at home, almonds come from plastic bags. Olives come from salty brine in plastic containers. The work done for us. The work hidden.

Here out on the trail we may have a plastic bag of almonds in our backpack, but we get a whiff of what it takes to prepare food for consumption. We experience the work. We experience hope.

Around the corner in the near distance is the white village we are heading toward. The sun hovers a few inches above the horizon.

"There's a fig tree," I say, searching every stem and leaf. "But no figs again."

Yesterday I found a fig tree with many young green figs the size of my thumbnail. The day before, another covered with dried figs, rock-hard. I don't understand fig trees. They are a mystery. They grow near abandoned stone ruins. They grow on the side of the road. But we have never seen a fig orchard.

Now we walk through ancient olive trees. Their twisted trunks become beautiful dancers with contorted bodies. To the left the land falls away, offering far-off views of the Mediterranean as it prepares to accept the setting sun.

One kilometer from town, we approach a pomegranate tree. Like the almond tree it is straggly, unformed, unpruned. Most of

its small fruits have split open like flowers but are still attached. Wasps of many shapes and sizes gorge on the sweet juices.

Finally, I see one that is whole, but I can't reach it. Without a word, Jim reaches high and, careful not to disturb the insects, plucks it. He hands it to me like the gift it is.

I pull out my knife and carefully slice and pull, slice and pull. The ruby jewels, exposed to the world, pose a sharp contrast to the dusty landscape. I offer half to my companion. We each place one ruby bead in our mouths, like mirrors.

Juice, slightly fermented; sweet nectar dances on our tongues. Then the crunch of the seed. Juice and crunch. Two for one.

Grateful to walk freely through the ancient countryside eating pomegranate seeds, one by one. One by one. Footstep by footstep.

KATHY ELKIND is a writer, walker, and eater. She is the owner of Elkind Nourishment. Her memoir of walking across Europe on the GR5 will be published in the fall of 2023. She lives in Fayston, Vermont, with her husband.

Gentrified

Bobi Gentry Goodwin

The man's hot breath met me as soon as I walked into Sabarino's deli—"The line is too long."

The door handle barely closed behind me. The large bells attached to the door announced my arrival. A half-hearted welcome rang out from someone in the back kitchen.

My glasses started to fog as I inched in. I glanced toward the corner at the rusted heater cranking out hot air as I inhaled the smell of sweat mixed with aged cheeses permeating the room.

The tall man stationed in front of me exhaled loudly. His tanned knuckles whitened around the handles of his briefcase. His gold watch glimmered underneath the sleeve of his black Patagonia jacket.

I inched closer, then took a quick step back. "How long have you been waiting?" I asked.

His neck turned quick, like he was backing up his car, and his caramel brown eyes met mine. His lips pursed. "Fifteen minutes!" he barked. His neck swiveled back into position too fast for me to say thank you.

"Tim Tim!" I yelled out at the Italian deli owner's son. Immediately my mind was flooded with the memory of the time he chased me to the next block after I snuck out of the deli without paying. We dated shortly after.

Everything looked the same in my neighborhood deli except the patronage. Same staff, same floor, fire-red seats, and metal napkin holders resembled the St. Louis Gateway Arch centered on two small round tabletops. The smell, the décor, and even the staff was a familiar warming of home.

"Twenty minutes!" the customer in front of me barked again.

My ears heated up faster than the rest of my body. I bit my lip, irritated that I asked him in the first place. I could hear my mother's voice bubbling up in my heart, telling me to be nice. My hands found their way into my pocket. Rubbing quarters in my pocket has always calmed me down.

The tactile stimulation kept my hands busy as time moved slowly. Fifteen minutes later, the quarters had been joined by a couple of lint balls. I might as well have been playing dice, because I hardly noticed the obscenities spewing from the tall man as he turned on his heels, pushed past me, and headed toward the exit. My lips curled. He didn't deserve Sabarino's.

I inched toward the tall white meat case, keenly aware that this might be the last time I'd see it. The refrigerated case loomed large in the small establishment. The top almost hit me at my chin when I wore my brown suede boots with the two-inch heels. I was so proud when I discovered I could reach over it to claim my usual. Salami, pastrami, and blocks of ham laced between swiss and provolone cheeses and surrounded by jars of olives and pickles created a beautiful tapestry. Fresh piles of French bread were packed high in wire bins behind the counter, to the side of staff stuffing hoagies with fresh meat and cheeses.

A slow wave in the corner caught my eye. The matriarch of the Sabarino clan still managed her lunchtime station in the corner, handing out melty cheese samples. Her smile was just as beautiful as it had been twenty years earlier. My hand found its way out of my pocket, acknowledging her recognition. My chin dropped to my chest as I took in the checkerboard floor, which looked more gray than white these days. Nostalgia cast out the sadness developing in my heart as I stepped on the familiar crack in the linoleum. A small reminder that my turn to order was inching closer. Mixed emotions clouded my mind.

"Do you see what time it is?"

I stumbled back onto the crack as an Apple Watch flew toward my face.

"This place!" Another exasperated patron huffed and headed toward the exit door.

"Yeah, this place!" I barked as I took his place in line. My braids brushed frantically against my cheeks, as I could no longer hide my irritation. I inched toward the white glass case, keeping my distance from the six or seven customers standing ahead of me. I wanted to be in this line. I wanted to be in this neighborhood. The forty-five-minute standard wait time at Sabarino's filled my history. I'd had many firsts in here. The first time soda flew through my nose. The first time I held a boy's hand. My first kiss with Tim. The sea of memories bombarded me.

I looked back toward the front door and surveyed my old neighborhood. This neighborhood—my neighborhood, my home—once so familiar to me, had changed. This deli was the last connecting link from the old neighborhood to the new. The bowling alley on the next block had been torn down three years earlier and replaced with a Whole Foods. Concrete rocks were carried away from the scene, snuggled in the arms of bowlers,

cementing what the monument had meant to them. The local neighborhood kids once stationed in front of the bowling alley had now disappeared too. In the opposite direction was the new Starbucks, which replaced the old neighborhood's favorite coffee shop. The place where my dad met my mother.

Mom-and-pop shops were not the only thing that had been replaced. The mothers and grandmothers stationed on stoops, watching out for everyone else's children, had relocated too. Selling their homes to the highest bidder, unable to afford escalating property taxes. My neighborhood was now no longer my own either. A real estate investor made my landlord an offer he said he couldn't refuse. He had no idea an extra four hundred dollars a month didn't fit into my budget.

I thought I could handle my emotions as I said goodbye one last time, but the pain labeled "progress" hurt more than I'd ever imagined it could. The anger that began with unreturned emails from the faceless corporation that purchased my building had been replaced with languishing feelings of powerlessness. It was hard to leave the atmosphere that raised me, my mother, and my grandmother. Daily, I struggled to feel revitalized like the remodeled buildings on every corner, but my heart simply couldn't be refaced.

I didn't hear Tim call my name as I two-stepped back and forth between what was and what is. The gap between me and the next customer was a gulf. The line danced out of rhythm as my nervousness hung in the air; I felt unsure of exactly where I belonged. My hands reached for the quarters in my pocket as I lunged forward to catch up to the woman in front of me. I inhaled, ready to place my final order.

"What's new?" Tim yelled out, his head bobbing in a familiar fashion.

Our eyes met.

"Everything!" we uttered together, a deep understanding piercing both our hearts.

BOBI GENTRY GOODWIN is the author of the novel, *Revelation*, and a native San Franciscan. The Bay Area was where she first discovered her love for people and their stories. She has held a passion for writing since early childhood, and as a clinical social worker her mission field has been working with women and children. She enjoys tea, hot showers, and living out loud.

What to Say to Ridiculous People in Unbearable Situations

Julie Ryan McGue

When my husband and I were raising our four kids—their ages spanned a decade—dealing with their various developmental stages meant shifting gears on a dime. One kid would be on the downhill slope of puberty's emotional roller coaster while another one was dealing with plain old thirst or hunger. Family life was an exercise in triage: deal with the most unhappy person first, and then go down the list.

On one of those weekends when my husband and I agreed to divide and conquer—e.g., he had two kids to tote to Saturday AYSO soccer while I had the baby with me at our eldest's hotter-than-heck indoor swim meet—he coined a phrase that, today, still gets the family giggles going.

After soccer game number one, my hubby hustled the "middle" kids into the car. He was in a race to cross town to the next kid's

soccer game. Sweaty soccer star number one squealed and whined. The tantrum no doubt had something to do with missing out on the sugary treats being handed out equally to winners and losers. My husband scooped up the malcontent, plopped him into the back seat, and clicked the seatbelt. This manhandling only intensified our entitled little athlete's histrionics.

My husband snapped, "You can't always get what you want. Get over yourself."

"Get over yourself!" *Isn't that a beaut?* This phrase has become my favorite comeback when dealing with ridiculous people in unbearable situations.

One week into 2022, just as the Omicron variant showed signs of slowing down, I slouched, bleary-eyed, in a hospital waiting room while my husband underwent surgery for cancer. I glanced up as a couple entered the small area and checked in with the staff member at the desk. When a nurse led the husband off for surgery, the wife took a seat close to me and the electronic patient-progress board.

But she didn't settle into the cushioned vinyl seat. Seconds after sitting, she stood. She paced. And then she strutted back up to the desk.

In a clear voice, she said, "We were scheduled for the first surgery slot, but got bumped. My husband's procedure was set up three weeks ago."

To which the desk attendant said something like, "The surgery schedule often changes."

I heard all this while rummaging in my purse for a nail file.

The woman wandered back to where she'd left her things. Standing, she surveyed the room. When I peeked up at the surgery board, her eyes whipped to mine.

"Is your husband here for surgery?" she asked.

Thinking she was looking for a friend with whom to commiserate, I answered quickly, "Yes, he is."

She leaned toward me. "What time is his surgery?"

In retrospect, I suppose that if I'd had enough coffee in me, I might have realized where the conversation was headed.

"It started at 7:00 a.m.," I said, squinting up at her.

"Who's the doctor?" she persisted.

My brain was still resting on a warm pillow at home, so even though her query blew several HIPAA bells and whistles, I supplied the surgeon's name.

"Aha," she proclaimed, puffing herself up like a proud detective who'd just unearthed the final clue to a tricky crime case. "You took our spot."

You took our spot?

My voice stalled at the back of my throat while my brain screamed curses like "you are just a nosy busybody, a troublemaker, and a HIPAA violator."

Eventually, my tongue scooped up more appropriate words. "I'm sure the surgeon had his reasons for changing the schedule."

And then I dished her a benign smile and turned my head away.

I dismissed her. Not because I wanted to be rude. Not because of her insensitive breach of my family's privacy. But for the sole reason that I was stifling an evil chuckle.

You see, what had suddenly popped into my head were the words: *Get over yourself!*

JULIE RYAN MCGUE is an American writer. Her debut memoir, *Twice a Daughter: A Search for Identity, Family, and Belonging* released in May 2021. Julie writes about finding out about who you are and where you come from, and making sense of it. Her work has appeared in the *Story Circle Journal*, *Brevity*, *Imprint*, and *Severance Magazine*, as well as at Adoption.com, Lifetime Adoption, and Adoption & Beyond.

Her Name
Is Natasha

Sophia Kouidou-Giles

A young refugee raises her head from her morning slumber; her face is thin, her eyes dark. She has been sleeping in a basement under a kindergarten where children used to play and giggle in days before bombs fell and shuttered their world. It's a windowless cement box, but it's safe.

Her first waking thought is to make sure her parents are with her.

Her shirt is stuck to her body, wet with the sweat of nightmares—nightmares born of days walking on the rubble of torn streets to find food for her parents. She is part of the mass of humanity that just days ago took the city bus to work or school and then back home, dismissing the threat of war. They will have to part from their beloved city for worlds unknown, in hopes of leaving the chaos behind, daring to believe in a new start that pushes away this dread.

Yesterday, the three of them were late getting to the tarmac and couldn't get on the transport. They do not know where their relatives are, and there is no point in returning to the village. Still, a bus is waiting for them this morning. They are among the lucky ones, able to flee their torn home. They will be refugees—a harsh word, filled with humiliation. Where will they settle? What will turn out to be their home?

She looks at her parents—an aging couple, her father already stooped from the years and her mother leaning on a cane. They look at her expectantly, say, "You are awake!" Still, there is some solace in knowing they will be able to lean on each other in the days to come.

The world is turning on television sets to watch and cry for them; the world is sending them support. Will it reach the city? Will it be on time? They can't wait any longer. The danger is high. Journalists wearing helmets and bulletproof vests broadcast scenes with soldiers, tanks, airplanes, flags, and devastation. They hear the explosions and the sirens, but they don't see the broadcasts or hear the pleas, the leader negotiations that fall flat. All they know is the horror inside and the hope that they can cross the border.

"Natasha, lead the way," her father says, already up and dressed. "We'll miss the bus!"

So recently—it seems like only yesterday—Natasha and her parents were talking about the Syrian and Afghan refugees escaping on precarious life transports, gray lifeboats in the cold Mediterranean Sea, wearing orange vests, hoping to make it to a shore. They contributed money to aid the millions of Yemenis, half of them children, starving in a remote part of the world.

They are about to earn the same stripes. It's not the first time the world has been saddled with a refugee crisis. On the

global scene, it's a daily event for an astonishing number of dislocated people barely tended to by governments and politicians. Amnesty International records over twenty million refugees in the world today. The root cause? War, ambition, age-old claims about empires, desires for domination, grabs for power, and insidious suppression of the weak, the starving, the poor.

The subject of refugees is personal to me. My Greek homeland is a country largely populated by people of the diaspora—like my own father, who came to Greece escaping the Turkish genocide of Greeks nearly a century ago—and yet leaders don't learn. Tragedies repeat and countries are often reluctant to welcome refugees.

I remember hearing stories about how it was for my parents during WWII, the years of deprivation and danger. My father's family survived because he found shelter in a tent at the beach to house him and his parents. Perhaps Natasha's family will land somewhere safe and find shelter on their journey. Perhaps there will be friendly people extending a helping hand.

Natasha had dreams. She still does. Her parents raised her in a house in the narrow streets of Kiev. Lately, beginning to learn independence, she was living at the university lecture halls by day and loitering in cafeterias with her friends in the evening. But her family's house is no more, and her parents now need her more than ever before. She dreams of becoming a violinist like her father, of studying in Budapest, the city they call Queen of the Danube. Instead, she is surrounded by the destruction of war, living in a place where families hide by day and count their dead by night.

Now she gets up, raises her eyes to the sky, moves to pick up a backpack she prepared last night. She motions to her parents she is ready to go. Her name is Natasha, and her youth

fuels her courage. The sirens are quiet. It is a good time to walk to the terminal, where freedom awaits.

Godspeed!

SOPHIA KOUIDOU-GILES was born in Greece and lives in America. A daughter of refugees, she is also a writer, poet, and translator. She published her memoir, *Sophia's Return: Uncovering My Mother's Past*, in Greek and English. Her novella, entitled *An Unexpected Ally*, is forthcoming.

I Wrote My Will Last Night

Lynda Smith Hoggan

I wrote my will last night. In bed. In my head. But I will put it down on paper and get it to an attorney as soon as I can.

Some of my affairs are already in order. Several years ago, I asked my sister to go with me to prepare living trusts. That's the protection you need if you own property and don't want your will to go to probate. Probate is a pain in the ass for the person(s) left behind. If I die before my sister (and it's likely I will, since I'm quite a bit older), she's already going to be dealing with grief and many other pains in the ass, so why not remove some of them, if I can? I also want her to have her own trust, to help me in case she's the first to go—because one never knows, right? I could be an old lady having to deal with the heartbreak plus the stress. So, we did the trusts.

But I never got around to doing the will part. That's where you identify things such as what to do with your personal belongings, what to do with your body, whether you want

a memorial service, and so on. I did have a fantasy of what I "hoped for" (ha!) After I died—either at home or in some facility nearby—I wanted my sister to take the things that she wanted and then have a party at my house. Invite my friends. Serve food and alcohol. Play Motown and Santana. Share stories about time spent together. And then choose items from my stuff that they like or need—photos, plants, furniture, kitchenware, books, art, music. They could enjoy those things, and there would be less for my sister to dispose of.

But unless I die soon—and that is not the desired outcome, either—it's unlikely that it will go that way. I am in the process of moving to Northern California to be closer to my sister, the only one left of my nuclear family. I know a couple of people there, but my friends from SoCal might have trouble making it to my cosmic send-off party up there. Still, I want a will to make it easy for my sister to know what to do.

Why did I let this go until 3:00 a.m. last night? Because my own mortality had not actually been real to me. In spite of my advancing age, I'm pretty healthy. The worst thing I've had to deal with is spinal problems that have limited my mobility somewhat. But they're not going to kill me.

What might kill me is the novel coronavirus. COVID-19. A global pandemic worse than any I've ever seen. If I've seen a global pandemic, it was HIV/AIDS. And COVID-19 is a lot easier to transmit than HIV. To contract HIV, one must allow one of only four body fluids (blood, semen, vaginal fluids, or breast milk) into one's own "portal of entry" (bloodstream, wounds, or mucous membranes). Blood donations are tested now. Pregnant women are tested now. So for most of us, if we don't share needles, and if we do use protection for insertive intercourse, we can avoid getting HIV. I'm not going to say

these are simple acts, because sexuality, and addiction, are not simple. But to get COVID-19, all one has to do is touch something, or breathe.

I touch things constantly. I breathe on a regular basis.

And I see how quickly this disease progression can go. One day you're healthy. The next day you're not. The next you're in the hospital. Then the ICU. The day after that, you're dead. So many dead. Not enough body bags for all the dead. Not enough refrigerated trucks for all the dead. Families trapped at home with their decomposing dead loved ones. Unthinkable.

You know what else is dead? Right now, my faith in the democracy of my country. Oh, I've always known it was flawed. There's been racism, sexism, unscrupulous politicians, corporate greed. Two steps forward and one step back throughout our history. Even when we had our first Black president, young men and women of color were being shot dead in the street by police officers who'd promised to protect and serve them.

But what has happened to allow a failed "businessman" (and isn't that an oxymoron)—with six bankruptcies, thievery from charities (charities!), a draft dodger, a man who says "grab [women] by the pussy," who has many sexual assault charges, who makes fun of disabled people and war heroes, who rejects science, who pretends to be Christian, who won't allow refugees into our country (my beloved grandfather was a refugee, you MOTHERFUCKER), who puts children in cages (children!), whose stupidity and vanity and obsession with his crowds and his TV ratings made it possible for COVID-19 to ravage our populace, and, perhaps worst of all, whose constant butt-licking of business interests removes environmental protections while a climate crisis takes us all to our ultimate doom—to become President of the United States? I will never understand it.

Of course, I get some of the factors. Voter suppression. Gerrymandering. Russian election interference. Uneducated voters who mostly didn't even know about those clandestine activities, they just thought they wanted "something different." Well, friends, you got it. We all got it. Along with the biggest stock market drop ever. The highest national debt. The most convicted appointees. The most pandemic infections in the world. So much winning.

I've seen memes on social media that say, in effect, "Why would one lose a friend over politics? Because it isn't about politics. It's about morality." I don't want to lose any friends, but politics are about so much more than just a party name or a mascot. They're about morals and one's philosophy of life. One of my UCLA public health professors explained the difference between the two main political parties this way: Republicans believe that this is a country of opportunity for everyone. Everyone starts at zero and has the same chance to pull themselves up. Democrats say that would be fine if everyone really started at zero and had the same chances, but they don't. Some start in the negative numbers and continue to face lifelong barriers. My philosophy of living is that people who have more must lend a hand to those who have less. Justice, fairness, kindness—that's my philosophy, and my morality, too.

Now, suddenly, COVID-19 has made the tenuousness of my life on this planet become quite real to me. So I will finalize my will. I'll listen to science over snake oil salesmen. I'll follow public health guidelines. I'll vote progressively, in alignment with my values. I'll continue to create in ways that illuminate the human experience. And maybe I'll try to regain hope that my country will get its head out of its ass—someday.

LYNDA SMITH HOGGAN is a professor emerita at Mt. San Antonio College in Southern California. She has published in the *Los Angeles Times*, *Westwind UCLA Journal of the Arts*, and *Cultural Daily*. Her first book, *Our Song: A Memoir of Love and Race*, will be published by She Writes Press in October 2022.

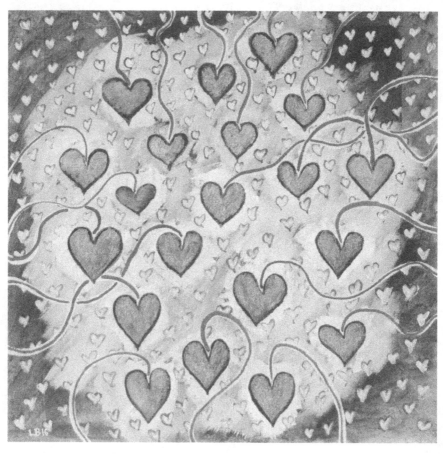

Hearts in the Storm, 20" x 20", acrylic painting
on canvas from a heart-themed series

Hearts in the Storm

LB Gschwandtner

LB GSCHWANDTNER is a writer and artist. She has shown widely and published seven novels, including one with She Writes Press and one with SparkPress.

Knitting My Way Through

Risa Nye

When the lockdown started, I bought some yarn. A blanket would be a good project to start, I thought. It might take a month to finish knitting, right around the time we would be back to normal, I thought.

The blanket was complicated, knitted in a circle, with many more stitches added during each round. It grew bigger and bigger as I made progress. Eventually, it covered my lap and began to weigh heavily on my legs. As I worked on the blanket, like so many other people at the beginning, I binge-watched hours of television. Pure escape as the needles clicked and the blanket took on a life of its own.

I finished the blanket, but the pandemic surged on. My sons and their families, although local, had formed independent bubbles with others. My activities were limited to walks with my husband and short, masked, outdoor visits with one family or the other. We had a few Google hangouts or FaceTime visits. My young granddaughter hid behind her mother when

we visited her in her backyard. She had grown accustomed to staying away from people and at age one couldn't make exceptions for her grandparents.

And so, to fill the days, I knitted. There were baby blankets for the grandchildren of friends. There were scarves made with thin yarn in rainbow colors, knitted on needles as thin as toothpicks. I made a lot of mistakes, ripped out many rows, cursed at the yarn and myself, continued to binge-watch some terrible shows and some really good ones. The pandemic dragged on, with no end in sight.

When my hands are busy, my mind has to focus on what's in front of me. Progress is measured in inches and rows, and there is something wonderful about watching a pattern take shape. When my thoughts wander, as they often do, I lose count or drop a stitch and have to go back and find it.

I spent hours online looking at patterns, saving some for later. I started projects and ripped them out. *How long will I be home knitting?* I wondered.

I found a pattern for nurse dolls, complete with face masks and blue scrubs. My daughter is a nurse, so I made one for her. And then I made another one and sent them both to Syracuse, where she was working with newly trained nurses, sending them off to work in hospitals with too many patients and not enough PPE. When we spoke she would tell me how she volunteered to take shifts, even though she hadn't done bedside nursing in a few years. Like all the health workers did, she would strip off her scrubs and jump in the shower at the end of another exhausting day. She stood at the bedside of more than one patient taking a last breath. I couldn't imagine the life she was living. "Don't worry, Mom," she told me, "the hospital is the safest place to be."

The scarves I knitted for her and my teenage granddaughter were woefully inappropriate for the harsh early spring of Syracuse, but I sent them anyway. I liked the rainbow colors and hoped that when the weather got warmer they might use them. I didn't really care. The act of making them had the greater meaning—for me, anyway.

Someone will need these things, I thought—the baby hats, the nests for young birds, the things I can knit and give away. So I made them.

And then I made hearts. One for my sweet young grandson who always likes reassurance that he is loved. One for my far-away friend whose sister is ailing. And one for myself, to help me practice self-compassion. I found some soft pink yarn—almost like a chenille—and paired it with a thinner white yarn with a little sparkle to it. The hearts came together easily. Soft yarn, simple pattern, message clear.

In a time of crisis, it seems, I always turn to yarn. Knitting as a kind of therapy isn't new to me. There has been a pattern over the course of my lifetime. I reached for needles and yarn when my infant daughter spent months in an intensive care nursery. After losing everything in a firestorm, I quickly replaced my needles and got to work making sweaters to replace the ones we'd lost. It wasn't much, but it was a start at rebuilding my life.

And now, another unbearable crisis: my husband of almost fifty years is losing his memory. I'm not sure, this time, if knitting will help me. I'll need something to do, to stave off the paralyzing fear about what may come next. Maybe I need to keep my hands moving so my mind will stay calm. Maybe it will work as it always has. I won't know until I pick up some yarn and begin.

RISA NYE lives in Oakland, California. Her memoir, *There Was a Fire Here*, was published by She Writes Press in 2016. She coedited the anthology *Writin' on Empty: Parents Reveal the Upside, Downside, and Everything in Between When Children Leave the Nest*. Find her other writing at www.risanye.com and www.berkeleyside.com.

Let It Go

Mary E. Plouffe

A small girl—not yet ten, I'd guess—stands hesitantly amid the crowd. The low ceiling and cluttered space tell you instantly that she is in a bunker, below ground, one of the many where Ukrainian families are hiding from the bombs. She is slight, with long blond hair pulled back in a loose braid. A voice encourages her, repeats a request. Her slender fingers twist near her mouth, unsure.

She wants to sing; I can see it in her face, that cross of excitement and fear. She looks to those around her for permission, for quiet. But even before it is there, she begins. A small voice, simple and pure, rising above the crowd. Tentative at first, but clear and true.

The murmuring around her stops; her voice is the only sound.

She knows this song well, has sung it a childhood-thousand times, watching the Disney film and becoming the *Frozen* princess whose anthem rises. Believe . . . Be true . . . Find yourself again . . . The language may be Russian or Ukrainian,

I am unsure, but no words are needed to understand where this song is taking us.

Adults lean wearily against concrete walls or huddle for warmth near suitcases and trash bags filled with belongings. A few pull out phones to record. They watch her courage build, hear her voice expand. What might have been distraction, mere indulgence of a childish whim, is suddenly transformed. I watch their eyes turn inward, faces open to the sound, until it finds that place inside where poetry and myth latch firm, where melody and magic anchor us to soul.

And then comes one pure moment when the music sets her free. Her head tilts back and she is lost in song. Eyes closed, she leads us then, and trusts pure sound to fill this holy place. Her fragile hands, no longer hesitant, fall gently on her heart.

Let it go . . . Let it go . . .

I want to remember so many things about the people of Ukraine: The courage of their leader, drafted to greatness by his moment in time. The thousands who stayed to fight, sending loved ones worlds away. One old woman on a balcony heaving a jar of sauce to down a drone while gray-haired men below turned wine bottles into weapons of war. I want to remember a thousand images, a thousand colors of courage that have grown like wheat from the fields of Ukraine.

But these memories will fade with time.

One, I know, will never leave me. It is, for me, an icon, painted in ancient tints, come alive on this terrifying day. A triptych of tragedy and evil and the power of wounded souls who join together. And one small child, standing alone, reminding us all how to be brave.

MARY E. PLOUFFE is a clinical psychologist and the author of *I Know It in My Heart: Walking through Grief with a Child* (She Writes Press, 2017). She writes essays and memoir, clinical theory of grief, and commentary on the world through a psychological lens. Please visit her at www.maryeplouffeauthor.com.

Lullaby and Good Night

Barbara Sapienza

I live in a tree house, surrounded by dancing branches of live oak that enhance an otherwise gray house. I've grown accustomed to their long arms, reaching out toward the sky. They're old arms, bumpy with brief interludes where they've been cut. These bulges and detours and even bifurcations tell of their history. Knobby scales and scars where one pathway was cut off from the trunk look raw, like the scabs that form in the healing of a wound.

Frankly, the hundreds of limbs elbowing out, trying to reach the sun and the sky, give me ease. When I listen, I can almost hear them breathing. When I inhale the tree's life-giving oxygen, I imagine them smiling to receive the carbon dioxide I exhale. We need each other. We're partners in this dance. I smile too, breathing them in as birds sing and squirrels chuck-a-chuck, scampering by along the outstretched limbs, seeming to know part of their world is endangered.

One day men wearing regulation COVID masks come by to say these limbs that hang over the street are a fire hazard. But actually they don't say, they just begin their preparations

to cut. When I spot them from my kitchen window, I scream and run out to the street.

"What are you doing?" I demand.

"We're cutting limbs that go over into the street," one of the tree men says.

"What?" My eyes widen.

"We sent you a letter. Didn't you get it?"

I shake my head. "No."

"Fire hazard," the tree man says. "California is burning. Wind's high."

"We have to cut back to protect people, firemen," his companion says.

"No way," I say. "You can't cut their arms off like this."

"These strong hot winds may ignite and bring your house down," the first one says.

Is this the Big Bad Wolf come to my door, disguised as a tree surgeon? What did the wolf say in that story, anyway? Was it, "Let me in or I'll blow your house down"? Was it the three little pigs who stalled the wolf to protect their home? Or am I mixing fairy tales?

"But these are *my* arms," I say. "I love these arms."

"Yes, sorry, ma'am, but they overhang a public road. Fire trucks. Equipment." The tree man has orders, and he wants to do his job well.

So we stand there in the street outside my house, looking at each other. Above the masks, our eyes seem to speak. I know I cannot fight the men who hold saws and hatchets in their hands. They have permits to crop overhanging branches and limbs deemed hazardous by a measuring stick.

I must be clever, like the little pigs. *What did they do?* my old mind wonders. Curiously, my arms hurt near the shoulder

joints and pain is spreading through my own trunk to the bones attached to my lower limbs. My feet tremble and I waver.

"May I speak with your boss?" I finally say, hoping to stall this unhappy event.

The kind worker digs into his fluorescent orange jacket and pulls out a card bearing the name of his boss, along with a telephone number. "You can call now and he'll come right over," he says.

"I'll have to call tomorrow," I say. "I have a doctor's appointment." I'm lying. I need time to think.

"Okay, miss, we will come back," the man says.

"But I'm no miss," I say. "I could be your *abuela*."

"Yeah, my *abuela*'s just like you." He laughs.

Thank God for abuelas. My arms and my legs ache as I get into the car. He waves and says goodbye.

I drive in circles to kill time. Now where to go? In these early COVID-19 days everything is closed—the butcher, the baker, the café, the candlestick maker. *Am I reciting "Rub-a-Dub-Dub, Three Men in a Tub"? I must be crazy!*

Okay, I think, talking myself through this. I know the potential damage to property and life from fire comes before saving the limbs of old trees. But I have vowed to save them. Okay, I know the loss we've had in Northern California. Okay, I remember the day the dark rosy-black fire cloud descended at sunrise and we couldn't breathe. Haven't too many people in Napa, in Sonoma, in the South Bay, in the East Bay lost their homes to fires these few months? Thousands homeless because of late-summer and early-autumn fires. Okay, I know cutting is like preventative medicine; "Cut this off so it won't spread," surgeons say to the diabetic. Yes, the operating word is *protective*, an attempt to save us from peril.

The next day I take out the card and call the tree man's boss. The man comes right over. He's young, probably younger than my son Peter. Polite and kind and handsome, you can see it in his face, in his dark eyes above the mask. He speaks softly, listens to my concerns. I don't know why I grab his arm, coronavirus and all, but I do. I pull him over to the tree in question. We look silently at its splendor. I don't know yet what will come of this. But standing in front of the old oak I begin to sing "Brahms's Lullaby," the one I sang to my kids, maybe even the one my *abuela* sang to me seventy-five years ago.

Lullaby and good night
With roses bestride
With lilies bedecked
'Neath Baby's sweet bed

May thou sleep, may thou rest, may thy slumber be blessed
May thou sleep, may thou rest, may thy slumber be blessed.

Lullaby and good night
Thy mother's delight
Bright angels around
My darling shall guide
They will guide thee from harm
Thou art safe in my arms.

People from the neighborhood surround me in front of the live oak, watching an old lady sing to a tree. But wait! They bow their heads as I sing my love song. Some even sing with me. Then I thank the arms for their gifts—for their shade and beauty, oxygen, and life support, stuff like that. Stuff like the whisper in their stillness and the joy in their dance.

"I love you," I say. "I'm sorry, forgive me. I know you have witnessed thousands of sunrises and sunsets, sucked in millions of drops of rain, held scampering paws and feet, reflected the moonlight and the canopy of stars, and listened to the old ones singing your praise."

Soon the men with the saws and hatchets return. They stand behind the circle of neighbors as we say goodbye to the extraordinary limbs of the great tree.

"May your spirit be uplifted so you can make rain," I pray.

My arms feel better. My trunk relaxes. I turn and I thank the boss. I'm aware he has tears in his eyes.

The sound of the saw, softened by tears, is not so abhorrent anymore.

BARBARA SAPIENZA, a retired clinical psychologist, entered a creative writing program at San Francisco State University in her late sixties. She published the novels *Anchor Out* (2017) and *The Laundress* (2020) in her seventies. *The Girl in the White Cape,* her next novel, will be released in July 2023. She lives with her husband in Sausalito and is currently at work on a memoir, *A Broken Hallelujah.*

Mosaic

Sherry Sidoti-Rego

I am rushing through the kitchen like a train off its rail. It is already after eight and I am late getting Miles to school. I grab my bag off the kitchen island, scream, "Monkey, let's go!" and when I go to throw my bag over my shoulder, I feel it snag, drag, and pull something heavy. I turn around quickly, throw my hands out, try to catch it, but it slips right through my fingers.

Smash! All over the floor. In pieces.

Fuck! Not the bowl! Not the bowl!

Not the beautiful white Tuscan porcelain salad bowl given to us at our wedding!

The last wedding gift I own is gone. All of them, gone. The kitchenware, the sheets and pillows, even the small bookcase handcrafted by Grandpa have been broken, or left behind, or lost during our moves from East Coast to West and West Coast back to East, or they've been donated to the thrift or regifted to a friend or are with Rob, in his new place. The inevitable wear and tear of fourteen years of marriage. All gone.

I look down and see white pieces of ceramic and the light brown clay behind the glaze, splintered all over my recently mopped oak floor. A large chunk is tipped on its side by my left foot. The rest are in dozens of puzzle-shaped shards, scattered. Under the dishwasher. Below the dining room table. One lonely sliver next to the woodstove. And dust. Too much dust. Everywhere.

Of all things, the bowl. *It figures.*

How symbolic. Our container, broken in pieces.

I burst into tears.

Miles comes downstairs. "What was that? Mom, are you okay?"

I gather composure and say, "It's fine, sweetie, I just dropped something."

But I am far from fine.

I barely slept last night. It was another hard night; even with the three melatonin gummies, I stayed up all night. I have had so many sleepless nights these past few months. Grieving the past, doubting my present, worrying about the future. It is hard sleeping alone after almost twenty years of sharing a bed.

Last night, Miles was upset during dinner. He was frowning and picking at his food, barely eating more than a few bites of his chicken and peas.

"What's up?" I asked.

"Nothing," he said in that pre-tween grunt I get from my son these days.

After dinner, he went straight upstairs to his room. He slammed his door, which he never does, and stayed in there for the night instead of binge-watching *The Office* in the living room with me, as we have been doing lately.

I went upstairs to say good night to him before bed. I leaned down to kiss his forehead and he shrugged to the side, he pulled away from me. In the blue glare of his iPad, I saw his eyes were bloodshot and his cheeks flushed. He had been crying.

"Aw, sweetie," I said and sat down on the side of the bed.

"Why won't you let Dad sleep home?" he demanded. "You're so mean. He wants to come home, you know?"

I felt a lump in my throat as big as the Croton Dam. A forest full of sticks and leaves and mud stacked by the beaver, lodged in the base of my Adam's apple.

I didn't answer him truthfully. I didn't say, "Why? Why? Because Dad is acting out like a man-child, and what example would that set for your future?"

I didn't say, "Because the things that made you fall in love with somebody are the exact damn things that later you can't stand about them."

No, I didn't say any of that. I had to uphold dignity. He is his father, after all.

So instead, I just said, "I love you, Monkey. I know this is hard. Things will be okay. Try to sleep. Tomorrow is a school day."

But things are far from okay. And my son deserves to know the real deal. His whole life is about to change. Soon he will be moving from house to house every other week. There will be no more family tickle time, no more winters in California or Mexico. No more movie nights with buttered popcorn on the couch. Our sweet little family of three is dissolving. And I am evolving, birthing a new me.

It happened one morning three months ago. Just a regular moment on a regular day. As we brushed our teeth next to each other over the marble sink, I looked up and there it was,

right before my eyes, reflected in the mirror. My husband was gone. *Poof*. He was next to me, yes, but he was gone. And even more frightening was, although he was looking at me, I could see in his eyes that he no longer saw me. The real me, the woman I have matured to be.

"I think we should try therapy," I said.

He paused, bent down, spit out the frothy toothpaste, wiped his face with a towel, and replied, "Honestly, I'm just not up for it."

"You're not up for it?" I repeated, making sure I heard him right.

"Yeah. No. I'm just not up for doing the work."

He said he felt okay with the way things were, he didn't see the problem. "We're fine, I love you, it'll all figure itself out."

I didn't feel fine. I felt flattened by our nonconnection. Like paper-plate cutouts of the couple we once were. Like the way metal corrodes under the elements, rust had formed around our marriage in places it wasn't meant to form. Our playful humor turned into sarcastic stabs. Romantic date nights into stubborn silence across two-tops. Passion into separate sides of the bed. Separate blankets, even.

Our life on a silver platter, oxidized. Junkyard loot.

And it did not all just figure itself out; *I* figured it out! I figured out the propane payments, Miles's baseball schedule, holiday dinners. I updated the website for our studio and took on extra private yoga sessions when the mortgage was due. He played golf and tennis. He surfed the internet. He got to coast. I was tired of being the man of the house. And Rob refused to man up.

The more alone I felt, the louder I yelled. The louder I yelled, the more avoidant Rob became. The more avoidant he

became, the more alone I felt. And so we spun, around and around. The same old cruel carousel.

"But don't you want something different?" I pressed. "More real? A relationship with purpose and plot twists? Don't you see we are disappearing?"

He looked at me blankly and said, "Not really."

I leaned closer to the mirror, twisted off the cap to my mascara, applied one full sweep of black liquid to my lashes, and said the words I had been holding back but knew deep down were my truth.

"I think we should separate."

I am squatting down looking at all the broken pieces of the bowl in the morning sunlight that splashes from the bay window. I can't help but think about how this bowl was once just a clump of clay, living on a hillside or at the bottom of a pond somewhere in Italy. And how the clay was sold to the potter and formed into a bowl under his hands at the wheel. I picture the clay hardening under thick layers of white glaze while burning in the fire of the kiln, then perched with the other bowls on the drying rack. I imagine it being boxed and shipped overseas and put for sale on a shelf in a store somewhere in New York City. Until one day, it was bought and wrapped in yellow paper with a white ribbon, with a handwritten note that said, *"Cheers to a long life of love!"* and put on the gift table at our wedding, on the lawn at my mother's house in the Berkshires, on that sunny mid-September day in 1998.

The bowl lived with us for fourteen years. It was family. I can't even count how many salads it's carried to potluck dinners. Or pieces of fruit it's held on display on our kitchen island in the summer. Or times it's been rinsed by hand because it took up too much space in the dishwasher.

Now, today, me and the bowl, and my marriage, are in pieces on the kitchen floor.

I put my bag down, pick up the pieces, and put them inside the half bowl that is still intact. I throw that lot in the trash. I look down to the top of the garbage pile. The broken pieces are too beautiful to throw away. I won't throw them away. I can't throw him away, not entirely. He was my best friend. And he is Miles's dad. And the bowl is all I have left from the wedding.

To know love is to know that it is fragile. Real things break. That's how we know they are real.

I lean down and take the bigger pieces out of the trash and place them on the island. I sweep up the rest of the shards and leave them in the dustpan on the floor.

"We have to go, we're late," I say to Miles.

I will deal with the rest of the wreckage later.

In the evening, after Miles has gone to bed, I sift through the broken bowl pieces on the island. Finger-size triangles and zig-zags. One even looks like a pointy heart. I hold it up to the light. I see sparkles, tiny crystals in the dry clay.

I go to the trunk where I keep art supplies. I take out glue, a small canvas, and a gold marker. I spread out the broken bowl bits onto the canvas, arrange them in different configurations, filling in some of the gaps with golden curves and swirls and the ceramic crumbles I collect from the dustpan.

I design a six-petaled rosette. It is one of my favorite shapes. I memorized this shape while studying the mandalas of sacred geometry. The six-petaled rosette symbolizes the ongoing, never-to-be broken connection between all things.

I stay up all night—gluing, arranging pieces, crying, drawing, sprinkling dust in the cracks, remembering, and gluing some more. It is cathartic.

In the morning, I leave the mosaic on the kitchen island with a note for Miles that says:

My Sweet Boy,
Even when broken, all the pieces are all still here.
The clay is still clay whether it is a bowl or a mosaic.
You, me, and Dad will always be family.
We've only just changed our shape~
Love, Mom

SHERRY SIDOTI-REGO is the founder and lead director of FLY Yoga School and FLY Outreach, a nonprofit that offers yoga and meditation for those in recovery from addiction and trauma on Martha's Vineyard. She leads courses, teacher training, and retreats globally. Her musings, infused by twenty years of practicing and teaching healing arts and mysticism, have been published by various magazines and periodicals. Sherry's memoir is forthcoming from She Writes Press in the fall of 2023.

A Psychiatrist-Novelist's Recommendations for Creativity as a Stress Antidote

Monica Starkman, MD

With stressors, especially lasting ones, many people experience a vague sense of uneasiness, a diminished feeling of well-being. They often suffer from a sense of loss—a loss of something specific, or of something they cannot define or name.

In addition to being a She Writes Press novelist, I am also a psychiatrist and neuroscientist. A major reason for the efficacy of psychotherapy is this: it transforms feelings and fleeting fragments of thought into words, and then activates the brain's motor system to say the words out loud.

You don't need to be in psychotherapy to take advantage of this process. Writing in a journal, for example, also transforms feelings and fleeting thoughts into words, which the motor system then writes onto a page. The nonverbal arts, such as drawing, painting, and instrument playing, also translate feelings into motor activity.

One of the most potent enhancers of resilience and coping ability is creativity. Adding creativity to the process of writing down feelings and fragments of thoughts gives it even more therapeutic power. As a novelist, I can confirm these benefits. Becoming engrossed in creative writing clears the mind of the routine and the stressful. It's a form of play for adults, and play stimulates the pleasure centers of the brain—a much-needed effect in general, but especially during times of stress.

Being creative is not an activity reserved for other people who we deem "creatives"; it's for everyone. Forget about being "good at" the creative forms you are choosing. Self-expression is the goal.

Building creativity into our daily lives is not as difficult or time-consuming as we might assume. You can make time for being creative without devoting half your day to it. Here's one way to do that: Free up time by establishing a limited period during the day devoted to worrying—for example, schedule fifteen minutes for worrisome thoughts. Then, during the rest of your day, let such thoughts just pass through your mind without either suppressing or giving attention to them. Remind yourself that tomorrow you will have another opportunity to devote yourself completely to worrying. This will increase the likelihood of worries not intruding into the rest of your day, so you have time and energy for creative activity.

Now, reserve fifteen minutes a day (or more) for creativity. You can choose an art form you are familiar with. Or you can grant yourself the freedom to experiment with something new, something you may have considered out of your wheelhouse of abilities in the past.

For example, you can write a song. It doesn't have to be complicated. Start by thinking of a topic or feeling you want to write about. Jot down words related to it, words that express

how you are feeling right now or have felt in the recent past, or what's been on your mind. Write a few lines using these words.

Rhyming may be helpful as a way to begin the process. For instance, find rhymes for a simple, easily rhymed-with word like "say" by going through the alphabet in order—e.g., bay, clay, day, fray, gray. Adding similes and metaphors may also be helpful—e.g., "I feel like a . . ." or "My sadness is a . . ." Alternatively, you can start with some words from a song you know and continue by adding words of your own. For example, "You are my . . ."

To add music, you can borrow or invent; play with melodies until you find one you can sing or hum with the words you have written. Or you can even begin the songwriting process with music. To do that, start with the melody of a song you know or your own musical phrase. Then, add your words to it.

Songwriting is but one example of how to expand your list of artistic possibilities. Exploring new ways to express your creativity is an exciting adventure. Whatever forms you choose, being creative will enhance your resilience, pleasure, and well-being at all times—and will be an antidote to stress during the difficult ones.

MONICA STARKMAN, MD, is a professor of psychiatry emerita at the University of Michigan, where she is currently a member of the Depression Center. Many of her research studies and publications have centered on the psychological aspects of women's reproductive lives. Her articles for *Psychology Today* appear regularly on her Expert's blog/column there, "On Call." Dr. Starkman's novel *The End of Miracles*, a deeply psychological, suspenseful story of a woman struggling with reproductive losses that threaten her sanity, combines these interests.

Musings on the Word "Atonement"

Roberta S. Kuriloff

As a child attending synagogue during the Jewish High Holidays, I'd yearly contemplate what actions of mine necessitated atonement for my so-called sins, praying for forgiveness to again be in God's good graces. Looking back, those transgressions weren't overly serious: stealing from the candy store, lying to elders, resentment toward the people controlling my life. As I matured, life became too serious, too hard, to regularly reflect or repent; I didn't want to face the infinite number of acts and thoughts needing atonement.

Now in the prime of life, I visualize atonement more conceptually—as "at-one-ment." Being at one with all that is, like the full moon glistening from the awareness that humans and animals and earth are all at one with each other. If you don't believe me, look closely at the moon—it's smiling.

Even oranges are at one with the sun: bright, circular, the same color, of course. And the rays of the sun are like the spritz

from an orange when you cut and peel it the wrong way. Oranges cause me to squint when I bite into them, like my eyes squint at the sun.

The earth orbits the sun, the moon orbits the earth, in cooperation with something greater than all three, with each movement blending in and out of our lives so smoothly that we take them for granted. They have nothing for which to atone; they know they are at one.

The problem is us humans—we forget our oneness. We detach from each other and ourselves, the scientific mind telling us that mind and body are not one, that my mind is better than yours. For me to be special, you can't be special. Us and them. Separation.

It seems that only crisis wakes us to what is real, like when people have near-death experiences and return with the knowledge that love is all that matters. Or when war wrenches people apart and our better angels emerge, making us more attentive, caring, giving.

Mind and body are separate, but not as science informs us. Both hold our essence, an essence that continues even beyond the body—learning, growing, still discovering at-one-ment, just elsewhere. Free to fly and dance and play and laugh while the body returns to its roots in the earth. All to happen again sometime, somewhere. No memory lost; just changing in colors and experience and flowing with the moon and oranges in trust of the next step.

COVID-19, and the current warfare in Ukraine, remind us that our lives cross the borders of countries, the borders of color, the borders of hate. Crisis can bring us together, or not. This is an imperative time to reflect on "at-one-ment." To accept that we are not alone, not different. While evil is part

of this world, it is not all-pervasive, not all-powerful, unless we allow it to be. Its strength is only in the power we allow it.

We are again gifted another challenging human opportunity to experience being at one with all that is. To reflect, and to brave the oneness of *all that is*.

ROBERTA KURILOFF is a writer, author, speaker, community activist, and former attorney. She is the author of *Everything Special, Living Joy: Poems and Prose to Inspire*, a book about how we look at life—the glass half empty or half full. Her short story "Unearthing Home" was published in the spring 2020 issue of *Yellow Arrow Journal*. Her forthcoming memoir on She Writes Press is *Framing a Life: Building the Space to be Me*. Roberta's website is www.robertakuriloff.com.

My High-Risk Pandemic: A Love Story

Cindy Eastman

In many ways, I was well suited to a global pandemic. I am a supreme homebody. When the pandemic came along and everyone had to hole up in their homes, it seemed like a snap; who loved staying home more than me? No trips to the store, no outings with friends, no evening meetings. No errands—or forgotten errands. No exercise class!

But of course that's not what my pandemic looked like.

When COVID closed our doors my household was deemed "high-risk": sixty-two-year-old me, seventy-one-year-old husband Angelo, and eighty-nine-year-old dad Warren. Dad had come to live with us three years earlier, after the death of my mom, mere months after Angelo and I had begun putting together a vision of what our lives would look like once he retired. He wanted to live part-time in his Italian hometown; I wanted to devote time to writing. It looked like it was something we could achieve.

At the time of my mom's illness—what we thought was pneumonia but turned out to be lung cancer—my brother, Richard, sister, Susie, and I took turns flying to Florida to care for our parents. We didn't know she was dying then. All we knew was that she was sick and Dad wasn't able to care for her, which made them both frightened and frustrated.

One night during my turn, Mom came into the living room after supper instead of heading to bed with her book. She sat on the love seat in between me on the recliner and Dad at the dinette—his usual spot. "Warren, come over here," Mom insisted, and she patted the sofa. He fumbled and bumbled his way across the two-foot distance and landed with thump, jostling her. She gave an irritated sigh as Dad clumsily tried to adjust himself around her, until finally she exclaimed, "Just hold my hand!"

He did. And there it was—a moment of love. My exasperated, dying mom asking my blind, confused dad to hold her hand and sit quietly with her, both their eyes closed. Just for a moment, he felt like he was taking care of her and she felt cared for by him.

Three years of caregiving later, the world closed down. None of us were going anywhere. Our household checked most of the "high-risk" boxes: Over sixty? Check. Diabetes? Check. Heart disease? Dementia? Check and check. We faced a new challenge to the already-difficult dynamic of caring for an aging parent at home: how to love and care for each other when we were always on top of each other. The daily functions of our lives—for all three of us—were going to be constant and draining. If we were going to experience peace at all, we would have to learn to appreciate—and recognize—those same moments of love.

Angelo, a therapist, transitioned seamlessly into teletherapy and fixed up a room upstairs for his office. When he ventured out, he was masked up, fortified with hand sanitizer and alcohol wipes. It was still a risk for him to go out, but there was little else we could do: Dad's diabetic needs required specific foods for meals and snacks. I'd never realized before what a luxury it was to be able to run out to the store for diet soda or no-sugar yogurt when we ran low.

Angelo went to the early-morning "Seniors Only" shopping hours, and every once in a while he visited his unused office on the way home. He only went to wipe the cobwebs off the lamps and check for mail, but his errand running provided him with the kind of alone time I craved. I reminded myself not to resent it; I had to remind myself of a lot of things as we adjusted to our new normal. Loving and caring for Dad was going to have to be intentional and forgiving. Focused and understanding. Angelo and I were also going to have to be intentional about enjoying our own time together—our own moments.

Even with that noble mandate, it wasn't always easy. We often remarked upon how lucky we were to have a comfortable home and the means to get our food and supplies and keep the lights on. We said it so often it started to sound like we were trying to convince ourselves of it. When friends started seeing their kids—expanding their bubbles—it was hard to tamp down the resentment it ignited. With my daughter and her family in the next town over and my son a half mile down the road, I wasn't used to *not* seeing them; I missed them. Being tethered this tightly to my responsibility was frustrating, and Dad didn't understand it either. But we couldn't risk the chance of any of them bringing the virus into our home. What if I got it? What if Angelo did? What if it killed me . . . or him? What

if we gave it to Dad? What if we never got the chance to see our dream to live in Italy realized? The risk permeated our days and our thoughts.

Dad's health, always precarious but astonishingly hardy, started to decline during this time, more so mentally than physically. He'd always taken great joy in seeing his grandkids—and in fact, being near them was a factor in his agreeing to move in with us. When they stopped coming to the house, paranoia crept into his questions about their whereabouts. He wanted to know why my son didn't come into the house when he dropped by to check on us or why my daughter and her family stayed outside and only talked to us through the storm door. When I reminded him about social distancing, he seemed suspicious— as in, "What the hell is social distancing?"

Taking care of ourselves reached a new level of both importance and imagination. Even though it felt bad, I began to limit how much time I spent with Dad to prevent possible negative interactions. Moments to salvage love rather than enjoy it. Self-care was measured in minutes rather than hours. For example, after lunch, when Dad headed into his room to "read" (nap), I'd go stretch out on my bed for fifteen minutes to play a game on my phone. Before, we'd called Dad into the kitchen for "cocktail hour" when we began preparing dinner and he'd joined us with his nightly wine spritzer and pretzels; now Angelo and I started earlier and had private "cocktail minutes"—ten or fifteen—to connect at the end of an often very long day before asking Dad to join us.

I knew Dad felt like a burden to us; he talked about it all the time. Every time he complained about being one, we countered with the insistence that he was not. But it didn't matter; he felt the way he felt. One reason was that he didn't think he

should even *be* here. With his health problems and blindness, nobody had thought he'd outlive Mom—especially him. But not only did he outlive Mom; he also outlived my sister, who'd died of ovarian cancer a year after he moved in. There were so many reasons he knew he shouldn't be here, but here he was. He felt like a burden the day he moved into our house, and nothing anyone could do or say would change his mind. The requirements of staying healthy during a pandemic only intensified those feelings.

The forced sheltering in place took its toll on Dad's ability to keep track of the few things he was still able to do. Even legally blind, he was an avid reader and listened to books on tape. When he wasn't reading, he followed current events via his favorite cable news anchors, although for all his following the news—and his often astounding ability to understand and discuss it—he didn't really seem to grasp what was going on with the pandemic. When he saw Angelo and me cleaning out the pantry (to make room to store bulk items), he thought we were sealing up the windows and doors to keep the virus out. He thought COVID came through the air and was worried when we opened the doors. As often as we reassured him that we were just taking precautions, just as often he acted like we were feeding him a line of crap. His ability to watch his blood sugar or take his shots became unreliable. Where I had once merely hovered during the mealtime shots, I now had to actually set the insulin pens to the right amount. His blood glucose was monitored by a device he wore on his hip 24-7, but he'd get nervous if the number dropped and would start popping glucose tablets into his mouth like, well, candy—which would send it careening up again. Luckily, I had an app for that, so I'd get notified when that happened.

Not that I was ever very far away.

But we found our moments. We had to. I took a part-time online teaching job; Angelo continued to see his clients via telehealth in the home office upstairs. At some point, out of desperation for my own space, I shoved boxes, moved old furniture, and set up bookcases to create a corner in our basement for my own "office." I escaped to this room of my own as much as possible, surrounded by scented candles and pictures of my family, and taught my classes and attended Zoom meetings there. There were times when I could only run downstairs to grab a book or find a bill on my desk. But being in the quiet place I'd created in the midst of a maelstrom of chaos and virus and paranoia even for a moment was calming and centering.

We eventually opened up our bubble to include our kids and a few others, but we still guarded Dad diligently. When my grandson Luca came over with his dog, Charlie, Dad was nearly giddy. Still careful, we'd let them "visit" with Dad in his room—the smile on his face was worth any of the risk—but only for a few minutes. We followed the news of the vaccine compulsively, looking forward to even more bubble-expanding. Dad, in his growing suspicions, questioned us about whether or not we were going to take him to get his shot. We did—the day after his ninetieth birthday. We posted a picture of him wearing his "I Got Vaccinated" sticker on Facebook with the caption "Best Birthday Ever!"

But he didn't get the second dose. Dad died almost a year after the pandemic had begun.

Happily, the moments we'd trained ourselves to look for and cultivate were aplenty in the week before he died. Paranoia and frustration gave way to memories of my mom and sister and a kind of silliness in regards to his whereabouts—as in, he wasn't sure where he was anymore, but not in an angry or

suspicious way, more like a "Hey, what's everyone doing here!" kind of way. During that time, Dad's sleeping schedule was off, his blood sugar was surprisingly holding steady, he wasn't eating much, and all his doctors suggested we take him to the hospital. But we kept him home.

When one of the hospice nurses suggested Dad was nearing the end, Richard immediately got on a flight from California to be with us. Dad died twenty-four hours later with the three of us—me, Angelo, and Richard—at his side. An unexpected, but deeply felt, moment of grace.

Angelo and I constantly talk about how grateful we were that we were able to keep Dad safe, COVID-free, and out of the hospital. As difficult as caring for an aging parent in your home is, layering a global pandemic on top of it was withering. And yet we found and felt joy, gratitude, and love. None of our lives were what any of us had expected, but often I feel like a survivor.

Sometimes even just for a moment.

CINDY EASTMAN is an award-winning author whose first book, *Flip-Flops After 50: And Other Thoughts on Aging I Remembered to Write Down*, is a collection of essays on getting older. She is the creator of the "Writual" writing program and has presented nationally at the Story Circle Network Women's Writing Conference. She is a contributor to *Laugh Out Loud: 40 Women Humorists Celebrate Then and Now . . . Before We Forget*, published in association with the University of Dayton's Erma Bombeck Writers' Workshop, and her work is also included in *Fast, Fierce Women*, an anthology edited by Gina Barreca and published by Woodhall Press.

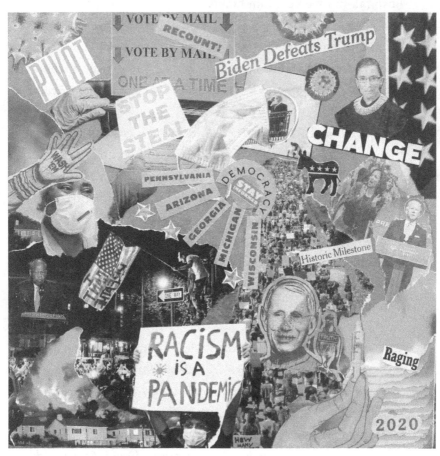

2020: What Was and What Will Be, 2020, collage

2020: What Was and What Will Be

Belle Brett

BELLE BRETT is an artist and writer. Her award-winning novel, *Gina in the Floating World,* was published by She Writes Press in 2018. Since retiring from paid work in 2017, she has been slowly sorting through a lifetime of memorabilia, a process that inspired the creation of a blog called *Our Slow Downsizing Journey* and a series of "memory collages," including some sparked by unsettling external events.

Y'all Need to Chill

Kelly I. Hitchcock

For Valentine's Day 2021, I was supposed to get a rare fancy night out with my partner in downtown Austin and an equally overpriced babysitter. Instead, I got an even-rarer ice storm, over a foot of snow, and single-digit temperatures that crippled the city's infrastructure, killed over two hundred Texans, and left much of the state without electricity, water, or both.

By that time, we'd been in some flavor of lockdown, quarantine, or shelter in place for the better part of a year. Just as there was hope on the horizon of a vaccine that promised we could finally venture out of our homes, the Texas winter storm blew in to remind us that we weren't going anywhere. I felt lucky that my childhood in the rural Midwest had prepared me well for being snowed in, since mayors and senators from the state I now call home made it clear that we were on our own.

As a self-proclaimed fence-ridin' centrist, the polarization between the political left and the right had always seemed silly to me. Something about the pandemic era, though, took all the silliness out of the petty political squabbles I saw between

friends. It saddened me when I saw the same friendships, some of which had been decades long, end over political differences. It angered me when I saw conservatives and liberals pitted against each other over fights that didn't even belong in the political realm, like masking up outdoors. But the breaking point for me was when Winter Storm Uri hit and people from the coastal cities (even Stephen King, whom I've idolized for much of my life) took to Twitter to say that even more of us deserved to starve and freeze to death because Texas had elected President Trump.

It's an easy scapegoat, but I blame the pandemic. Isolation can make you forget that the people who vote differently than you are not monsters but living, breathing humans who struggle with the same shit the rest of us do; they just don't happen to share 100 percent of your political beliefs. It's a lot easier to dehumanize someone because of their voting choices when you've never met them, unlike the feeling you get when you find out someone you've known for years has some wacky political stance that does little more than take you aback a bit.

In contrast, *crisis* has a way of making insignificant differences in political beliefs seem even more insignificant. I know I certainly didn't ask my neighbors which senator they voted for before hauling coolers full of their pool water across the ice-covered street so I could flush the toilets in my house. I was just happy I had toilet paper and firewood to offer in return (thank you, rural Midwest upbringing).

Yes, there was always a chance that COVID *could* kill you, but exposure—no heat, no food, no water—*would* kill you. That was a hard fact many people I knew, including those with newborn twins who weren't yet able to regulate their body temperatures, came to grips with as they abandoned their frozen

and flooded homes and traveled across icy, unplowed roads to go stay with those of us lucky enough to still have heat and food and water. Some of them hadn't seen people who didn't live in the same house as them for a year. Some of them had been relying solely on a grocery-delivery service that doesn't run when the entire state is covered in snow and the grocery store is running on a backup generator.

The COVID vaccine was open to only a small population at the time of the winter storm; the only people I knew personally who'd received a dose were doctors and nurses. But the ethereal risk of catching COVID suddenly didn't seem so scary when it was weighed against the very real risk of dying from exposure while sheltering in place in a place without life-sustaining necessities.

For our part, we only lost electricity for a few hours because our house happened to be on the same power grid as a fire station and a nursing home (a key selling point for the future), but we didn't have running water for a week, and we struggled to untrain our four-year-old twins from flushing the toilets after peeing. After having condemned germs, germs, germs for a year, we had to explain that even though we couldn't wash our hands, the germs weren't going to kill us. While I was going out of my mind watching our '80s-era windows frost over from the inside, trying to keep our pipes from freezing without the help of running faucets, and struggling to make meals out of our dwindling freezer stockpile of food, my kids put on their dance-recital costumes and pretended our couch was a trampoline park.

The girls were too young to register that there were people in other parts of the country who thought they deserved to freeze and go hungry because a little more than half of the electors in our very gerrymandered state voted with the red team. They were just happy they didn't have to go to preschool, and

also too busy drawing picture after picture for Mom and Dad as we conserved power and kept Disney Plus to a minimum to notice that anything was off. I still have a picture that one of them made for me, covered in the Valentine heart stickers they never got to use for their preschool Valentine party that never happened, in my desk drawer. It's hardly fine art, but it's a reminder to me that while Mom and Dad were terrified of losing power and not having enough firewood to keep everyone warm, scared we'd run out of food before the grocery supply trucks could make it to H-E-B, and worried we'd have to venture out over snowy streets with people who had no experience driving in inclement weather, our kids were having the time of their lives on their extended snow day.

That sticker-covered coloring book page serves as a reminder for me of how powerful perspective is. No matter how scared people were of dying from COVID, they were way more scared of dying of hunger, thirst, or extreme cold. No matter how much people had isolated from their neighbors before the storm, they still offered up their pool water so those neighbors could flush their toilets when no one had indoor plumbing. No matter how awful people with opposing beliefs had been to each other in the previous months, those differences ceased to matter in Texas's time of crisis.

To this day, I'll still find a Valentine sticker from the snowbound week of Winter Storm Uri stuck somewhere in the house—usually somewhere with carpet, of course—and it will remind me that no one's political beliefs, however different from my own, should prevent me from treating that person with kindness. That person may very well be the person who comes and relights the pilot on my hot water heater at no charge so that I can take my first hot shower in two weeks (even after our water was restored,

we still didn't have hot water for another week after that, and when we got it back it was only because of the neighborhood plumbers making round-the-clock service calls for free).

At the 2022 South by Southwest conference (the first since 2019), NYU professor Scott Galloway said in his keynote, "People remember how you behave in a crisis." As much as I can't forget the people who wrote off 29 million freezing Texans as casualties of an electoral outcome, I'll choose to remember the plumber who restored our hot water, our neighbors who let us use their pool water to flush our poop, and the local pizza place that served us our first meal in a week that didn't include rice. And I'll keep my kid's heart-sticker-covered coloring book page in my desk drawer to remind me that no one forgets kindness, and everyone deserves it.

KELLY I. HITCHCOCK is a literary fiction author, humorist, and poet who lives the Austin, Texas, area. She has published several poems, short stories, and creative nonfiction works in literary journals and is the author of the coming-of-age novel *The Redheaded Stepchild*, a semifinalist in the literary category for The Kindle Book Review's "Best Indie Books of 2011," and *Portrait of Woman in Ink: A Tattoo Storybook*. Her newest novel, *Community Klepto*, debuted in June 2022, courtesy of She Writes Press.

War Music

Brenda Peterson

Besides the ear-shattering percussion of exploding missiles and falling bombs, there is also enduring, life-saving music in war. Songs are as much a part of war as any battle kit. Music can be used to attack or defend, to mourn or to survive. The *New York Times* recently reported that on the outskirts of Kyiv, besieged by a menacing but stalled Russian convoy forty miles long, a Ukrainian soldier—Jeka Stencenko, twenty-eight—prepared for the imminent attack by singing the classic Nina Simone ballad "Feeling Good."

Why that buoyant song before battle? Why not a dutiful march or the boisterous Ukrainian anthem that is echoing around the world on social medias and protests? Why such a happy-go-lucky song in the face of death?

Hearing this story of a soldier singing for his life—knowing that many Ukrainian and Russian soldiers are so unbearably young—I remembered my own grandfather, still a boy when he fought with the Rainbow Division caissons in another world war. What young men know of war and what old veterans understand about war may take a lifetime to fathom.

Grandfather Harold, a World War I veteran and gorgeous Irish tenor, asked two things of me as an old man on his death-bed: To read to him the unvarnished truth about war from his WWI diary, and to sing the war songs that were once the soundtrack to his survival. Like the Ukrainian soldier, he now needed music to accompany him in a battle he might lose.

"Sing to me, girlies," my grandfather whispered.

My mother and I wheeled him down to the hospital's visitor's room with its grand piano and wall of breathing, green plants.

Always a slender man, my grandfather's sallow face was now hollowed out so that his cheekbones slanted almost pain-fully high in his narrow face. His shock of silver hair shot straight up like a bird's ruff that my mother was always trying to smooth down. She did that now, lifting her treble hand from the piano to pat down his wild, wispy hair. Then she expertly played the keyboard, nodding to me to sing the WWI song "My Buddy"—heartily, because Grandfather Harold was hard of hearing.

Nights are long since you went away
I think about you all through the day

My grandfather closed his eyes, nodding in rhythm, mouth-ing the words. I sang harmony the way I always had, to blend with his robust tenor. But Grandfather's voice now was a faint and hoarse whisper as he tried to sing. All that came out was a hum. Tuneless. It was the first time in my whole life I'd ever heard my grandfather off pitch—and it destroyed me. Tears streamed down my face, and I was glad that his eyes were tightly closed, as if it took all his concentration to hear the music.

My buddy, my buddy
Your buddy misses you

Suddenly, Grandfather Harold opened his bloodshot blue eyes, groaned, and, with a mighty effort, sat up straight in his wheelchair. Startled, I looked at him as he cocked his head to listen. The dry skin on his forehead creased with strain and he gasped for air, as if inhaling before a deep dive. Then Grandfather opened his mouth and one pure note tenor came out, aimed straight at his beloved and only daughter. He'd always doted on her; it was from him she had inherited her musical genes.

Instinctively, Mother stopped playing piano and just listened to him—that endless note echoing in the hospital room with its tall windows streaming sunlight. The two of them, father and daughter, held in the shimmering halo of sound.

"Misses youuuuuuuuuuu," my grandfather sang until he was breathless, choking for air, sputtering.

"He needs his oxygen." Mother jumped up from the piano and wheeled her father back through the circuitous hospital halls to his room.

I lifted my grandfather's 117 pounds from the wheelchair to his hospital bed and settled him under his oxygen tent while Mother went to get him some lunch. I sat vigil with Grandfather, still humming "My Buddy" softly.

Breathing in the cool oxygen, Grandfather Harold's eyes brightened; he turned to me expectantly with a nod. This was our signal to take up again our secret ritual: reading him his WWI diary from the trenches.

I couldn't refuse him his own story.

"If no one listens," he'd argued when I'd tried, "I'll have to tell my story to a stranger."

So again I opened the thick, water-stained leather diary Grandfather had entrusted to me and began to read to him. We'd arrived at an entry set at the German front where Grandfather was soldiering with the horse and caissons brigade. It was there a wild dog had bitten him in the face, leaving a scar and a damaged tear duct that eternally dribbled, as if he were crying. As a toddler I was fascinated by this scar, which ran between his eyes and near his nose. I'd trace it with my fingers as he'd tell me again how it happened and then sing me to sleep with his inherited family lullaby.

Now he was dreaming, eyes half-closed, as he listened to me read his own stories of war buddies, battles, death tolls, and the 1918 influenza epidemic on the home front, which killed more civilians than the war had American soldiers. Suddenly the room seemed to teem with the marching drama of the Great War.

At one point, he suddenly winced and struggled to sit up in his oxygen tent.

"Those Germans," he murmured with a grudging respect. "Never thought they'd lie in wait this long to ambush me." Grandfather gave me a rare direct gaze, his pale blue eyes so bright it hurt to look at him. "They're *here*, you know, right here with us."

He was not rambling. We were no longer in a hospital room but back with his army unit. We were on the battlefield, surrounded by death. Grandfather waved an arm and opened his oxygen tent for me to come closer. I slipped my hand through the plastic to touch his shoulder.

"Oh, girlie," he said. "I didn't write down the real story in that diary. I've never told a living soul the truth." He coughed and grabbed my hand, which was darkly spotted with age and IV bruises.

"Tell me," I breathed.

He sighed. "Strutting and singing and winning—that's all folks wanted to hear. And when I got back from the front, well, no one likes a crybaby in the middle of a big celebration, now, do they?" He laughed, and his voice cracked. Then a coughing spell silenced him for a long time. When it subsided, Grandfather seized my arm fiercely. "I've got to tell my story to *them*."

His eyes flickered around the hospital room, as if to at last meet the gaze of the German soldiers whom he believed had taken up residence to haunt this tidy, antiseptic barracks.

"And somebody . . . somebody still living."

"I'm here, Grandpa," I said softly, trying to steady my voice.

Grandfather was quiet a long time. "You see, girlie, I killed them—not like you do these days, with bombs and rockets, but with my bare hands." He nodded to a far corner of the room. "See that German over there? I gutted him with my bayonet. He was just a boy, like me. A soldier boy." Grandpa paused to gather himself and then continued, "The boy held on to my bayonet and his eyes rolled back, but then he kept staring at me like he wanted to see somebody's face while he was dying, even if it was his killer's. I'll never forget that look, no sirree. I've carried him with me like we were kin, like he was really somebody to me instead of a stranger . . . Poor fellow on the wrong side of my gun."

My grandfather shivered and I pulled the thin covers up over the feeding tubes in his belly. I held his feet now, gently massaging the crooked, bony toes. His feet were freezing, as if he'd been tramping all night on a cold battleground.

It was getting late, and visitors' hours were almost over, when he asked, "Sing me that old spiritual . . . 'Wayfaring Stranger'?"

He could only mouth the words with me:

331

I'm going home to meet my mother
I'm going home no more to roam
I'm only going over Jordan

Suddenly he sat up in his hospital bed, staring and pointing to the opposite corner of the shadowy room. "Don't you see him? There's that hefty fella, beet-faced still. He got his head blown off, girlie. I found it in a field of cabbages, looking like it just grew there. I didn't kill him. But I didn't bury him, either. I just kept grabbing those cabbages—that's all we lived on during that long march. We were the first division to cross the Krauts' border, the first to see all the dead, theirs and ours."

Suddenly my grandfather laughed and looked at me fondly. "You taking notes?" he demanded. His hand clawed mine. "Don't call 'em Krauts when you tell this story to the family. No one can look at these faces so close now and call 'em Krauts." Grandfather tried to sit up in his bed and managed only to raise himself up on his bony elbows. "Besides, these boys are finally here to carry me on over. Ain't that a fine fiddle, girlie? I killed them—now they're gonna carry me."

I held his wasted hand. It felt like a cornhusk—light, with a vegetable rot. They say in the South that before a body dies, it gives off the scent of crushed pumpkins. Grandpa smelled sweet and rank like compost. Right then, I knew this was my last visit with my grandfather.

Leaning in, I listened to his whispers.

"Honey, because I'm meeting these German boys now, man to man, I believe some of them are forgiving me. Remember your scripture? 'For now, I see through a glass darkly, but then, face-to-face.' Well, I'm seeing them face-to-face now. It's not judgment. It's more like meeting up with a man again I didn't

much understand before. It's like meeting yourself . . . well, coming *and* going, ha!"

Then my grandfather curled up within the translucent wings of his oxygen tent and sighed, "Sing on, honey."

Slowly I reached out and parted wide the plastic veil between us. Grandfather opened his eyes and nodded with pleasure as I began the song that he'd sung to me when I was small. It wasn't his all-healing lullaby, though I'd sang that to him many times as he lay dying. This time I sang what he most requested.

"Over there, over there," I sang. "Send the word, send the word over there. Say the Yanks are comin', the Yanks are comin', so beware . . ."

"*This* Yank is comin'," my grandfather sang out softly . . . as if it were a prayer, as if all the ghosts gathered around him in that room would finally hear why a world war made a young soldier sing and take up arms, and how an old man now was taken up—in their arms.

BRENDA PETERSON is the author of over twenty-three books, including the recent memoir *I Want to Be Left Behind*. Her novel *Duck and Cover* was a *New York Times* Notable Book of the Year. Her most recent books are *Wolf Nation: The Life, Death, and Return of Wild American Wolves*, chosen as a "Best Conservation Book of the Year" by *Forbes* magazine; her children's books include *Wild Orca* and *Catastrophe by the Sea*. Her work has appeared on NPR and in the *New York Times*, the *Christian Science Monitor*, *Tikkun*, the *Seattle Times*, and *Oprah* magazine.

You Must Laugh
When Nothing Is Funny

Jill Sherer Murray

A few summers ago, my husband and I were visiting the Smoky Mountains when I found myself crouched over a toilet seat in a public restroom after too many cups of coffee and bottles of water. I will spare you the gory details, other than to say my stream was hearty and strong—so much so that it just wouldn't stop.

After several minutes of listening to it hit the toilet water, I started to wonder if there was something actually wrong with me. I mean, of course I'd been making sure to hydrate—it was hot out there. But this was unprecedented.

I checked my phone for the time, waited, and checked again: I was now three full minutes in.

Then five.

Then six.

Then before I knew it, fifteen.

My husband, who was waiting for me outside, texted: *Everything okay in there?*

NO, I CAN'T STOP PEEING. I THINK I'M DYING.

How I wished I'd gotten a pizza for dinner the previous night instead of yet another grilled-chicken salad. I'll never make that mistake again.

At this point, my quads weren't the only things shaking. My hands were too. As the liquid drained out of me like water from a rain spout, I was growing frantic. What if it never stopped?

Then I had an idea: *I'll do a Kegel.* If for no other reason than to prove I still had control of my faculties.

I took a deep breath in, squeezed my groin muscles as if an incontinence doula were outside cheering me on, and prayed the stream would go silent. But it didn't. So I got really bold—and stood up. And do you know what happened?

Absolutely nothing.

That's when it hit me: The noise of urine hitting the bowl wasn't me peeing. It was the toilet running.

Now, that's funny, right? I mean, go ahead, laugh. Laugh at me! (My husband still does.) And if you can't because you feel like you shouldn't—because people are dying, there's war and pandemic, you gained two pounds for no reason, your power is out, your beau ghosted you, you can't afford gas or cupcakes, or whatever else sucks in your universe—you're right. Bad stuff is not terribly hilarious.

But rocking under the coffee table and refusing to laugh because it feels inappropriate is not going to turn things around. To the contrary, it's the laughter that will save you.

I know this because I learned it from my father. For as long as I can remember, he used humor as a way to deal with problems. For example, when I was a teen I locked myself in

my bedroom for privacy—as I did often back then, against my parents' protests—and the lock got stuck.

My dad jiggled the doorknob from the outside for a few seconds and then said, "I can't get it. See you whenever."

I never locked my door again.

Then there was the time he was wheeled into recovery after having a spot on his lung removed. The first thing he said when he opened his eyes was, "How's my hair?" I told him that surgery really became him. And we laughed. Even though that spot was cancer (he's okay!), laughing in the face of terminal illness felt pretty awesome.

Which is the biggest reason to do it. Add the fact that fifteen minutes of laughter is not only good for your abs but is also akin to getting two hours of drool sleep. It can burn forty calories, tallying up to three or four pounds a year. And while that won't make you unrecognizable to those who know you, it's *easy weight loss*, people. If you're a lifelong dieter like me, that's a win!

According to research, a hearty chuckle can distract you from pain and physical stress, leaving you feeling loosey-goosey for up to forty-five minutes. It increases immune cells and infection-fighting antibodies. Triggers the release of dopamine. Protects the heart. Defuses anger and conflict.

It can even help you live longer. A study done in Norway found that people who had a strong sense of humor lived longer than those who didn't—a difference that was particularly notable for those battling cancer. Which, I think we can all agree, is definitely not a hootenanny.

And you don't even have to find anything really funny to reap these benefits. Since the body can't tell the difference between simulated laughter and spontaneous laughter, you can

be like a self-cleaning oven. Fake it till you make it. To which I say, let's get this party started.

I'll begin: Sixteen years ago, my then seventy-year-old mother took my then forty-seven-year-old husband to the circus. Since he grew up in a cult and was shunned by his parents early in life, he never got to do normal kid things—like sit in a tent and eat peanuts and stare at the elephants.

Isn't that sad? And just a slingshot funny? Whenever I feel the need to scream into a pillow, I imagine my grown man-child of a husband gnawing at a hairy stick of pink cotton while holding my beaming mother's hand. It just slays me. Takes me away from the fact that my pants are tight. Or the anxiety I feel when deciding whether to wear a mask.

Look, life can be hard. We can either meet sadness and despair with more sadness and despair, or we can meet it with perspective . . . and the giggles.

Because trust me when I tell you: it's us gigglers who survive intact. Should my husband live in a constant state of misery for believing the apocalypse is coming like a package from Amazon? Hell's bells, no. He knows that whenever he feels himself spiraling into a tunnel of grief over his losses, it's time to write a song (because music is another one of his saviors) and watch a Monty Python marathon. Or reach for a funny memory.

Like the time we went hiking in the redwoods and I tripped over a pebble because, okay, I was wearing platform sandals (in my defense, they were super cute and on sale). I call it my "Chariots of Fire" Fall because that was the song playing in my head, while I took what felt like forever to hit the ground. Oh, sure, I was fine—I'm not graceful as a lifestyle. But when I recount the story—and how, despite my husband's attempts to grab me, I face-plowed into the grass—we literally squeal.

That kind of laugh, which comes up through the windpipe as pure joy, is healing salve. It's like a scone and coffee after a long fast. A call from an old friend. Unexpected praise. It's when you finally leave the house after two years of being afraid to go to the Piggly Wiggly, for fear you'll contract the plague. Snort wine out of your nose. Realize you've dodged a bullet.

It's the mean girls from high school whose metabolisms have finally caught up to them. A poem that makes you cry. A stranger who tells you your perm is cool. It's love at the right time and in the right amounts—love that makes you feel less alone.

It's the courage to donate the jeans that don't fit anymore, that you've moved to and from three houses, because you've finally figured out you don't need them to be the badass you already are.

Now that's what I call a real kick in the pants.

Here's the thing: There will always be reasons to crawl into bed and sob until your face is covered in two-day-old mascara. And yet when we lose our ability to laugh at the same time, we risk losing ourselves. Because laughing is in our DNA. It's how we cope—and connect. It reminds us, in our darkest moments, that we're all the same.

Today, I learned that someone I knew in my twenties had died. We weren't close, but still, it made me sad. And had me contemplating my own mortality. Heavy stuff.

To get the reprieve I needed, I took our puggle and lab mix to the park, plunked them in front of a large statue of some old white guy, and laughed out loud while they barked at it for twenty minutes. A few bystanders joined in. One was feeling especially anxious about going back to the office after COVID. The other had just gotten divorced.

There we were. Holding our stomachs. We knew laughing wasn't going to erase the specter of death, make a return to work easier, or cure a broken heart, but it sure did feel swell. And that's the point.

There is zero payoff for being a martyr or stoic in the face of suffering. That won't stop it from happening. You won't receive a Presidential Medal of Honor for being unhappy into perpetuity. George Clooney will not show up at your house in a cape with Girl Scout Cookies.

All the more reason to embrace life and laughter as two sides of the same coin. Knowing that where there's darkness, there's light. Where there's drama, there's comedy. Where there's pain, there's humor.

And where there is humor, there is grace.

Face it, folks: This roller coaster called life is a nonstop ride. You're either on or you're off.

When I was growing up, my mother worked as a part-time receptionist for a proctologist (and no, I'm not obsessed with bodily functions . . . these things just happen). She was so proud; and to show it, she drove around with a box of enemas in the trunk of her Dodge Dart. Have a cold? A backache? Knee trouble? Bend over. She was there for it. All the more reason for those of us close to her to stay healthy . . . and upright.

That she never left the house without a few pooper snoopers in tow is funny, right? And kinda sad, too, because some folks were really happy to see them.

All of which begs the question: Whatcha gonna do? About war, illness, hemorrhoids, or [insert your tragedy of choice]? I say yuck it up, friends. Because sometimes it's when things are just not funny at all that we need to laugh the most.

JILL SHERER MURRAY is an award-winning author, journalist, communications specialist, and founder of Let Go For It, which helps improve people's situations through the simple mantra of letting go. Her TEDx talk, "The Unstoppable Power of Letting Go," has been viewed by millions of people. She wrote the book *Big Wild Love: The Unstoppable Power of Letting Go* (She Writes Press, 2020) for the many people from all over the world who reached out for advice after seeing it. Reach her at www.letgoforit.com.

Proceeds:
Our Commitment

The collection of essays, poetry, and art in this book are meant to feed and nourish our hearts and minds. It's what women do—we feed people. To that end, the proceeds from this work will be donated to the nonprofit World Central Kitchen, an organization conceived by chef José Andrés as a way to feed people affected by natural disasters and war.

World Central Kitchen financially supports food banks and restaurants that provide free food throughout the world.

Acknowledgments

Thank you to the women of She Writes Press who contributed to this book. Your work shines a light on the essential goodness of humanity, keeping hope, love, and beauty alive in the face of daunting times.

SELECTED TITLES FROM SHE WRITES PRESS

She Writes Press is an independent publishing company founded to serve women writers everywhere. Visit us at www.shewritespress.com.

A Delightful Little Book on Aging by Stephanie Raffelock. $19.95, 978-1-63152-840-8. A collection of thoughts and stories woven together with a fresh philosophy that helps to dispel some of the toxic stereotypes of aging, this inspirational, empowering, and emotionally honest look at life's journey is part joyful celebration and part invitation to readers to live life fully to the very end.

A Theory of Everything Else: Essays by Laura Pedersen. $16.95, 978-1-63152-737-1. Take a break or recharge your batteries with these laugh-out-loud witty and wise ruminations on life by best-selling author, former *New York Times* columnist, and TV show host Laura Pedersen—essays that vividly demonstrate how life can appear to grind us down while it's actually polishing us up.

Life's Accessories: A Memoir (And Fashion Guide) by Rachel Levy Lesser. $16.95, 978-1-63152-622-0. Rachel Levy Lesser tells the story of her life in this collection—fourteen coming-of-age essays, each one tied to a unique fashion accessory, laced with humor and introspection about a girl-turned-woman trying to figure out friendship, love, a career path, parenthood, and, most poignantly, losing her mother to cancer at a young age.

No Thanks: Black, Female, and Living in the Martyr-Free Zone by Keturah Kendrick. $16.95, 978-1-63152-535-3. In essays written with humor and wit, Kendrick reimagines what it means to be "a good Black woman"—from women choosing never to have children to mothers regretting their choice to have them, from being a lonely Black atheist to conquering loneliness as a single woman in a foreign country—and, in the process, challenges the expectation that Black women will serve as either noble martyrs or sacrificial lambs.

Finding the Wild Inside: Exploring Our Inner Landscape Through the Arts, Dreams, and Intuition by Marilyn Kay Hagar. $24.95, 978-1-63152-608-4. What might it be like to step away from your busy life and figure out what truly gives your life meaning? This book encourages readers to discover that wildly creative place inside that knows there is more to life than we are currently living—and that life lived from the inside out offers us a path to authenticity and belonging.

CPSIA information can be obtained
at www.ICGtesting.com
Printed in the USA
JSHW060001130722
27985JS00002B/7

9 781647 424893